DRAWING

A Contemporary Approach

Reproduced on the cover
Michael Heizer. *45°, 90°, 180° Geometric Extraction Study #1*,
detail. 1983. Silkscreen, watercolor, crayon, ink on paper, 50 × 50"
(125 × 125 cm). Private Collection. Courtesy of the Margo Leavin
Gallery. Photo: © Douglas M. Parker.

Cover design
Caliber Design Planning, Inc.

DRAWING

A Contemporary Approach

Second Edition

Claudia Betti
Teel Sale
North Texas State University

Holt, Rinehart and Winston
New York Chicago San Francisco Philadelphia
Montreal Toronto London Sydney
Tokyo Mexico City Rio de Janeiro Madrid

To my students
—Claudia Betti

For my son Richard,
who taught me the meaning of process
—Teel Sale

Publisher Susan R. Katz
Editor Karen Dubno
Picture Research Joan Scafarello, Amy Butler
Project Editors Arlene Katz, Maruta Mitchell
Copy Editor Susan C. Winslow
Production Manager Pat Sarcuni
Design Supervisor Louis Scardino
Designer Caliber Design Planning, Inc.

Library of Congress Cataloging in Publication Data

Betti, Claudia.
 Drawing: a contemporary approach.

 Bibliography: p.
 Includes index.
 1. Drawing—Technique. I. Sale, Teel. II. Title.
NC730.B43 1986 741.2 85–5617

ISBN 0-03-070339-5

CBS COLLEGE PUBLISHING
Holt, Rinehart and Winston
The Dryden Press
Saunders College Publishing

PREFACE

The underlying assumption of *Drawing: A Contemporary Approach* is that drawing is an exciting and necessary activity. We believe that drawing can be taught through a series of related steps and diverse techniques that will show students their own powers of observation, execution, and capacity to discover new concepts. The ability to observe, distinguish, and relate is much the same in all areas of art, whether the student's area of concentration is painting, sculpture, crafts, or the commercial fields.

Drawing has historically been an essential, albeit preliminary, step for all the visual arts. In the 20th century, however, this relationship has undergone a major change. Drawing is now viewed as a major art form; it enjoys an elevated status among artists, critics, and collectors alike.

Because the handling of space is such a major concern in drawing, as in all the visual arts, the formal art elements are approached through a study of spatial relationships. This text is built around a series of problems, each of which is designed to encourage fluency in drawing, give experience in handling media, foster self-confidence, and instill an understanding of the basic art elements and their role in spatial development.

The word *contemporary* in the book's title has two implications. First, we have emphasized a method of learning to draw that is contem-

porary in outlook. Second, in choosing the art work reproduced and discussed we have introduced new concepts and considered current concerns in art. We have tried to show art's multidimensional pursuit of significance, which frequently means going beyond conventional rules of composition. We have attempted to indicate the incredible range of possibilities open to the practicing artist in media, style, and meaning. Occasionally paintings, prints, watercolors, photographs, and even sculpture are shown. We have included this wide range of work to show the indispensible role of drawing in every aspect of art production. Almost all of the illustrations date from the 20th century. The drawings illustrated include both masterworks and examples from the classrooms at North Texas State University.

Supporting the text are four "Practical Guides," which deal respectively with materials, presentation, keeping a sketchbook, and methods for breaking artistic blocks.

This new edition has several major changes. Chapter 2, "Learning to See," has been expanded to include a broader range of beginning approaches. In addition, there is more concentration on composition, both in the discussion of the illustrations and in the problems. Chapter 7, "Color," has been added. It explains present-day attitudes, applications, and functions of color, introducing students to some basic terms and concepts for their initial drawing experiments with color. Nine color plates accompany this chapter. Chapter 8, "Spatial Illusion and Perspective," now includes a discussion of perspective appropriate for the beginning student. Chapter 11, "A Look at Art Today," deals with styles, techniques, and media of the 1980s. Finally, the illustrations throughout the text have been updated to include more current examples. We have expanded our discussions of the illustrations, keeping in mind a focus on composition and content.

We do not promote a single, rigid method of learning to draw. We believe the students' involvement in their own work along with familiarity with the concerns and styles of other artists will help them solve their own problems and develop a personal expression in an exciting way. We hope *Drawing: A Contemporary Approach* will keep students moving along an ambitious path that involves growth in intellectual, emotional, sensory, and artistic capabilities.

Acknowledgments

Many people have assisted and encouraged us in preparing this text. We are grateful to our colleagues at North Texas State University, especially to Richard Sale, who has helped in many ways. Our appreciation also goes to the staff at Holt, Rinehart and Winston, to our editor Karen Dubno and to Joan Scafarello, Amy Butler, Nikki Harlan, Jane Knetzger, Arlene Katz, Maruta Mitchell, and Ed Cone.

The photographs of student drawings in this book were taken by Pramuan Burusphat and Danielle Fagan. Finally, and above all, we continue to be indebted to the students whom we have taught—and who have taught us.

C.B.

Denton, Texas T.S.

CONTENTS

PART ONE

Introduction to Drawing

CHAPTER 1

Drawing: Thoughts and Definitions

The process of drawing develops a heightened awareness of the visual world, an awareness that is both subjective (knowing how you feel about things) and objective (understanding how things actually operate). Perception, the faculty of gaining knowledge through insight or intuition by means of the senses, is molded by subjectivity as well as by the facts of the world.

Drawing affords you an alternative use of experience. It provides a new format for stating what you know about the world. Through drawing you are trained to make fresh responses and are furnished a new way of making meaning. Finally, drawing teaches you to observe, distinguish, and relate.

The exciting process of creating art may seem complex to the beginning student. A way through this complexity is to recognize that art has certain categories or divisions. The focus here is on *drawing*, one of the major areas of artistic activity. Drawings, however, are not of interest to artists only. Illustrators, designers, architects, scientists, and technicians make use of drawing in their professions. Just as there are different uses for drawings, there are many types of drawings.

Subjective and Objective Drawing

In its broadest division drawing can be classified as either subjective or objective. *Subjective* drawing emphasizes the artist's emotions. In *objective* drawing, on the other hand, the information conveyed is more important than the artist's feelings. Claes Oldenburg's plan for *Mouse Museum* (Fig. 1) is concerned with design information—measurement, scale, and proportion between parts—and thus belongs to the objective

1. Stuart E. Cohen for Claes Oldenburg. Construction plan for revised version of *Mouse Museum.* 1977. Pencil, 20 × 30″ (51 × 76 cm). Museum of Contemporary Art, Chicago (gift of the architect).

2. Claes Oldenburg. *Proposal for a Facade for the Museum of Contemporary Art, Chicago, in the Shape of a Geometric Mouse.* 1967. Crayon and watercolor, 10½ × 16¼" (27 × 41 cm). Collection the artist.

category. Oldenburg's highly energetic and witty drawing in Figure 2 is an example of the subjective category. The artist proposes a mouse façade for a museum. The quickly stated ink wash in the background and the immediacy of the line quality convey the humorous intent of the project. Oldenburg combines both the subjective and objective approach in his *Symbolic Self-Portrait with Equals* (Fig. 3). This deceptively simple

3. Claes Oldenburg. *Symbolic Self-Portrait with Equals.* 1969. Pencil, color pencil, spray enamel on graph and tracing paper, 11 × 8¼" (28 × 21 cm). Collection the artist.

drawing is loaded with symbolic content. The diagrams of the symmetrically balanced objects in each quadrant refer to Oldenburg's sculptures. The ice bag signifies a beret, the stereotypical attribute of an artist. The staring eyes refer to the conditions of making a self-portrait (staring into a mirror) as well as emphasizing the artist's dependence on the eyes. Oldenburg says his intent was to make a combination image of magician and clown, both metaphors for the artist. A great deal of the humor of this portrait comes from the fact that Oldenburg combined two opposite approaches in a single drawing—the abstracted indications of the objects in the quadrants drawn in engineering style along with the highly personal view of the self. This duality of subjectivity and objectivity is carried through in nearly every aspect of the work.

Another set of drawings that clearly contrasts the subjective and objective approach can be seen in two skull drawings. For an anatomical illustration (Fig. 4) it is important that every part be clearly visible and descriptive. The illustrator has employed such devices as receding spaces noted by darker value and small groups of lines to indicate the bulging features of the skull.

The skull has always been a popular artistic and literary image for its loaded symbolic content. Nino Longobardi has depicted this menacing image alongside commonplace objects that by scale and context serve to make the work even more bizarre (Fig. 5). The studio scene, which logically should be larger than the skull, is dwarfed by the looming, aggressively stated skull. The artist and models are seemingly oblivious to the presence of the firmly rooted, animated skull. The artist turns his back on the dark presence and energetically confronts his painting. Is this a metaphor for the life-directed goal of art? This subjective drawing not only conveys the heightened feelings of the artist, it engenders a heightened response from the viewer as well. We try to find meaning in the disparity of the sizes of the objects and in their relationship to one another. Of course, not all subjective drawings are as extreme as Longobardi's work, nor are all objective drawings as readily classifiable as the anatomical illustration.

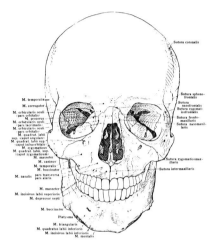

above: 4. The skull; anterior view with muscular attachments.

below: 5. Nono Longobardi. *Self-Portrait.* 1983. Mixed media on canvas, 6'7" × 17'6" (2 × 5.36 m). Courtesy Charles Cowles Gallery, New York.

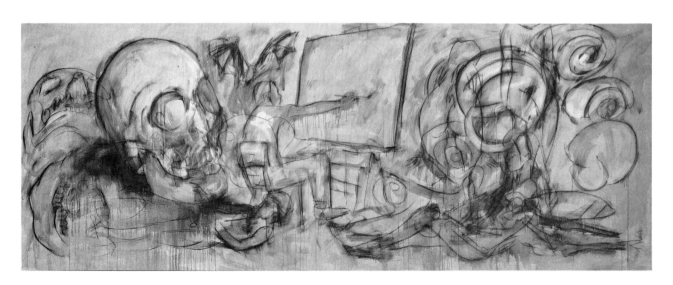

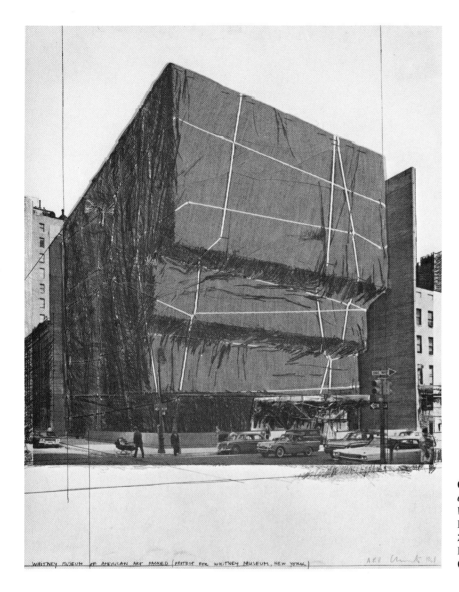

WHITNEY MUSEUM OF AMERICAN ART PACKED (PROJECT FOR WHITNEY MUSEUM, NEW YORK) ART Christo 1968

6. Christo. *Whitney Museum of American Art Packed (Project for Whitney Museum, New York).* 1968. Photolithograph and collage. 28 × 22″ (71 × 56 cm). Published by Landfall Press, Inc., Chicago.

Informational Drawing

The objective category is also called *informational drawing.* It includes diagrammatic, architectural, and mechanical drawings. Informational drawings may clarify concepts and ideas that are not actually visible. Many serious 20th-century artists have used art as documentation and information. In Christo's proposal for packaging the Whitney Museum (Fig. 6), he combines photography, collage, and drawing to present an accurate visual description of the museum as if it were wrapped. Christo, like Oldenburg, uses a museum as the subject of his art; his project makes a statement on packaging art as a commodity. Christo's plans are frequently carried out; that is, they are not merely proposals, and he documents these projects both in drawing and photography.

Schematic Drawing

Another type of objective drawing is the *schematic*, or *conceptual*, *drawing*. It is a *mental construct*, not an exact record of visual reality. A biologist's schematic drawing of a molecular structure is a guess used for instructional purposes. Comic book characters and stick figures in instruction manuals are familiar examples of schematic drawings. We do not think of them as complicated, but they are schematic and conceptual; they are an economical way to give information visually. We know what they stand for and how to read them. They are *conventions*, just as the western hero riding into the sunset is a convention. This conventional schematization is easily understood by everyone in American culture.

At this point the two broad categories of subjective and objective begin to overlap. A schematic, or conceptual, drawing may be objective, like the illustration of stick figures in an instruction manual. It may also be intensely subjective, like a child's drawing in which the proportions of the figure are exaggerated in relation to its environment (Fig. 7). Scale is determined by importance rather than by actual visual reality.

Saul Steinberg uses the schematic approach in a subjective manner. In *Main Street* (Fig. 8) he employs a number of conventions to indicate movement: The swirling lines in the clouds create a somewhat turbulent sky (a metaphor for all the flurry of activity below?); the cloud and ball, trailing long shadows, seem to be scurrying along at a quicker pace than the rather static figures, whose thrown-back arms and billowing skirt are the only indicators of motion. Steinberg's humorous intent is heightened by his shorthand style. The emphasis is on idea, on concept, rather than on visual reality. There is a flourishing movement in contemporary art involving schematized drawings that employ apparently direct and simple schematized images to carry sophisticated and subjective expression.

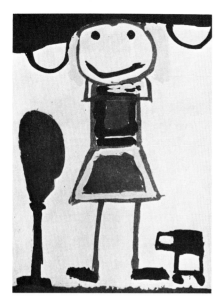

7. Child's drawing.

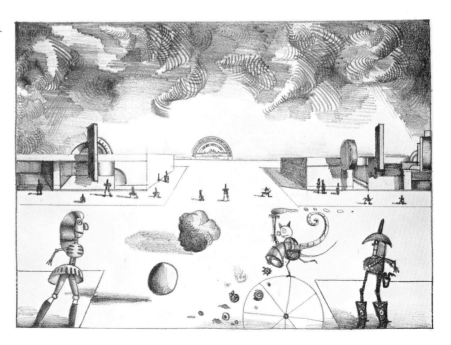

8. Saul Steinberg. *Main Street*. 1972–73. Lithograph, 15¾ × 22″ (40 × 56 cm). Museum of Modern Art, New York (Gift of Celeste Bartos).

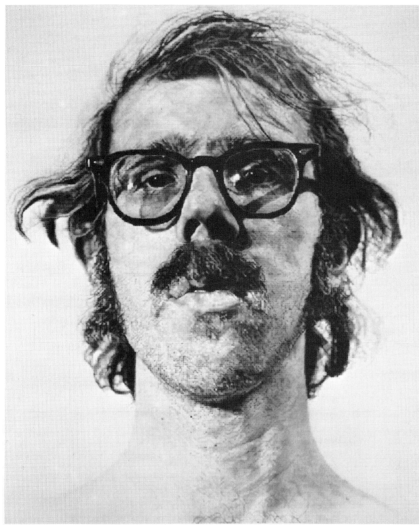

9. Chuck Close. *Self-Portrait/58424.* 1973. Ink and pencil.
5'10½" × 4'10" (1.79 × 1.47 m). Courtesy Pace Gallery, New York.

Pictorial Recording

Another important category in drawing is *pictorial recording*. The medical illustrator, for example, objectively records an image with almost photographic accuracy. Yet for some artists, imitating certain photographic techniques can lead to highly subjective effects. A number of contemporary artists are concerned with duplicating what the camera sees—both its focus and distortion. This movement is known as *Photorealism.* The work of these artists suggests a bridge between subjective and objective art, for even in the most photographic drawing or painting a part of the artist's personal style enters.

In the Photorealist self-portrait by Chuck Close (Fig. 9) a strong element of subjectivity is revealed in the camera angle, in the aggressive confrontation between camera and subject. This element is even more

pronounced in a real encounter with the drawing, which is of enormous scale (5 feet 10½ inches by 4 feet 10 inches [1.79 × 1.47 m]). The tousled hair and unshaven beard seem out of keeping for a portrait. The movement of the hair suggested by blurring and lack of focus contrasts with the otherwise motionless, frozen, centralized image. Close's drawing technique is, on the other hand, highly objective. He uses a grid pattern, barely discernible in the finished work, to lay out the image. He grids both the photograph to be copied and the surface onto which it is to be drawn; then, beginning at top upper left, he proceeds, transferring the image square by square exactly and sequentially, duplicating from the photograph.

Another example of pictorial recording can be seen in Claudio Bravo's pastel drawing titled *Pamela* (Fig. 10). The subject has been painstakingly and directly observed. The likeness is a result of an intense and accurate observation on the part of the artist. Bravo has faithfully recorded the young girl's appearance and has captured her personality. She seems to be somewhat vulnerable; the direction of her eyes leads us to believe she is not conscious of the artist (as opposed to the direct confrontation between Close and the camera). Bravo has conveyed a tactile sense in the drawing—the texture of her hair, scarf, shirt, and jeans is well observed and convincingly rendered. As in the Close self-portrait, there is a combination of subjectivity and objectivity.

below left: **10.** Claudio Bravo.
Pamela. Pastel on paper.
17⅛ × 11½″ (44 × 29 cm).
Courtesy Sotheby's, New York.

below right: **11.** Andrew Wyeth.
Beckie King. 1946.
Pencil. 30 × 36″ (76 × 91 cm).
Dallas Museum of Fine Arts
(Gift of Everett L. DeGolyer).

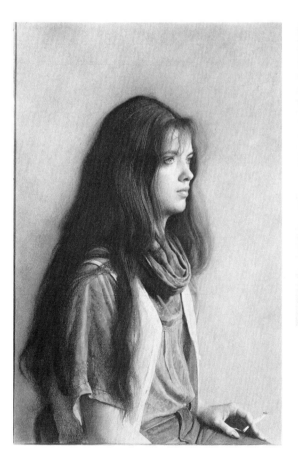

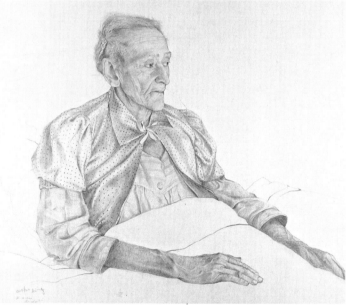

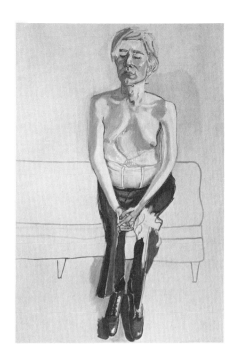

12. Alice Neel. *Andy Warhol.* 1970. Oil on canvas, 5′ × 3′4″ (1.52 × 1.02 m). Whitney Museum of American Art, New York (Gift of Timothy Collins).

A third example, one that combines a subjective approach with an objective drawing technique, is the portrait of Beckie King by Andrew Wyeth (Fig. 11). Wyeth's penetrating and sympathetic drawing conveys the calm, serene attitude of his subject. Wyeth, like Bravo, uses his acute eye to capture the mood of his subject. He has concentrated our attention on the bedridden figure; the sparsely indicated cover and pillow do not allow our eyes to wander from the central focus of the old woman. The texture in Wyeth's drawing is even more pronounced than in the Bravo pastel; each vein, each wrinkle stirs an empathetic response in the viewer. Beckie King seems to be unaware of the artist; her eyes are focused on another place, another time.

Subjective Drawing

Just as in every other human activity, there is a full range of the subjective element in artistic production. Alice Neel is more interested in the psyche of her sitters than in a direct transcription of visual reality. Although she works from direct observation, she says she is more interested in "what people are like underneath how they look." Neel's style is spontaneous and energetic and more immediately recognizably subjective than those of the two previously discussed artists. In the portrait of Andy Warhol (Fig. 12), as in her other works, she uses distortion, an unfinished quality, and an uncomfortable arrangement of limbs and posture as theme and variation. Warhol's eyes are averted, the focus is internal, his vulnerability is suggested by the closed eyes and the scarred body. The psychological truth for Neel is more important than a literal realism.

A drawing, then, may be slightly or highly personal; there are as many degrees of subjectivity as there are artists.

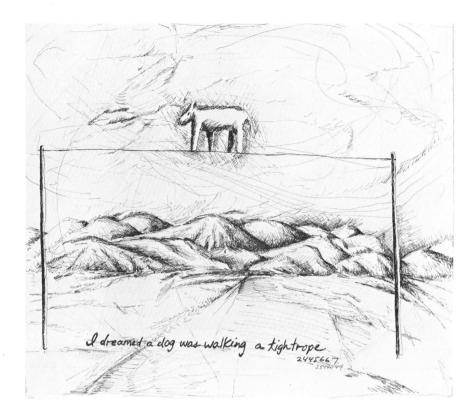

13. Jonathan Borofsky. *I dreamed a dog was walking a tightrope at 2,445,667 and 2,544,044.* 1978. Ink and pencil, 12 × 13″ (30 × 33 cm). Private collection, New York.

14. Jean Tinguely. *Study of Machine.* 1965. Ink, 12⅝ × 15⅞″ (32 × 40 cm). Courtesy Iolas-Jackson Gallery, New York.

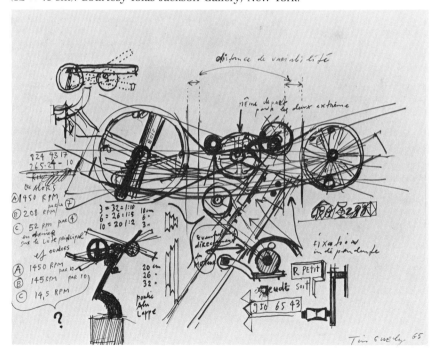

The Viewing Audience

Another set of distinctions involves the question: For whom is the drawing intended? Artists make some drawings only for themselves. These drawings may be preparatory to other work, like Jonathan Borofsky's study for a wall drawing (Fig. 13). An artist may wish to solve some problems or play with ideas before beginning the final piece. Artists may also draw to sharpen their sense of observation, to experiment with materials, or to increase their knowledge of the subject. These drawings-for-the-self are investigations ranging from pictorial accuracy through varying degrees of subjective interpretation.

Drawings not specifically intended for viewing audience, however, do not prevent our enjoyment of them. Jean Tinguely's *Study of Machine* (Fig. 14) gives the viewer an insight into the playful mind of the artist. Tinguely is a sculptor whose machine constructions are highly inventive. Their many moving parts with their unpredictable motions make a wry commentary on the role of the machine in technological society. Tinguely's light-hearted drawing style conveys this idea of the machine's highly improbable actions. An intimate glimpse into an artist's sketches is often as satisfying as the look at a finished drawing.

Of course, a drawing can also be a final graphic statement intended as an end in itself rather than a preparation for other work. Julio Fernandez Larraz' pastel drawing *The French Poacher* (Fig. 15) is as ambitious and skillfully finished as any of his paintings.

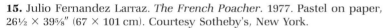

15. Julio Fernandez Larraz. *The French Poacher.* 1977. Pastel on paper, 26½ × 39⅝" (67 × 101 cm). Courtesy Sotheby's, New York.

Our enjoyment of an artist's work increases in proportion to our knowledge of the work. The more familiar we are with the style of an artist, the more we are able to relate a new drawing to works remembered. Because his style is so widely recognized, we cannot view a drawing by Pablo Picasso (Fig. 16) without many of his other works coming to mind.

Furthermore, some works are more meaningful when viewed in relation to the works of other, earlier artists—that is, when seen in the perspective of art history. Art about art has always intrigued artists, and there is a lively concern in contemporary art with this subject. Our understanding of Rico Lebrun's drawing of Maria Luisa (Fig. 17) is increased

16. Pablo Picasso. *29.12.66.III* (*Mousquetaire et profile*). 1966. Pencil and bistre, 21⅝ × 18⅛″ (55 × 46 cm). Courtesy Éditions Cercle d'Art, Paris.

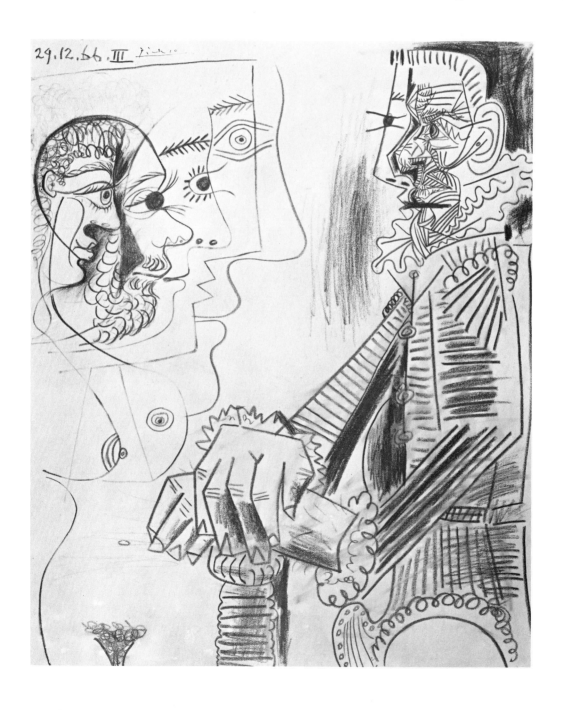

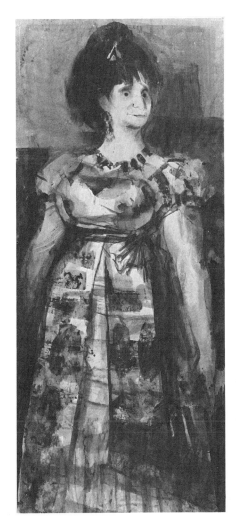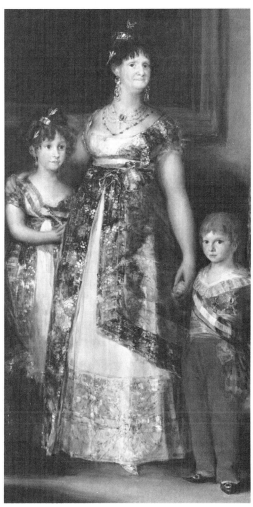

when we know the source of his image, Franciso Goya's *The Family of Charles IV* (Fig. 18). Goya, as court painter to Charles IV, suggested as much as he dared about the character of Charles' queen. Lebrun singles out Maria Luisa from the composition and makes a much more explicit and pointed statement about the queen's decadent character. Maria Luisa's face is quickly and deftly noted. The drawing becomes a caricature of a caricature.

left: **17.** Rico Lebrun.
Maria Luisa (after Goya). 1958.
Ink wash, 7'2" × 3' (2.2 × .92 m).
Private Collection.

right: **18.** Francisco Goya.
The Family of Charles IV (detail).
1800. Oil on canvas, entire
work 11' × 9'2" (2.79 × 3.35 m).
Prado, Madrid.

Subject and Treatment

Another major determinant in an art work is the subject to be drawn. Once the subject is chosen, the artist must determine how it is to be treated.

Landscape, still life, and figure are broad categories of subject sources. Nature is a constant supplier of imagery, both for the ideas it can offer and for the structural understanding of form it gives. Two widely different approaches to using natural subjects can be seen in the study

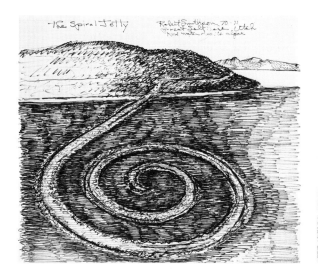

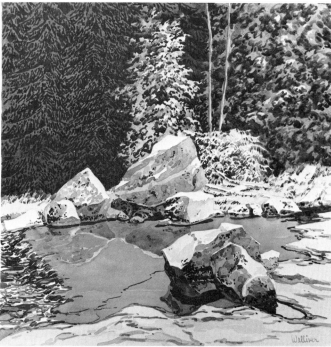

The Spiral Jetty (Fig. 19) by Robert Smithson and in the watercolor *Cedar Water Pool* by Neil Welliver (Fig. 20). Smithson proposes changes to an existing landscape. His choice of a causeway in the form of a spiral is in keeping with the symbolic implications of the work. The spiral is an ancient form symbolic of continuity. For his earth work Smithson chose a site in Utah that the Indians believed to be the hub, or navel, of the world. He proposed a jetty as a man-made form that is subject to the changes that nature imposes. So change and continuity are incorporated into a landscape that itself is continually changing.

Welliver's *Cedar Water Pool* depicts a wilderness in a rather straightforward manner, a contemporary treatment of a traditional theme. The composition is complex, filled with visual information and carefully scrutinized detail. Light and shadow activate the surface of the work, and the structural notation of the granite boulders gives weight to the picture.

The artist may choose an exotic subject, such as Robin Endsley-Fenn's *Mujeres* (Fig. 21), or may find significance in a commonplace subject, as in Irene Siegel's drawing of an unmade bed (Fig. 22). In Endsley-Fenn's work, the women's masks are in keeping with the richness of the patterned surface. The lizards are transformed into leaves and combine with repeating breast shapes to convey an exotic idea of women (*mujeres*). Siegel's treatment of an everyday subject is equally rich. The recurring motif of folds appears in the pillows, sheet, spread, chair, lampshade, and even the flower on the table. Both the exotic and the commonplace may be equally provocative to the artist.

An image can be treated symbolically; it may stand for something more than its literal meaning. A combination of a literal image with a

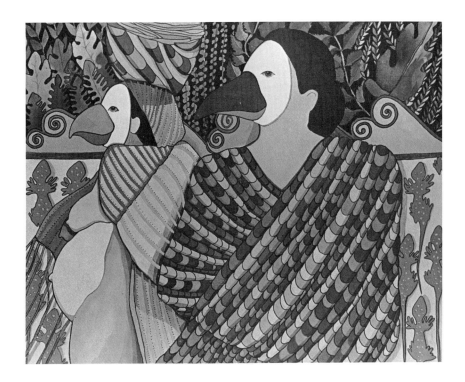

above: **21.** Robin Endsley-Fenn. *Mujeres.* 1978.
Gouache, 16 × 20″ (41 × 51 cm). Courtesy the artist.

below: **22.** Irene Siegel. *Unmade Bed, Blue.* 1969.
Pencil, 30 × 40″ (76 × 102 cm). Collection Roberta Dougherty.

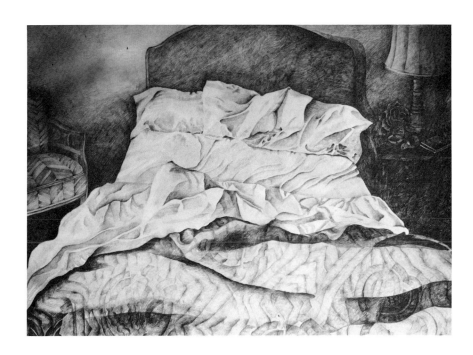

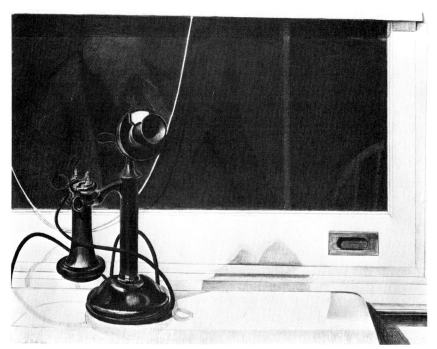

23. Charles Sheeler. *Self-Portrait.*
1923. Conté crayon, gouache, and
pencil; 19¾ × 25¾″ (50 × 65 cm).
Museum of Modern Art, New York
(Gift of Abby Aldrich Rockefeller).

24. Sharon Wybrants.
Self-Portrait as Superwoman
(*Woman as Culture Hero*). 1975.
Pastel, 12 × 5′ (3.66 × 1.52 m).
Courtesy the artist.

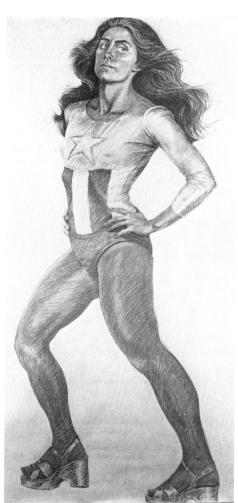

18

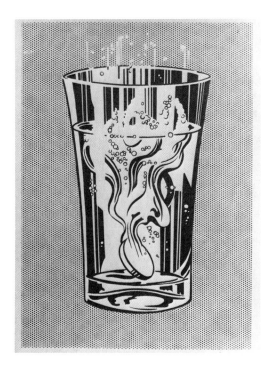

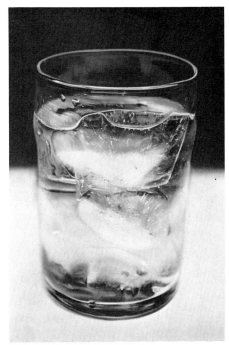

symbolic one is found in Charles Sheeler's *Self-Portrait* (Fig. 23). A clue to Sheeler's symbolic intent is given by the title of the drawing. We can only speculate how the telephone, accurately rendered, represents the artist's self, but we do know that Sheeler has made a connection between his idea of inner self and the relation of that self to the outer world. Sheeler's image is obscurely reflected in the window behind the telephone. We might find significance in the fact that the telephone is not in use and that the window to the outer world is closed.

Sharon Wybrants is far more explicit in her directions for reading her drawing. *Self-Portrait as Superwoman (Woman as Culture Hero)* (Fig. 24) is direct both visually and verbally. The image is firmly placed, filling the picture plane with its energy and vitality. The strength of the figure along with the defiantly held head attest to an unmistakably feminist stance; the social comment is obvious. The superwoman costume humorously lightens the otherwise strident message.

In Figures 25 and 26 a glass of water is given two different treatments by two contemporary artists, Roy Lichtenstein and Ben Schonzeit. Both artists have presented their subject frontally, centralized and balanced within the frame. Both glasses are greatly magnified—the Schonzeit work is monumental in scale, 6 by 4 feet (1.83 × 1.22 m). Here the similarity ends. We are impressed with Schonzeit's ability to portray photorealistically the textural details within the glass. The magnified close-up focuses on the ice cube at the top of the glass, while the back, side, and bottom are blurred. Each minute detail is convincingly rendered. Lichtenstein, on the other hand, presents his glass in a stylized, abstract manner. We are at once struck by the repeating motifs of stripes and circular patterns (bubbles, tablet, background dots, negative air bubbles above the glass, and curvilinear swirls). The stripes compress the

left: **25.** Roy Lichtenstein.
Tablet. 1966. Pencil on paper,
30 × 22″ (76 × 56 cm).
Private collection.

right: **26.** Ben Schonzeit.
Ice Water Glass. 1973.
Acrylic on canvas,
6 × 4′ (1.83 × 1.22 m).
Sydney and Frances Lewis Collection.

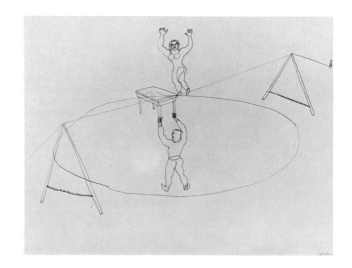

27. Alexander Calder.
Balancing Act with Tables. 1931.
Ink, 22¾ × 30¾″ (58 × 78 cm).
Fort Worth Art Museum, Texas.

distance between the back of the glass and the front. Lichtenstein's style is readily recognizable—his trademark is the use of the Benday dots, a process associated with commercial art and banal subject matter. His "billboard" style contrasts with Schonzeit's meticulous trick-the-eye textural effect. This contrast illustrates the fact that there is no end to the richness and variety in treatment of the same subject matter.

28. Robert Horvitz.
Personal Domain of Freedom and Ecstasy No. 3. 1973.
Ink, 20 × 20″ (51 × 51 cm).
Courtesy the artist.

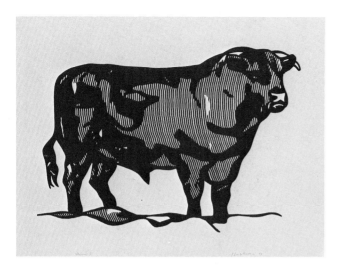

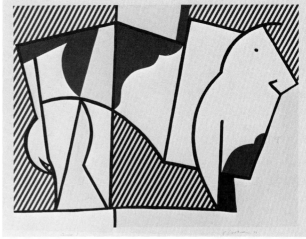

above left: **29.** Roy Lichtenstein.
Bull I from *Bull Profile Series.* 1973.
One-color linecut, 27 × 35″ (69 × 89 cm).
Courtesy Gemini G.E.L., Los Angeles.

above right: **30.** Roy Lichtenstein. *Bull III*
from *Bull Profile Series.* 1973. Six-color
lithograph, screenprint, linecut;
27 × 35″ (69 × 89 cm).
Courtesy Gemini G.E.L., Los Angeles.

below left: **31.** Roy Lichtenstein.
Bull VI from *Bull Profile Series.* 1973.
Five-color lithograph, screenprint, linecut;
27 × 35″ (69 × 89 cm).
Courtesy Gemini G.E.L., Los Angeles.

The manner in which an artist chooses to depict a subject can be extremely simple or highly complex. Alexander Calder's whimsical *Balancing Act with Tables* (Fig. 27) reduces the subject to the simplest of lines. Calder is a sculptor whose wire compositions are line drawings in space. The transparency of the forms occurs both in his sculpture and in his drawings. Note the focal point of the drawing; the juncture of the foot of the trapeze artist, table, high wire, and circular arena.

Robert Horvitz' ink drawing *Personal Domain of Freedom and Ecstasy No. 3* (Fig. 28), on the other hand, treats a difficult abstract concept in a complex manner. The richly textured surface, the compact overall composition, the multitude of geometric shapes, and the interplay of large and small shapes and of light and dark create a vigorous statement of theme and variation, a rhythmic design full of movement and activity. The compositional complication underscores the ramifications of Horvitz' complex subject.

The image can be an object taken from the real world and then altered beyond recognition. In the oversized comic-book-style prints by Lichtenstein (Figs. 29, 30, 31) we see the bull abstracted through a num-

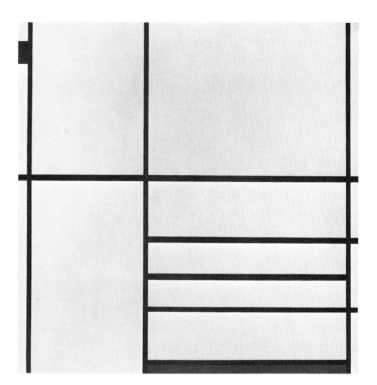

right: 32. Piet Mondrian. *Composition in White,
Black and Red.* 1936.
Oil on canvas, 40¼ × 41″ (102 × 104 cm).
Museum of Modern Art, New York
(Gift of Advisory Committee).

below: 33. Richard Smith. *Large Pink Drawing.* 1970.
Oil pastel and pencil, 2′5½″ × 4′9″ (.75 × 1.45 m).
Collection Betsy Smith.

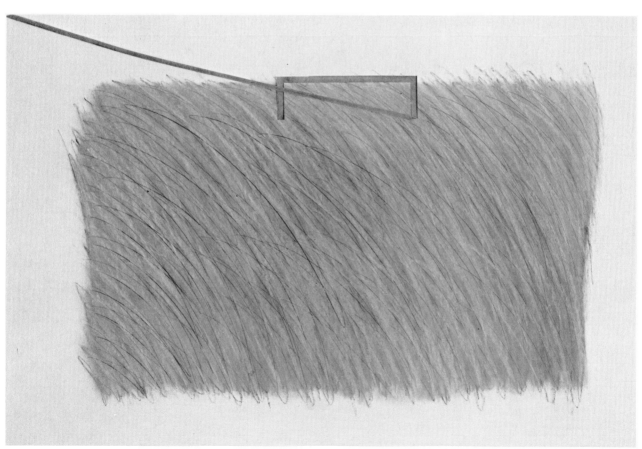

ber of stages. In this series, Lichtenstein makes a wry comment mirroring the style of Piet Mondrian. Mondrian, unlike Lichtenstein, did not begin his composition with a recognizable image and then abstract it; instead he strove for a neutral form using reductive means—line, shape, and color (Fig. 32). The arrangement of these nonobjective, geometric shapes becomes the subject of the work; all associative meaning is avoided. Balance and stability, attained through a precise arrangement of vertical and horizontal elements, were crucial concerns for Mondrian.

An artist may deal with compositional options such as shape, scale, and placement. These compositional concerns become the subject of the work. In Richard Smith's *Large Pink Drawing* (Fig. 33) the pastel and pencil marks themselves are the subject of the work. The rigidly drawn, right-angled form shoots out of the field of vigorously stated, layered marks. The two modes—one using a simple geometric shape and the other asserting the obviously handmade yet uniform lines—reinforce Smith's interest in shape, texture, and edge, all formal concerns of the artist.

Conclusion

Drawing was formerly considered a minor, although essential, art form, a preliminary step for all the visual arts. In the 20th century, however, the status of drawing has changed. The distinctions between painting and drawing, for example, are breaking down. Critics, curators, teachers, and artists today view drawing as a major art form that is lively and viable. There are as many, if not more, drawing shows as there are painting or sculpture exhibits. "Works on Paper" is a popular category in museums and galleries. Drawing is done not only on paper but also on canvas and even on three-dimensional objects.

The therapeutic value of art is well accepted; the intellectual benefits are many. Art is a way of realizing one's individuality. The making of art, the making of the self, and the development of one's own personal style are all a part of the same exciting process.

We have looked at a few of the many reasons why artists draw and a few of the many means available to an artist; now the exciting process of drawing begins.

CHAPTER 2

Learning to See: Gesture and Other Beginning Exercises

There are two basic approaches to drawing, both involving time. The first, called *gesture*, is a quick, all-encompassing overview of forms in their wholeness. The second, called *contour*, is an intense, slow inspection of the subject, a careful examination of its parts. Offshoots of these two basic approaches are *continuous-line drawing* and *organizational-line drawing*.

Gesture Drawing

The formal definition of the word *gesture* amplifies its special meaning for the artist: the act of moving the limbs or body to show, express, or direct thought.

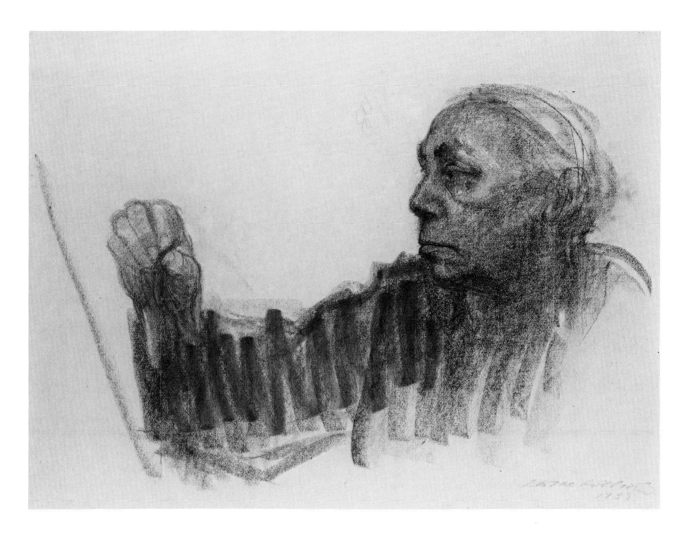

The gestural approach to drawing is actually an exercise in seeing. The hand duplicates the motion of the eyes, making a gesture that quickly defines the general characteristics of the subject—placement, shape, proportion, relationship between the parts, its arrangement in space, and so on.

In Käthe Kollwitz' self-portrait (Fig. 34) the gestural mark connecting the hand and head is the carrier of meaning. This emphatic, quickly stated line is symbolic of the energy that flows between the eye and hand of the artist. Careful modeling refines the head and hand while traces of the gestural beginning are clearly apparent in the torso, arm, and hair. The calm, coolly observed head study is sharply juxtaposed to the risky, jagged line spanning the loaded empty space between eye and hand. The mark stretches and conceptually fills the centralized space.

Gesture is not unlike the childhood game of finding hidden objects in a picture. Your first glance is a rapid scanning of the picture in its entirety; then you begin searching out the hidden parts. In Claes Oldenburg's monument drawing (Fig. 35) the viewer is first struck by the very active lines, giving a kinetic effect to the landscape. Our eyes are orchestrated by the movement of the line, weaving through and around the

above: **34.** Käthe Kollwitz. *Self-Portrait with a Pencil.* 1933. Charcoal drawing, 18¾ × 24⅞" (48 × 63 cm). National Gallery of Art, Washington, D.C. (Rosenwald Collection).

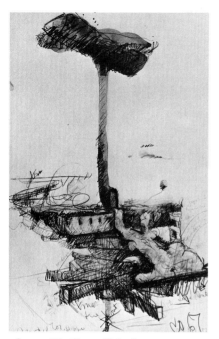

drainpipe building. The marks are not contained within a form; they search out and quickly describe the entire setting. We can detect the quick wrist movements of the artist, who occasionally transforms the scribbles into written notations.

Gesture is indispensable for establishing unity between drawing and seeing. It is a necessary preliminary step to gaining concentration. We can recognize friends at a glance and from experience we do not need to look at them further for identification. We perform an eye scan unless there is something unusual to make us look intently—unusual clothes, a new hair style, or the like. For most daily activities, too, a quick, noninvolved way of looking is serviceable. For example, when we cross the street, a glance at the light, to see if it is green or red, is enough. We may add the precaution of looking in both directions to check on cars; then we proceed.

This casual way of screening information is not enough in making art, however. Even if the glance at the subject is quick, our eyes can be trained to register innumerable facts. In the subject to be drawn, we can train ourselves to see nuances of color, texture, lights and darks, spaces between objects—measurable distances of their height, width, and depth—the materials from which they are made, the properties of each material, and many more things as well.

Through gesture you will learn to translate this information into drawings. Gesture is the essential starting point.

Artists throughout the ages have used the gestural approach to enliven their work. An 18th century artist, Gaetano Gandolfi, used gesture to

above: **35.** Claes Oldenburg.
Proposed Monument for Toronto: Drainpipe. 1967.
Pencil and watercolor,
40 × 26" (101 × 66 cm).
Private collection.

36. Gaetano Gandolfi. *The Marriage Feast at Cana.*
Late 18th century. Pen and brush with ink and wash,
9¾ × 8⅛" (25 × 21 cm).
Pierpont Morgan Library, New York
(Janos Scholz Collection).

37. Salvator Rosa. *Jael Killing Sisera.* 17th century.
Pen and ink with wash, 6⅛ × 5½" (16 × 14 cm).
Pierpont Morgan Library, New York
(Janos Scholz Collection).

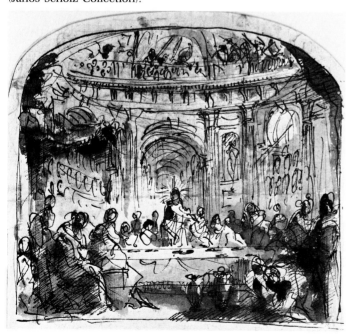

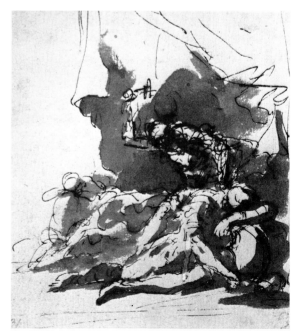

establish his composition (Fig. 36). He quickly translated three-dimensional forms onto the two-dimensional surface of his paper, establishing scale and proportion early. The drawing thus becomes a blueprint for further development. Salvator Rosa, in the ink wash drawing illustrated in Figure 37, used a gestural approach to introduce lights and darks at an early stage. Rosa's placement of these lights and darks economically establishes a dramatic feeling in the work.

Although Rico Lebrun's *Woman Leaning on a Staff* (Fig. 38) is more developed than the two preceding drawings, the gestural approach is maintained. The drawing remains flexible, capable of being corrected and further developed. Through gesture Lebrun reveals the underlying structure, capturing the attitude of the woman's pose.

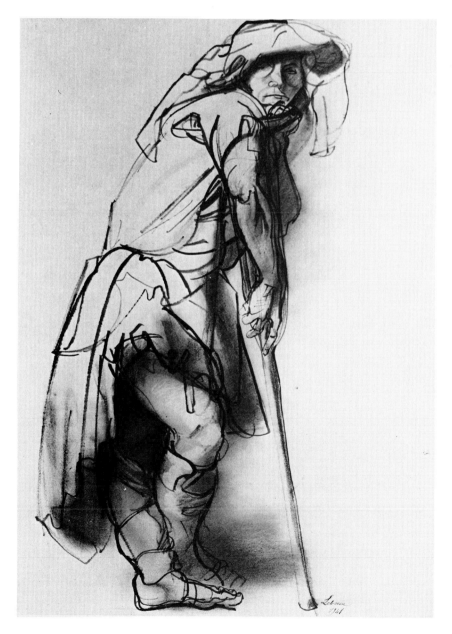

38. Rico Lebrun.
Woman Leaning on a Staff. 1941.
Ink and chalk,
25¼ × 11¼″ (64 × 29 cm).
Private collection.

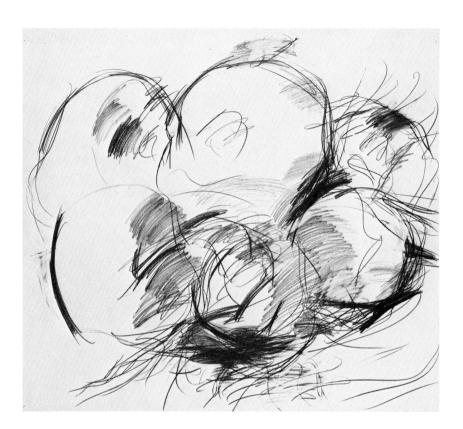

39. Wolfgang Hollegha. *Fruits.* 1963.
Pencil, 4'3" × 5' (1.3 × 1.5 m).
Courtesy the artist.

Artists have used gesture in many ways. Wolfgang Hollegha's gestural notation *Fruits* (Fig. 39) is a record of the energy that went into making the marks. The drawing is thereby infused with vitality and immediacy. The quickly scribbled lines reveal the visual connection between the artist and the objects. The spontaneously weighted lines are created by pressure change. They indicate shadow and emphasize the weight of the fruits; in addition the heavier grouped lines define the spatial relationships between the forms. Alice Yamin has used gesture to organize and compose her still life (Fig. 40) to indicate the spatial relationship between the objects and to infuse the inanimate objects with a vitality and movement that makes them seem to dance about the page. In all these drawings the strokes convey an immediacy and directness that gives us an insight into the artist's vision. Gesture trains the eye and the hand, and it opens the door most effectively to unexplored abilities.

Before Beginning to Draw

Some general instructions are in order before you begin. You may first want to consult Guide A, "Materials," which contains a comprehensive list of materials for all the problems in the book. Gesture drawing can be done in any medium, but compressed stick charcoal, vine charcoal, or ink (with 1-inch or 2-inch [2.5 or 5 cm] varnish brush or a number 6 Japanese bamboo-handled brush) are recommended in the beginning. After you have learned the technique of gesture, begin drawing and ex-

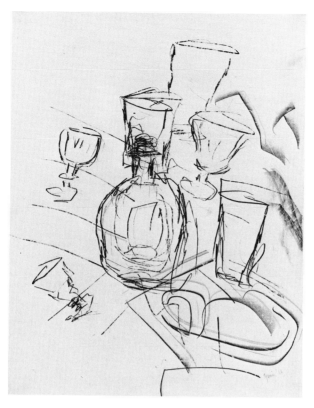

40. Alice Yamin.
Cocktail Series. 1966.
Carbon, 25½ × 20″ (65 × 51 cm).
Collection CIBA-Geigy Corporation,
Ardsley, N.Y.

perimenting with a full complement of drawing implements. Changes in media make for exciting results.

Since gesture drawing involves large arm movements, the paper should be no smaller than 18 inches by 24 inches (46 × 61 cm). Until you have fully mastered the technique of gesture, it is essential that you stand (not sit) at an easel. Stand at arm's length from your paper, placing the easel so that you can keep your eyes on the still life or model at all times. Make a conscious effort to keep the drawing tool in contact with the paper for the entire drawing; in other words, make continuous marks.

In the initial stage while you are becoming acquainted with the limits of the paper and with placement and other compositional options, you should fill the paper with one drawing. Later several gesture drawings can be placed on a page.

The drawings should be timed. They should alternate between 15- and 30-second gestures; then the time is gradually extended to 3 minutes. Spend no more than 3 minutes on each drawing; the value of gesture is lost if you take more time.

When you draw from a model, the model should change poses every 30 seconds for a new drawing. Later the pose is increased to 1, then to 2, then 3 minutes. The poses should be energetic and active. Different poses should be related by a natural flow of the model's movement. The goal is to see quickly and with greater comprehension. Immediacy is the key. Spend at least fifteen minutes at the beginning of each drawing session on these exercises.

Types of Gesture Drawing

You will be working with five types of gesture drawing in this chapter—mass, line, mass and line, scribbled-line, and sustained gesture (Figs. 41–50). The distinctions between the five along with a fuller discussion of each of the types follow.

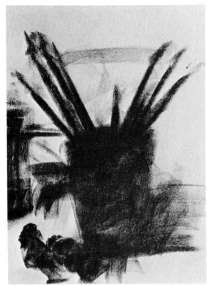

41. Mass gesture of still life.
Example by Rick Floyd. 1984.
Charcoal, 24 × 18″ (61 × 46 cm).
Private collection.

42. Mass and line gesture of still life.
Example by Rick Floyd. 1984.
Charcoal, 24 × 18″ (61 × 46 cm).
Private collection.

43. Line gesture of still life.
Example by Rick Floyd. 1984.
Charcoal, 24 × 18″ (61 × 46 cm).
Private collection.

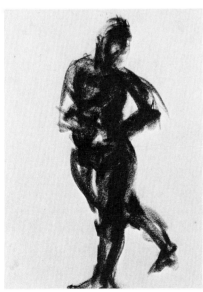

46. Mass gesture of figure.
Example by Susan Harrington. 1984.
Charcoal, 24 × 18″ (61 × 46 cm).
Private collection.

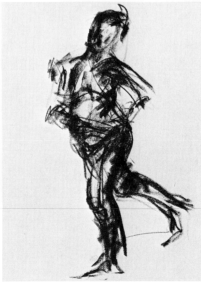

47. Mass and line gesture of figure.
Example by Susan Harrington. 1984.
Charcoal, 24 × 18″ (61 × 46 cm).
Private collection.

48. Line gesture of figure.
Example by Susan Harrington. 1984.
Conté crayon, 24 × 18″ (61 × 46 cm).
Private collection.

Mass-Gesture Exercises

Mass gesture, so called because the drawing medium is used to make broad marks, creates mass rather than line.

Use the broad side of a piece of compressed charcoal broken to the length of 1½ inches (4 cm), or use wet medium applied with a brush. Once you begin, keep the marks continuous. Do not lose contact with the

44. Scribbled-line gesture of still life. Example by Rick Floyd. 1984. Charcoal, 24 × 18″ (61 × 46 cm). Private collection.

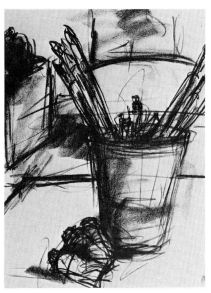

45. Sustained gesture of still life. Example by Rick Floyd. 1984. Charcoal, 24 × 18″ (61 × 46 cm). Private collection.

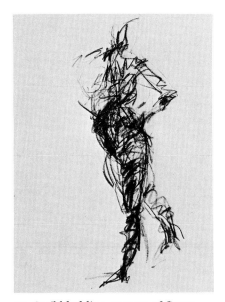

49. Scribbled-line gesture of figure. Example by Susan Harrington. 1984. Pencil, 24 × 18″ (61 × 46 cm). Private collection.

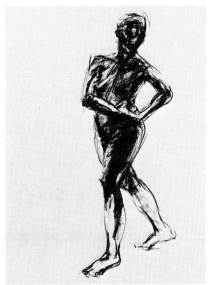

50. Sustained gesture of figure. Example by Susan Harrington. 1984. Charcoal, 24 × 18″ (61 × 46 cm). Private collection.

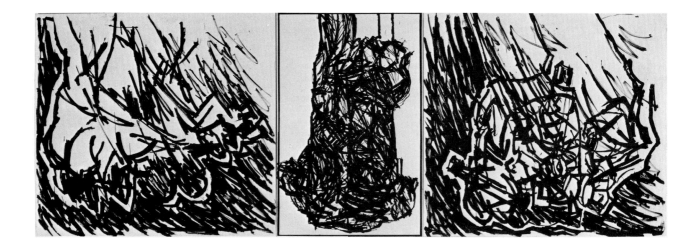

51. Arnold Mesches. *Publicity*. 1981. Acrylic on canvas, 5′ × 14′4″ (1.53 × 4.37 m). Courtesy Karl Bornstein Galleries, Santa Monica, Calif.

paper. Look for the longest line in the subject. Is it a curve, a diagonal, a horizontal, or a vertical line? Allow your eyes to move through the still life, connecting the forms. Do not follow the edge or outline of the forms. Coordinate the motion of your hand with the movement of your eyes.

In gesture you are not concerned with copying what the subject looks like. You are describing the subject's location in space along with the relationships between the forms. Keep your eyes and hand working together. Your eyes should remain on the subject, only occasionally referring to your paper. This procedure will be uncomfortable at first, but soon you will learn the limits of the page and the location of the marks on it without looking away from the subject.

When you draw from a model, try to avoid a stick-figure approach. Note the angle of the various body masses—upper and lower torso, upper and lower legs, angles of arms and head. Indicate the most obvious directions and general shapes first. Go from the large to the small. Begin at the core of the subject rather than at its outer edge.

Remember to keep the marks wide, the width of the charcoal stick or the brush. Try to create shapes as opposed to lines.

If you are drawing from a still life, place the several objects so that there are intervals of empty spaces between the various parts. (A tricycle or tree branch, for example, might serve the same purpose, affording intervals of empty spaces between the parts.) In some of your mass gestures, draw in these blank, *negative spaces* first. Emphasize the negative shapes in your drawing. You can use a figure for this exercise as well, but keep your focus on the negative shapes surrounding the figure and on the enclosed shapes (shapes formed between arms and body, for example).

In the two outside panels in Arnold Mesches' triptych (Fig. 51), the brush strokes in the negative space seem to be repelled by the emptier positive figures. The figures themselves are indicated as a group; the gestural connections transform the individuals into a single entity. The centralized torso crowds the negative space; its forms push against the outer limits of the center panel.

After you have become comfortable with the idea of looking at the shape of the negative spaces between the objects, note the depth be-

tween them. You might make an arrangement of variously sized objects, arranging them in deep space. Early in the drawing note the base line of each object. The *base line* is the imagined line on which each object sits. Noting the base line will help you locate forms in their proper spatial relationship to one another.

In drawing it is easier to indicate height and width measurements of objects than it is to suggest the third dimension, depth. You are drawing on a surface that has height and width, so lateral and vertical indications are relatively simple. The paper has no depth, so you must find a way of indicating this important measurement. The use of diagonals, of angles penetrating space, is of prime importance.

Establish the gesture by pressing harder on the drawing implement when you draw the objects farther away; lighten the pressure for those objects nearer to you. By this means you will have indicated a spatial change; the darks appear to be farther back, the lights nearer.

In addition to the important spatial differentiation that mass gesture introduces into the drawing, mass gesture gives an early indication of lights and darks in the composition. These lights and darks unify the drawing. Rhythm and movement are suggested by the placement of the various gray and black shapes.

As you can see, mass gesture helps you translate important general information from the subject onto your paper—information dealing with spatial arrangement, measurement, relationships between forms, and most importantly, with your personal response to the subject.

Line-Gesture Exercises

Related to mass gesture is *line gesture*. Like mass gesture, it describes interior forms, following the movement of your eyes as you examine the subject. Unlike mass gesture, it uses lines; these may be thick, thin, wide, narrow, heavy, or light.

Jasper Johns' pencil drawing of a flag (Fig. 52) could be an inventory of gestural line quality. The lines range widely from thick to thin, light to

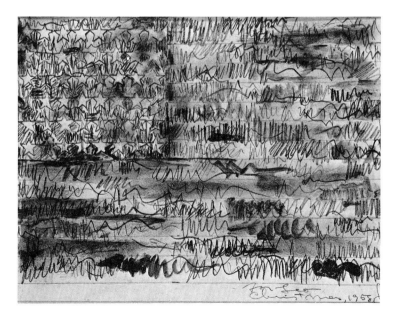

52. Jasper Johns. *Flag.* 1958.
Pencil and graphite wash on paper,
7½ × 10⅜″ (19 × 26 cm).
Private collection.

dark, tightly grouped to more openly extended. Johns leads the eye of the viewer over the surface of the flag by use of lights and darks. If you squint your eyes while looking at the composition, you will see how the distribution of darks creates an implied movement and how stability is achieved by a concentration of heavier marks at the bottom of the drawing.

In line gesture the lines are tangled and overlapped, spontaneously and energetically stated. They may look like a scribble but not a meaningless one.

The pressure you apply to the drawing tool is important; vary heavy, dark lines with lighter, looser ones. The darker lines might be used to emphasize those areas where you feel tension, where the heaviest weight, the most pressure, the most exaggerated shape, or the most obvious change in line direction exists.

As in mass gesture, the tool is kept in constant contact with the paper. Draw each object in its entirety even though the objects overlap and you cannot see the whole form. The same is true when drawing the figure; draw to the back side of the figure; draw the forms as though they were transparent.

It is a challenge for the artist to relay the effect of motion. Line gesture is particularly effective in capturing motion. Have the model take two poses and then alternate between them every 30 seconds. The poses should be connected movements. Unify the two poses in one drawing. One part of the pose should remain stationary; for example, the torso might be kept stationary while the model pivots on one leg as in the student drawing Figure 53.

Experimentation with linear media is encouraged. Any implement that flows freely is recommended. Found implements or traditional ones are appropriate.

Try to avoid centrally placed shapes every time. Lead the viewer's eyes to another part of the page by different kinds of placement or by a concentration of darks in an area away from the center. Experiment with activating the entire surface of your paper by making the composition go off the page on three or four sides.

53. Line gesture using overlapping figures. Student work. Charcoal, 24 × 18″ (61 × 46 cm).

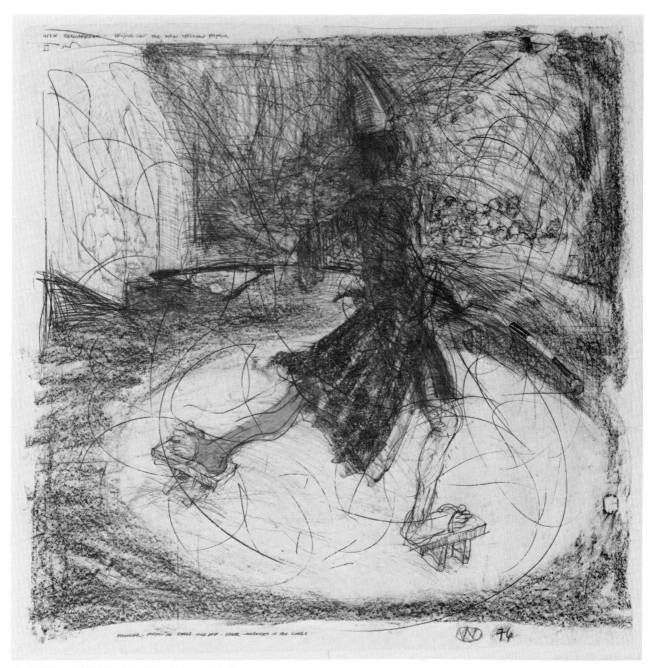

54. William T. Wylie. *Familiar Forms.* 1976.
Charcoal, pastel, and wax on buff drawing paper; 41½ × 42″ (105 × 107 cm).
Collection Mrs. Julius E. Davis, Minnesota.

Mass- and Line-Gesture Exercises

This exercise combines mass gesture and line gesture. William T. Wylie demonstrates this in his cartoonlike drawing (Fig. 54). Wylie alternates thick and thin lines using compressed charcoal.

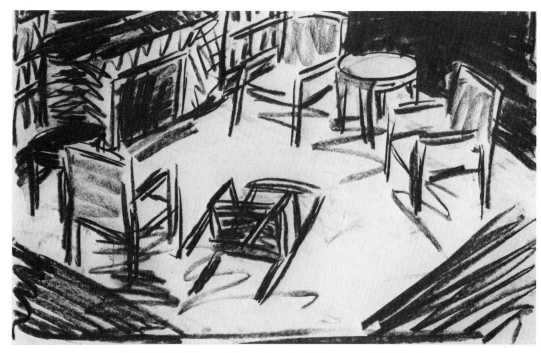

55. Michael Hurson. *Room Drawing (Overturned Chair).* 1971.
Charcoal on paper, 7½ × 12″ (19 × 30 cm). Collection the artist.

The masses or lines may be stated with charcoal or wet media with a wide brush. Begin with either mass or line, then alternate between the two. Define the more important areas with sharp, incisive lines. Michael Hurson has used mass and line in his *Room Drawing* (Fig. 55). The corners of the drawing are activated by the broad, gesturally stated triangles. The base lines of the chairs reinforce this angularity. The furniture is sketchily noted; the white central shape emphasizes the room's emptiness.

Indicating the forms as though they were transparent, restate the drawing; correct and amplify your initial image. You may wish to change the position or placement of the forms or to enlarge or decrease the scale of certain parts. Keep the drawing flexible, capable of change.

Try to fill the entire space, and do not neglect the empty or negative space. Begin laying the wash areas in the negative space and then add the positive shapes. Let the wash areas or the mass gesture marks cross over both positive and negative space.

In *Acrobats and Horses* (Fig. 56) Marino Marini combines mass and line gesture. He uses darks to indicate weight and distance; for example, the front of the acrobat's torso is white, the sides, as the figure recedes into space, are dark. Marini also uses this device in his notation of the horses' shapes. In addition to the heavier, darker forms indicating receding planes, the darks also show weight and tension. The subject crowds the edges of the picture plane, going off the page on all sides. The resulting enclosed white shapes echo the positive shapes. The necks of the

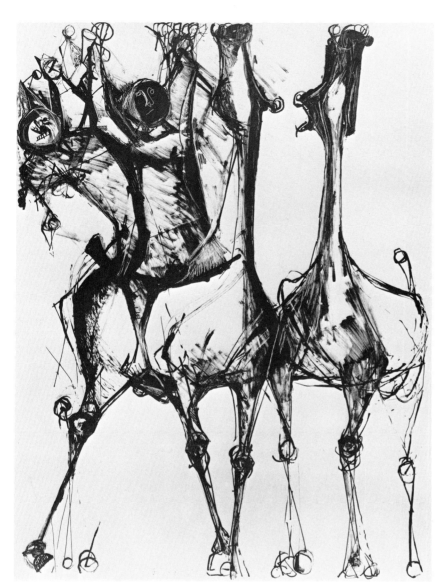

56. Marino Marini. *Acrobats and Horses.* 1952.
Lithograph, 22¼ × 17″ (56 × 43 cm).
Fogg Art Museum, Harvard University, Cambridge, Mass.
(Gift of Meta and Paul J. Sachs).

horses thrust upward, and the raised arms of the acrobats repeat this taut movement. A major motif that unifies the drawing is the repeating circular forms seen in the horses' knees and hoofs and the heads and hands of the acrobats. What more appropriate technique than gesture to capture the vital physical gesture of Marini's subject!

Scribbled-Line Gesture Exercises

The *scribbled-line gesture* consists of a tighter network of lines than was used in the preceding exercises. Alberto Giacometti's triple head

drawing (Fig. 57) is a good example of this technique. The free-flowing ball-point pen builds volume: the multiple, overlapping lines create a dense mass in the interior of the heads. The form is filled from the inside by a tangled mass resembling a wire armature. The scribbles begin at the imagined center of the object, and the lines are built from the inside out.

In a scribbled-line gesture, the outside of the form will be somewhat fuzzy, indefinitely stated. The darkest, most compact lines will be in the core of the form. The outer edges remain flexible, not pinned down to an exact line. As in the other gesture exercises, the drawing tool remains in constant contact with the paper. The scribbles should vary between tight rotation and broader, more sweeping motions.

Negative space is an appropriate place to begin a scribbled-line gesture. The marks will slow down and be somewhat more precise as they reach the edge of the positive shapes. As in the student drawing (Fig. 58) the positive shapes will be lighter than the densely filled negative space.

If most of your drawings have begun in the center or top of the page, try to change your compositional approach and consider a different kind of placement, one that emphasizes the edges, sides, or bottom. You can develop a focal point by being more precise in one particular area of the drawing.

By varying the amount of pressure on the drawing tool and by controlling the denseness of the scribbles, you can create a range of white to black.

below left: **57.** Alberto Giacometti. *Diego's Head Three Times.* 1962. Ball-point pen, 8⅛ × 6″ (21 × 15 cm). Courtesy Pierre Matisse Gallery, New York.

below right: **58.** Scribbled-line drawing with emphasis on negative space. Student work. China marker, 24 × 18″ (61 × 46 cm).

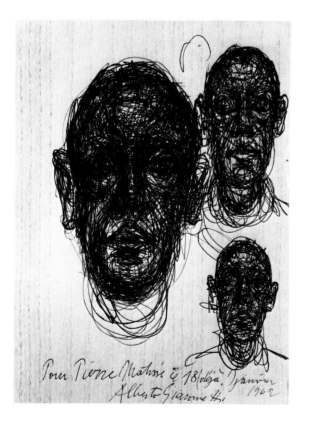

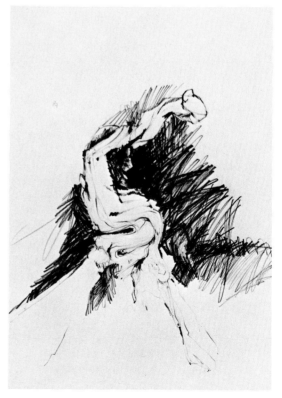

Sustained-Gesture Exercises

The use of *sustained gesture* combines a description of what the object is doing with what it actually looks like. Verisimilitude was not a primary concern in the earlier exercises. Sustained gesture begins in the same spirit as before, with a quick notation of the entire subject. After this notation, however, an analysis and examination of both the subject and the drawing take place. At this point you make corrections, accurately establishing scale and proportion between the parts. In addition to drawing through the forms, you define some precise edges. The result is that the sustained gesture drawing actually begins to look like the object being drawn.

In *Study after Three-Part Poison* (Fig. 59) Mac Adams uses sustained gesture. Traces of the gestural beginning remain in the lower half of the drawing. The upper section is far more refined and precisely drawn, while gestural marks are still evident in the negative space. The edge of the table and cloth and a few of the items on the table are drawn more carefully; the three chairs and some of the objects at the back of the table remain cursorily suggested. The rigid line leading from the chandelier to the table and onto the fallen plate divides the picture vertically; the written notations on either side of the table segment the drawing horizontally. The dark patterns in the drawing duplicate the movement of the mechanically drawn line, and the movement of the tablecloth narrows, pointing to the overturned objects. By changing the pressure on the drawing tool, Adams creates a weighty, dominant mass on either side of the table and behind the chandelier.

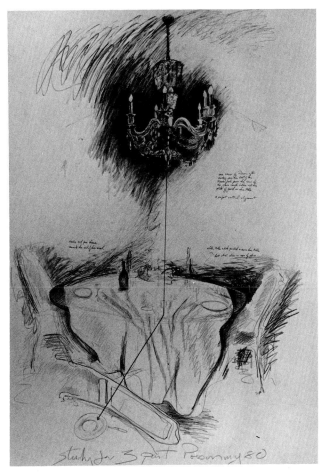

59. Mac Adams.
Study after Three-Part Poison. 1980.
Graphite on paper,
5'4″ × 3'4″ (1.63 × 1.02 m).
Commodities Corporation (USA),
Princeton, N.J.

Before drawing a still life, think of a verbal description of what it is doing. If you speak of a drooping flower, an immediate visual image comes to mind. This is a good way to approach sustained gesture. Look at the subject. Is the bottle *thrusting* upward into space? Is the cloth *languishing* on the table? Find descriptive terms for the subject and try to infuse your drawing with a feeling that is commensurate with the verbal description.

If you are drawing a figure, take the pose of the model yourself. Hold the pose for three minutes. Where do you feel the stress? Where is the most tension, the heaviest weight in the pose? Emphasize those areas in your drawing by using a darker line. Lighten the marks where there is less weight. Thinking of the attitude of the model and empathizing with the figure's pose will add variety and interest to the exercises and will help infuse the drawing with an expressive quality.

Quick gestures take from 30 seconds to 3 minutes. The sustained gesture takes longer—5, 10, even 15 minutes, as long as the spirit of spontaneity can be sustained.

In a sustained gesture you may begin lightly and darken your marks only after you have settled on a more definitely corrected shape. Draw quickly and energetically for the first two minutes; then stop and analyze your drawing in relation to the subject. Have you stated the correct proportion and scale between the parts? Is the drawing well related to the page? Redraw, making corrections. Alternate drawing with a careful observation of the subject. Avoid making slow, constricted marks. Do not change the style of the marks you have already made. Give consideration to the placement of the subject on the page, to the distribution of lights and darks; look for repeating shapes; try to avoid overcrowding at the bottom or sides of the paper. Look for a center of interest and by a more precise line or by a sharper contrast between lights and darks in a particular area, create a focal point.

In this exercise, and in those to follow, it is imperative that you stand back and look at your drawing from time to time as you work. Drawings change with viewing distance, and many times a drawing will tell you what it needs when you look at it from a few feet away.

Of all the exercises discussed, you will find sustained gesture the most open-ended for developing a drawing.

Try to keep these nine important points in mind as you work on gesture exercises.

1. Stand while drawing.
2. Use paper at least 18 by 24 inches (46 × 61 cm).
3. Use any medium. Charcoal or ink is recommended.
4. Use large arm movements.
5. Scan the subject in its entirety before beginning to draw.
6. Be aware that the hand duplicates the motion of the eye.
7. Keep your drawing tool in contact with the paper throughout the drawing.
8. Keep your eye on the subject being drawn, only occasionally referring to your paper.
9. Avoid outlines. Draw through the forms.

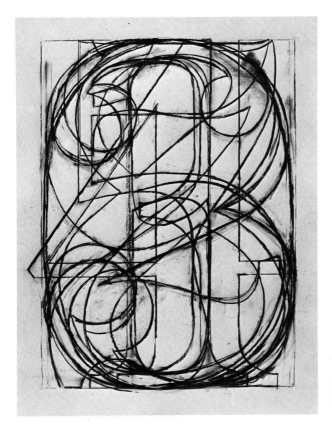

60. Jasper Johns.
0 Through 9. 1960.
Charcoal on paper,
29 × 23″ (74 × 58 cm).
Collection the artist.

Other Beginning Exercises

Other exercises that are helpful to the beginning student are continuous-line drawing, organizational-line drawing, and blind contour. Like gesture these exercises emphasize coordination between eye and hand. They help translate information about three-dimensional objects onto a two-dimensional surface. They have in common with gesture the goal of seeing forms in their wholeness and of seeing relationships between the parts.

Continuous-Line-Drawing Exercises

The line in a *continuous-line drawing* is unbroken from the beginning to the end. The drawing implement stays in uninterrupted contact with the surface of the paper during the entire length of the drawing. Jasper Johns' charcoal drawing *0 Through 9* (Fig. 60) is an example of this technique. The numbers are layered, stacked one on top of the other, all sharing the same outer edges. The numbers are transparent, and slightly unintelligible, and the overlapping, intersecting lines create shapes independent of the numbers themselves.

Once you make contact with the paper (you may begin anywhere, top, bottom, side), you are to keep the line flowing. The completed drawing gives the effect that it could be unwound or unraveled. Rather than using multiple lines, you use a single line; however, as in gesture, you

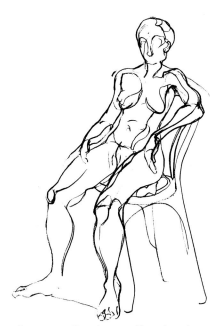

draw through the forms as if they were transparent. The line connects forms, bridging spaces between objects. Not only are outside edges described, internal shapes are also drawn. A continuous, overlapping-line drawing has a unified look that comes from the number of enclosed, repeated shapes that naturally occur in the drawing. The resulting composition is made up of large and small related shapes.

Again, as in gesture, try to fill the entire surface of your paper. This, too, will insure compositional unity. Let the shapes go off the page on at least three sides. Vary the weight of the line, pressing harder in those areas where you perceive a heavier weight or a shadow, or where you see the form turning into space, or in those areas of abrupt change in line direction (Figs. 61, 62).

Felt-tip pens, brush, pen and ink, and pencil are suggested media for continuous-line drawing. Any implement that permits a free-flowing line is appropriate. Here are some important points to keep in mind when doing continuous-line drawing:

1. Use an implement that permits a free-flowing line.
2. Use an unbroken line for the entire drawing.
3. Keep your drawing implement constantly in contact with the paper.
4. Draw through the forms as if they were transparent.
5. Describe both outside edges and internal shapes.
6. Fill the entire surface of your paper, encompassing positive and negative shapes.
7. Vary the weight of the line.
8. Your lines will overlap.

above: **61.** Continuous-line drawing. Example by Susan Harrington. 1984. Conté crayon, 24 × 18″ (61 × 46 cm). Private collection.

below: **62.** Continuous-line drawing. Example by Rick Floyd. 1984. Pencil, 18 × 24″ (46 × 61 cm). Private collection.

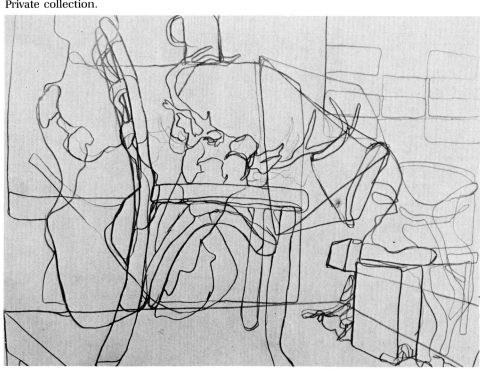

Organizational-Line-Drawing Exercises

Organizational line provides the framework for a drawing. This framework can be compared to the armature upon which a sculptor molds clay or to the scaffolding of a building.

Organizational lines take measure; they extend into space. Like gestural lines and continuous, overlapping lines, they are not confined by the outside limits of objects. They, too, are transparent; they cut through forms.

Organizational lines relate background shapes to objects; they organize the composition. They take measurement of height, width, and depth of the objects and the space they occupy. And like gesture, organizational lines are grouped; they are stated multiple times.

To use organizational line choose a still life with several objects; include background space and shapes such as the architectural features of the room—ceiling, juncture of walls, doors, and windows. Begin with horizontal and vertical lines, establishing heights and widths of each object and of the background shapes.

Note Giacometti's use of organizational line in Figure 63. His searching lines extend into space beyond the confines of the objects to the edge of the picture plane. The objects themselves seem transparent; they are penetrated by groups of measurement lines. Multiple lines are clustered at the edges of forms, so the outer edge is never exactly stated; the edge lies somewhere within the cluster.

63. Alberto Giacometti. *Still Life.* 1948. Pencil, 19¼ × 12½" (49 × 32 cm). Fort Worth Art Museum, Texas.

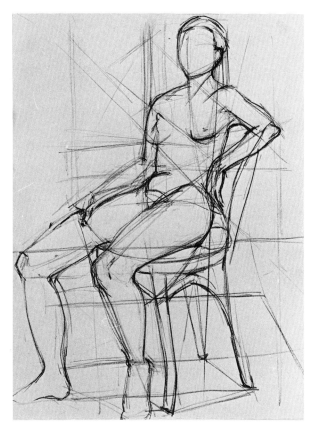

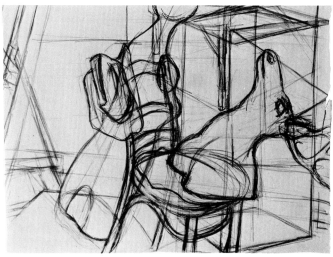

left: **64.** Organizational-line drawing.
Example by Susan Harrington. 1984.
Pencil, 24 × 18″ (61 × 46 cm). Private collection.

above: **65.** Organizational-line drawing.
Example by Rick Floyd. 1984.
Pencil, 18 × 24″ (46 × 61 cm). Private collection.

In your organizational-line drawing, continue to correct the basic shapes, checking on proportion between the parts, on relative heights and widths. Look for diagonals in the composition; state the diagonal lines in relation to the corrected horizontal and vertical lines. Continue to refine the drawing, registering information about scale and space.

By closing one eye (to diminish depth perception) and holding a pencil at arm's length from you, you can measure the height and width of each object and make comparisons between objects. This is called *sighting* and is an important device in training yourself to quickly register proper proportion. It is an indispensable aid for learning to translate three-dimensional objects onto a two-dimensional surface.

In addition to helping you establish correct proportion and placement between the parts, the buildup of multiple, corrected lines creates a sense of volume, of weight and depth in your drawing. After you have drawn for ten minutes or longer and when you have finally accurately established proper proportion between the parts, you can then darken some of the forms, firmly establishing their exact shape. By this means you will have created a focal point; you will have directed the viewer to look for certain priorities that you wish to be noticed. You can direct the viewer's eyes through the drawing by means of these darker lines and more precise shapes.

Many artists use this analytical approach even though the armature is not readily apparent (Figs. 64, 65). Here are some important points to keep in mind when doing organizational-line drawings.

1. Begin with horizontal and vertical lines, both actual and implied; add diagonal lines last.
2. Establish heights and widths of all objects and background shapes.
3. Allow lines to penetrate through objects, establishing relationships between objects.
4. Correct basic shapes.
5. Check on proportion, relative heights and widths.
6. Lines should continue past objects into negative space.
7. When you have established proportions, darken some of the forms, establishing their exact shapes.

Blind-Contour Exercises

In contrast to the immediacy of the gestural approach, which sees forms in their wholeness, the contour approach is a slower, more intense inspection of the parts. A contour line is a single, clean, incisive line, which defines edges. It is, however, unlike outline, which states only the outside edge of an object. An outline differentiates between positive and negative edges. A contour line is more spatially descriptive; it can define an interior complexity of planes and shapes. Outline is flat; contour is *plastic*, that is, it emphasizes the three-dimensional appearance of a form.

A quick way to understand the difference between contour and outline is to look at Figure 66. If you were drawing a pencil using contour line, you would draw a line at the edge of every shift in plane. The ridges along the length of the pencil, the juncture of the metal holder of the

66. Contour and outline.
Student work.
Pencil, 18 × 24″ (46 × 61 cm).

eraser with the wood, the insertion of the eraser into its metal shaft—all are planar changes that would be indicated by contour line.

In addition to structural, or planar, edges, contour line can indicate the edge of value, or shadow, the edge of texture, and the edge of color.

There are a number of types of contour, several of which are discussed in Chapter 5, "*Line*," but this chapter will concentrate on working with *blind contour*, an exercise that involves not looking at your paper.

Some general instructions are applicable for all types of contour drawing. In the beginning use a sharp-pointed implement (such as a 2B pencil or pen and ink). This will promote a feeling of precision, of exactness. Contour drawing demands a single, incisive line. Do not retrace over already stated lines, and do not erase for correction.

In blind contour, keep your eyes on the subject you are drawing. Imagine that the point of your drawing tool is in actual contact with the subject. Do not let your eyes move more quickly than you can draw. Keep your implement in constant contact with paper until you come to the end of a form. It is imperative to keep eye and hand coordinated. You may begin at the outside edge of your subject, but when you see that line turn inward, follow it to its end. In a figure drawing, for example, this technique may lead you to draw the interior features and bone structure without completing the outside contour. Remember to vary the pressure on the drawing tool to indicate weight and space, to imply shadow, and to articulate forms.

67. Blind contour of figure.
Example by Susan Harrington. 1984.
Pencil, 24 × 18" (61 × 46 cm).
Private collection.

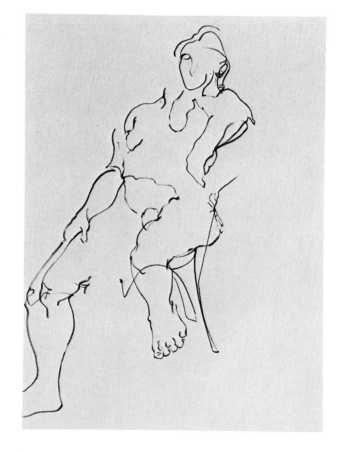

Draw only where there is an actual, structural plane shift or where there is a change in value, texture, or color. Do not enter the interior form and aimlessly draw nonexistent planes or make meaningless, decorative lines. (In this regard, contour drawing is unlike a continuous, overlapping-line drawing, where you can arbitrarily cross over shapes and negative space.) When you have drawn to the end of an interior shape, you may wish to return to the outside edge. At that time you may look down and realign your drawing implement with the previously stated edge. With only a glance for realignment, continue to draw, keeping your eyes on the subject. Do not worry about distortion or inaccurate proportions; proportions will improve after a number of sessions dedicated to contour.

For this exercise choose a complex subject; in the beginning a single object or figure is appropriate, such as a bicycle, typewriter, or skull. Distortion and misalignment are a part of the exercise. Do not, however, intentionally exaggerate or distort. Try to draw exactly as you see. If you have a tendency to peep at your paper too often, try placing a second sheet of paper on top of your drawing hand, thereby obscuring your view of your progress.

Blind-contour drawing should be done frequently, and with a wide range of subjects—room interiors, landscape, figure, still lifes (Figs. 67, 68). Here are some important points to keep in mind when doing blind-contour exercises:

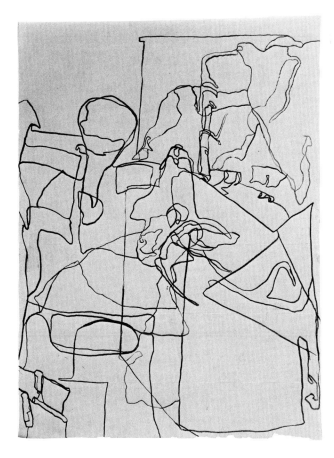

68. Blind contour of still life. Example by Rick Floyd. 1984. Pencil, 24 × 18″ (61 × 46 cm). Private collection.

1. Use a well-sharpened pencil or pen and ink. Later felt-tip markers and grease pencils can be used, but in the beginning use a sharp-pointed implement.
2. Keep your eyes on the subject.
3. Imagine that your drawing tool is in actual contact with the subject.
4. Keep eyes and hand coordinated. Do not let your eyes move more quickly than your hand.
5. Draw only where there is an actual structural plane shift, or where there is a change in value, texture, or color.
6. Draw only existent planes. Do not make meaningless lines.
7. Do not retrace over already stated lines.
8. Do not erase for correction.
9. Remember that contour line is a single, incisive line.
10. Vary the weight of the line to relay information about space and weight and to offer contrast.

SUMMARY: The Benefits of Gesture, Continuous-Line, Organizational-Line, and Blind-Contour Drawing

Gesture drawing is a record of the energy that went into making the marks, and this record makes a visual connection between the artist and the subject drawn. Gesture drawing, then, encourages empathy between artist and subject. The gestural approach gives the drawing vitality and immediacy. It is a fast, direct route to the second self, that part of us that has immediate recognition, that sees, composes, and organizes in a split second. Through gesture drawing we bring what we know and feel intuitively to the conscious self, and this is its prime benefit.

Three of the basic approaches—gesture, continuous-line, and organizational-line drawing—train us to search out the underlying structure. They help us to digest the whole before going to the parts, to concentrate in an intense and sustained way. The three approaches furnish a blueprint for a more sustained drawing and provide a compositional unity early in the drawing.

Contour drawing, on the other hand, offers a means to a slow, intense inspection of the parts. It refines our seeing and leads us to a more detailed understanding of how the parts relate to the whole.

These beginning approaches introduce some ways of translating three-dimensional forms onto a two-dimensional surface. We are made aware of the limits of the page without our having to refer constantly to it. These approaches offer a means of establishing unity in the drawing, placing shapes and volumes in their proper scale and proportion; they introduce lights and darks as well as a sense of space into the drawing; they suggest areas for focal development, and they provide rhythm and movement.

Finally, these beginning approaches provide a flexible and correctable beginning for a more extended drawing. They give options for developing the work and extending the drawing over a longer period of time. They point to a route to a finished drawing.

PART TWO

Spatial Relationships of the Art Elements

CHAPTER 3

Shape and Volume

Introduction to Spatial Relationships of the Art Elements

Since our ideas about ourselves and the world are constantly changing, it is logical that the art reflecting our ideas changes also. These philosophical ideas—what we think about ourselves and about our relationship with nature and society—affect the conventions of our art. The elements of art—shape, volume, value, line, texture, and color—have remained the same throughout the ages. However, the ways they are used and combined to create different kinds of space have undergone changes.

69. Keith Haring. *Untitled.* April, 1982.
Marker ink on found painted canvas, 8′1″ × 7′8″ (2.46 × 2.35 m).
Private collection.

In drawing, we are translating objects as they exist in real space, which has height, width, and depth, onto a flat surface, which has only height and width. The space conveyed can be relatively *flat* (shallow) or *illusionistic*, that is, giving the impression of space and volume.

Let us look at some drawings to help clarify these terms. Keith Haring's work (Fig. 69) is close to that of a comic strip. He combines comic figures with his own imagery in a flat space. The figures are drawn with simple outlines which delineate outer edges only; no depth is suggested. There is some overlapping which suggests a spatial arrangement, but the figures themselves have no depth; they are flat.

In Figure 70 Sue Hettmansperger has chosen forms that in the real world are flat strips of paper. She conveys an illusion of volume by using cast shadows. The undulating forms advance toward the viewer. The strips seem to have been peeled off their background surface. The plane behind these bulging shapes is absolutely flat. Although the subject is simple, the resulting drawing is rather complex with its interplay of cylin-

ders and triangles created by a light source which falls across the paper from the upper left. The forms seem to press out of the picture plane.

In addition to being relatively flat or illusionistically volumetric, the space conveyed can be *ambiguous*, not clearly flat or clearly three-dimensional. Ambiguous space is a combination of both two- and three-dimensional elements. The sketch of Picasso by Jasper Johns (Fig. 71) incorporates collage, watercolor, and drawing and combines illusionistic space with flat outline. The photograph is partially flattened by an overlay of transparent gray paper that repeats the profile and by a line that traces the features. A flat, displaced, somewhat smaller profile appears on the right side of the drawing overlapping the four drawings of cups. The space in this segment of the sketch is very shallow, even though the two cups on the lower right have some indication of background. The composition has an integrated spatial organization due to the repeating shapes of the profiles (even the two negative shapes on either side of the cup with the written notation suggest profiles), the repeating grid patterns, and the distribution of grays and blacks throughout the drawing. This combination of illusionistic space and flat outline has the effect of spatial ambiguity.

We all have a subjective response to space; each of us experiences and interprets space in an individual way. A child's idea of space differs from an adult's. Space has been treated differently in different eras and cultures. The flattened space in a Mixtec codex, or manuscript book

left: 70. Sue Hettmansperger. *Untitled.* 1975.
Watercolor and pencil, 23 × 25″ (58 × 64 cm).
NCNB National Bank.

right: 71. Jasper Johns. Sketch for *Cup 2 Picasso/Cups 4 Picasso.* 1971–72.
Collage and watercolor, 15½ × 20¼″ (39 × 51 cm).
Courtesy the artist.

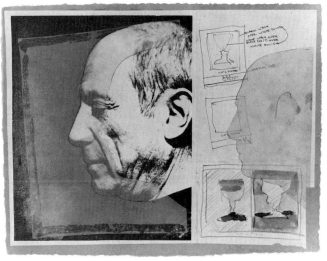

(Fig. 72), contrasts the illusionistically deep space in a Renaissance drawing by Federigo Zuccaro (Fig. 73), although both were produced during the same period. In the Mixtec panel the space remains flat because of the use of unmodeled, or flat, value shapes and outline. The figures share the same base line, the imaginary lines on which they stand. Hieroglyphs in each unit form a repeating pattern which further flattens the space. The background is empty; the main focus remains on the positive figures and their static and symbolic relationship with each other. The Mixtec artist was governed by a hierarchy of forms, both in his art and in his culture.

By contrast the Renaissance artist depicts a stepped progression of space. This effect is achieved by placing the figures and buildings in accurate proportion with each other, by making objects diminish in size as they recede into the distance, and by using darker washes and more precisely drawn lines in the foreground. The picture plane is penetrated by the diagonal lines (on the ground and in the building on the right) that point to a deep space. Column, figures, and building seem to be washed by a gentle light; soft grays and whites indicate various volumes. Unlike the Mixtec artist, Zuccaro had as a goal the depiction of real space.

Whether the emphasis is on flat, illusionistic, or ambiguous space, the concept of space is of lasting interest to artists. Space is to the artist what time is to the musician. Although ambiguous space has been a continuing concern of the 20th-century artist, a range of spatial concepts from shallow to deep are evident in the art of today.

Part 2 deals with the spatial relationships of the art elements. Beginning with shape, we will consider the way the elements can be used to create different kinds of space.

left: 72. *Nine Pairs of Divinities.* Mixtec codex, Mexico. 14th–16th century. Vatican Library, Rome.

right: 73. Federigo Zuccaro. *Emperor Frederic Barbarossa before Pope Alexander III.* Late 16th century. Pen and ink, wash over chalk; 10⅜ × 8½″ (26 × 21 cm). Pierpont Morgan Library, New York (Janos Scholz Collection).

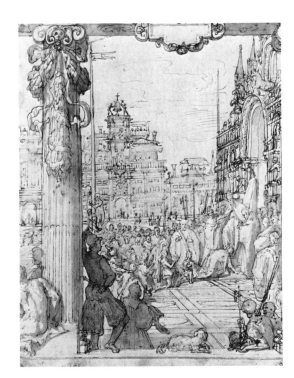

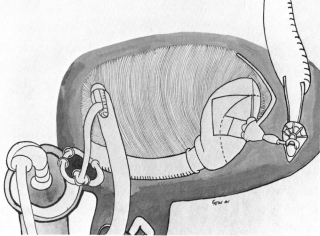

left: **74.** William Gatewood. *Kimono.* 1982. Mixed media, 41½ × 29¾ (105 × 76 cm). Courtesy Karl Bornstein Gallery, Santa Monica, Calif.

right: **75.** Eva Hesse. *Untitled.* 1965. Ink, gouache, watercolor, and pencil on paper; 11⅜ × 16″ (28.95 × 40.64 cm). Estate of the artist.

Shape

An object's shape tells you what that object is. A shape is a configuration that has height and width and is therefore two-dimensional. Shapes can be divided into two basic categories: geometric and organic.

Geometric shapes are created by mathematical laws. They include squares, rectangles, triangles, trapezoids, hexagons, and pentagons, as well as circles, ovals, and ellipses. William Gatewood in Figure 74 presents a geometric configuration, a sort of pattern for a kimono. The rigid arrangement of rectangles and triangles contrasts with the scratchy, expressionistic lines that lie on top of the heraldic shape. There is a tension between the controlled shape and the looseness of the lines that gives interest to the work.

Organic shapes, sometimes referred to as *biomorphic* or *amoeboid*, are free form, less regular than geometric shapes. The sculptor Eva Hesse is known for her use of coils and organic, ropelike shapes. This interest is seen in her drawing (Fig. 75). Here the shapes are described by varied lines; the heavier marks at the bottom of the composition lend weight to the forms while the shape on the upper right is lighter and seems to be suspended in air. These amorphous shapes with thin valvelike connections suggest the internal workings of some animated machine.

above: **76.** Romare Bearden. *Interior with Profiles.* 1969.
Collage, 3′ 3¾″ × 4′ 1⅞″ (1.01 × 1.27 m).
First National Bank of Chicago.

left: **77.** Leonard Baskin. *Egyptian Ballet—Horns and Hands.* 1971.
Ink and wash, 40 × 27½″ (101 × 70 cm).
Courtesy Kennedy Galleries, New York.

Usually we find a combination of geometric and organic shapes in an artist's work. In *Interior with Profiles* (Fig. 76), Romare Bearden combines geometric and amoeboid shapes in a well-integrated composition. The figures in Bearden's collage are built of organic shapes, while the background is predominately geometric—squares and rectangles. Texture is an important element in Bearden's work. Shapes are created both by textural patterns and by flat and modeled values in the hands (and in the still-life objects in the background). The collage is organized along horizontal and vertical axes which both flatten and stabilize the composition. The figures remind us of an Egyptian frieze. There is a timeless

quality in Bearden's work that comes from his faultless sense of balance and rhythm. Unity is achieved by repetition of shape and value. Spatially, the work is very complex; it is difficult to locate exactly each figure in relationship to the other. This ambiguity of placement is further reinforced by the illogical scale between the parts.

As you have seen, shapes can be made by value, line, texture, or color. They may even be *suggested* or *implied*. In the drawing *Egyptian Ballet—Horns and Hands* (Fig. 77), Leonard Baskin suggests or implies by minimal use of line the shape of the man-goat figure. The negative white space is conceptually filled by the mythic creature's body. Although the shape of the figure is not explicitly shown, we imagine it to be there. Baskin develops three focal points named in the title, horns and hands. Somewhere between head and hand the goat has undergone a transformation, and this transformation is left for the viewer to construct. The richly rendered centers of interest are in bold contrast to the white void that spans the space between them. Placement of the developed areas is crucial: The head is centralized; below the head a dark value shape leads our eyes to the hands, which are asymmetrically placed. The hand in the center points to the one on the right; a black shape under the thumb directs the movement back into the picture plane, away from the edge.

Perception is such that we fill in an omitted segment of a shape and perceive that shape as completed, or closed (Fig. 78). In doing so, we tend to perceive the simplest structure that will complete the shape rather than a more complex one (Fig. 79). We also group smaller shapes into their larger organizations and see the parts as they make up the whole (Fig. 80).

Peter Plagens' drawing (Fig. 81) seems to be a commentary on perception. The aggressive, heavy, open, circular form seems out of keeping with the wispy, faint scribbles in the background. Even the firmly centered shape is not enough to inhibit the implied movement in the work. It

78. Incomplete shapes are perceived as completed, or closed.

above left: **79.** The four dots are perceived as forming a square rather than a more complex shape.

above right: **80.** Smaller shapes are perceived as part of their larger organization.

81. Peter Plagens. *Untitled* (48-76). 1976. Pastel, oil pastel, and gouache; 32 × 47″ (81 × 119 cm). Courtesy Nancy Hoffman Gallery, New York.

left: **82.** Hans Hofmann. *Cathedral.* 1959.
Oil on canvas, 6′2⅛″ × 4′ ⅛″ (1.88 × 1.22 m).
Promised gift of Agnes Gund to the Museum
of Modern Art, New York.

above: **83.** Robert Longo. *Untitled.* 1978.
Charcoal on paper, 30 × 40″ (.76 × 1.02 m).
Collection Robert Halff.

seems that Plagens is purposefully questioning the rules of composition
and of perception; he defies the viewer to complete the circle.

Shapes of similar size, color, or form attract each other, and in this
way the artist organizes the picture plane. In Hans Hofmann's work (Fig.
82), the large shapes appear to advance and the small ones to recede.
This kind of attraction and tension between shapes is a major theme in
Hofmann's work.

Positive and Negative Space

On the *picture plane*—the surface on which you are drawing—there is
another distinction between shapes, that between positive and negative.
Positive shape refers to the shape of the object drawn. In Robert Longo's
drawing (Fig. 83), the dark, isolated shape of the jacket is the subject of
the work. This somewhat menacing form is at first glance difficult to
identify; it overpowers the figure below. There is nothing in the back-

ground to give further information. The man is unidentifiable; his coat seems unforgettable.

Negative space describes the space surrounding the positive forms. Negative space is relative to positive shapes. In Richard Diebenkorn's drawing (Fig. 84), a woman is reclining on a bed; the bed is on the floor and in front of a wall. The floor forms a *ground* for the *figure* of the bed; the bed and wall form a ground for the figure of the woman. Thus, the floor and wall are negative to the bed, and the bed in turn is negative to the figure.

In real life we are conditioned to search out positive shapes, but this habit must be altered in making art. On the picture plane all shapes, both positive and negative, are equally important. Combined, they give a composition unity. Paul Wieghardt's integration of positive and negative shapes is so complete that it is nearly impossible to classify each shape as either positive or negative (Fig. 85). The progression of space in the Wieghardt painting does not follow the logical recession seen in the Diebenkorn drawing. Shapes that we logically know are more distant (note the placement of the woman on the right) are, in fact, perceptually on the same plane. Notice the relationship between the laps and legs of the two women. Wieghardt, like Hofmann, uses shapes of similar size, value, and form to attract each other and by this means creates a tight, interlocking composition.

left: 84. Richard Diebenkorn. *Untitled* (Girl Looking in Mirror). 1962. Ink and pencil, 17 × 12⅜″ (43 × 31 cm). San Francisco Museum of Modern Art (purchased through anonymous funds and the Albert M. Bender Bequest fund).

right: 85. Paul Wieghardt. *The Green Beads.* 1951. Oil on canvas, 39⅜ × 20″ (101 × 77 cm). Location unknown.

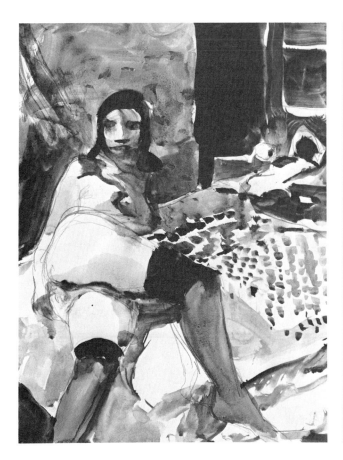

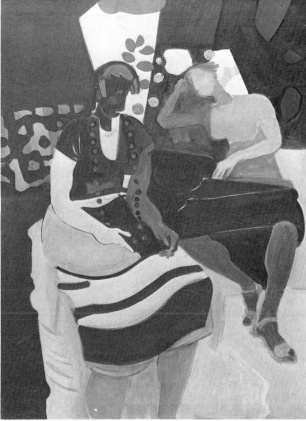

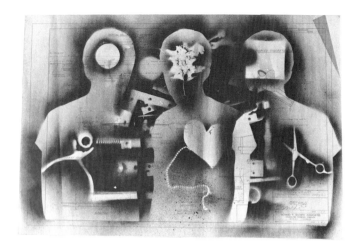

left: 86. Dmitri Wright.
Untitled. 1970. Stencil print,
23⅞ × 36⅛″ (61 × 92 cm).
Brooklyn Museum (Gift of the artist).

right: 87. Lee Bontecou.
Untitled. 1967.
Pencil and ink on paper,
20 × 26″ (51 × 66 cm).
Courtesy Leo Castelli Gallery,
New York.

In Dmitri Wright's stencil print (Fig. 86), we see a changing emphasis from the positive images to the negative space surrounding them. The print has the look of a photographic negative. Reverse values and spatial dislocation of the objects contribute to a feeling of emptiness. Wright has used a blueprint as the base for the stencils. The geometric shapes and words behind the figures and implements create a second level of space, which further enhances and complicates interpretation of the print.

In the Lee Bontecou work reproduced in Figure 87, positive and negative shapes switch with each other. Viewing the image one way, we see the white shapes as positive; viewing it another way, we see the white as background to the black forms. This interchange is more pronounced in the actual work. The artist has used ink and pencil, and the ink has a weightier quality than the pencil, thereby enhancing its "positive" effect.

The terms *positive/negative* and *figure/ground* are interchangeable. Other terms are *foreground/background, figure/field,* and *solid/void.* Negative space is also called *empty space* or *interspace.*

 Problem 3.1
Geometric Positive and Negative Shapes

Make a quick, continuous-line drawing of a still life. You may wish to refer to the description of this technique in Chapter 2. Redraw on top of the drawing. Regardless of the actual shapes in the still life, reduce both positive and negative shapes to rectangles and squares. Repeat the problem, this time using ovals and circles. You will, of course, have to force the geometric shapes to fit the actual still-life forms.

Look carefully at the subject. Which shapes are actually there? Which shapes are implied? What types of shapes predominate? In asking these questions you are giving yourself some options for the direction the drawing is to take. You may note that circular forms predominate, and you may or may not choose to emphasize a circular motif in the drawing. In making this quick analysis, you are bringing to consciousness information that will be helpful as you extend the drawing.

Repeat the initial procedure, using landscape as a subject. Draw only organic forms in both positive and negative shapes. One way to

insure that negative spaces form enclosed shapes is to make the composition go off the page on all four sides.

Problem 3.2
Invented Negative Shapes

Choose any subject—landscape, still life, or figure. In your drawing invent some negative shapes that relate to the positive shapes of your subject.

In Rufino Tamayo's *The Water Carrier* (Fig. 88), the symmetrical composition is structured around the shape of the water container. The woman's skirt and upper torso repeat the shape, while variations of the form fill the background. The shape structures the work both visually and conceptually.

Problem 3.3
Collaged Negative Spaces

Begin by making a collage of torn paper to represent the negative spaces in a still life. Then impose a simple line drawing of the still life, allowing line to cross over the collage shapes. This procedure will help integrate the positive and negative areas. Use enclosed shapes in both positive and negative spaces (Fig. 89).

left: **88.** Rufino Tamayo. *The Water Carrier.* 1956. Watercolor with pencil, 25¾ × 19¾" (66 × 50 cm). Courtesy Sotheby's, New York.

right: **89.** Collage shapes. Student work. Collage and ink, 24 × 18" (61 × 46 cm).

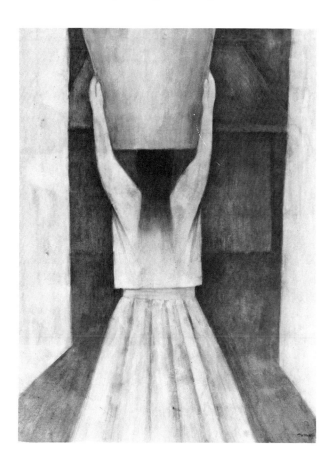

left: 90. Interchangeable positive/negative shapes. Student work. Conté crayon, 18 × 24″ (46 × 61 cm).

right: 91. Interchangeable positive/negative shapes. Student work. Pencil, 24 × 18″ (61 × 46 cm).

 Problem 3.4
Interchangeable Positive and Negative Shapes

Make an arrangement of several objects or use a figure in an environment. In this drawing, emphasize the negative spaces between the objects by making them equal in importance to the positive shapes (Fig. 90).

In a second drawing place emphasis on negative space. This time try to make the positive and negative shapes switch off with one another; that is, see if you can make the positive forms seem empty and the negative shapes positive. In other words, try to make the positive shapes recede and the negative shapes advance. In the student drawing (Fig. 91) this effect is heightened by the vertical stripes which simultaneously advance and recede. The blank shape in the upper half of the drawing in one view seems to be a positive shape, and in another view it seems to be background.

 Problem 3.5
Enclosed Invented Positive and Negative Shapes

For this drawing you are to invent a subject. It may be taken from your memory of a real object or event, or it may be an invented form or abstraction, but it should be a mental construct. Look back at the discussion of conceptualized drawings in Chapter 1 to refamiliarize yourself with their nature.

Once you have thought of a subject, draw it by using enclosed shapes in both positive and negative space. Define the shapes by outline or by texture or by flat value. Fill the entire page with enclosed shapes. There should be no leftover space (Figs. 92, 93).

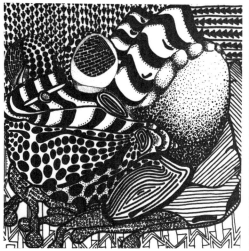

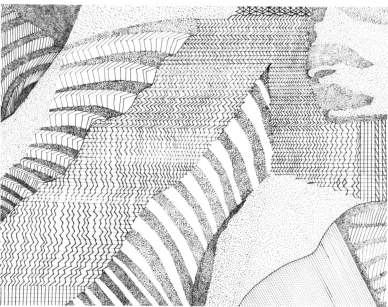

above: **92.** Enclosed shapes.
Student work.
Pen and ink,
14 × 14″ (36 × 36 cm).

above: **93.** Enclosed shapes.
Student work. Pen and ink,
19 × 25″ (48 × 64 cm).

The Shape of the Picture Plane

The shape of the picture plane has an effect on the type of composition chosen. David Fick's round picture plane is an appropriate choice for his subject in *Mother and Child* (Fig. 94). The circular form, in addition to its symbolic message of wholeness, visually reiterates the curvilinear forms of the mother and baby. Traditionally, the round picture plane has been used for Madonna-and-child themes; Fick follows the tradition in this contemporary work.

above: **93.** Enclosed shapes.
Student work. Pen and ink,
19 × 25″ (48 × 64 cm).

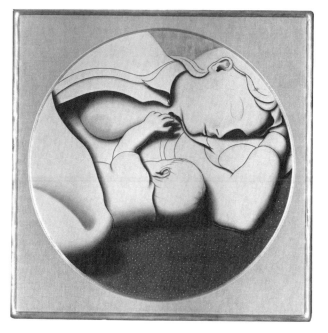

94. David Landis Fick.
Mother and Child. 1979–80.
Charcoal, sepia, touches of white,
fine gold leaf on Arches paper;
48″ (122 cm) diam.
Collection of the artist, on
loan to Florence Talbot Cooley,
Houston, Texas.

63

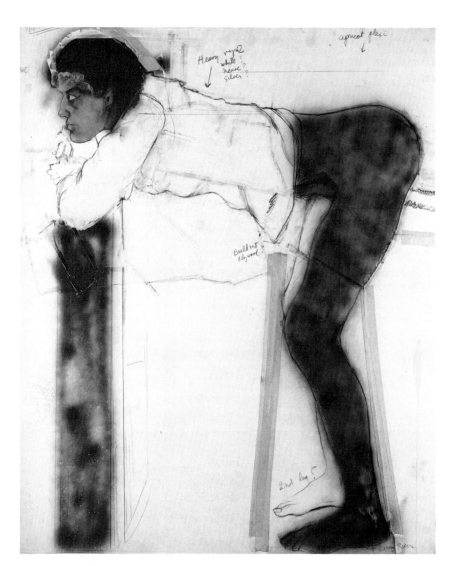

95. Larry Rivers. *Drawing for Lampe's Man Loves It.* 1966. Pencil, acrylic, and paper collage laid down on canvas; 4'10" × 3'10¾" (147 × 119 cm). Collection Mr. and Mrs. Allen M. Turner.

96. Neil Jenney. *Window #6.* 1971–76. Oil on panel, 1'3¾" × 4'9½" (1.01 × 1.46 m). Collection Doris and Charles Saatchi, London.

Larry Rivers welds image and format into a tight unit in his drawing (Fig. 95). The viewer has the impression that the model intentionally bent his legs in order to fit into the squat rectangular format. Edges are emphasized by the L-shaped pose of the model and by the long, dark, rectangular shape defining the left edge. The space enclosed by the body and frame creates a rectangular void in the center of the composition.

Neil Jenney's assemblage (Fig. 96) is another example of image conforming to the shape of the picture plane. The tree is particularly suited to the chopped-off format; the angle of the limbs points to the lopsided structure, while the enclosed negative shapes—the intervals between limbs and edges of the frame—establish a secondary theme.

Problem 3.6
The Shape of the Picture Plane

In your sketchbook draw four or five different formats to be used as picture planes—a long horizontal, a square, a narrow vertical, a circle, and an oval. Quickly draw a composition in each unit, using the same subject in each of the formats. Change the composition according to the demands of the outside shape. You will have to adjust your composition from format to format, changing the relationships of size, shape, and value. Each different outside shape demands a different response of the internal forms. You may use still life, landscape, or nonobjective images.

In Figures 97 and 98 the student has chosen a subject from art history. The second drawing has been elongated to fit a more vertical format.

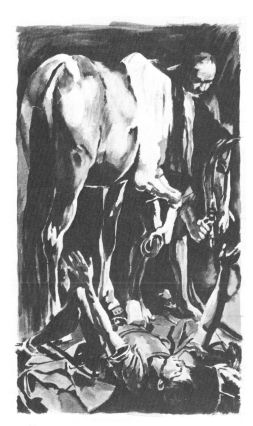

above: 97. Shapes changed to fit the shape of the picture plane. Student work. Litho stick and felt-tip marker, 18 × 24″ (46 × 61 cm).

right: 98. Shapes changed to fit the shape of the picture plane. Student work. Ink, 40 × 20″ (102 × 51 cm).

99. Cross-shape form made from an opened box.

above left: **100.** Diagram of a cube.

right: **101.** Cube diagram with interior lines erased.

Shape as Plane and Volume

It has been difficult to speak of shape without occasionally referring to volume. *Volume* is the three-dimensional equivalent of two-dimensional shape. Shapes become volumetric when they are read as *planes*. In the graphic arts and in painting, volume is the illusion of three-dimensional space. Volume defines *mass*, which deals with the weight or density of an object.

The way shape becomes volume can be seen in an illustration of a cube. If you take a cube apart so that its six sides, or planes, lie flat, you have changed the cube from a three-dimensional form into a two-dimensional shape (Fig. 99). This new cross shape is made up of the six planes

right: **102.** Clarence Carter. *Siena.* 1981. Acrylic on canvas, 6′6″ × 5′ (1.98 × 1.52 m). Courtesy Gimpel and Weitzenhoffer Gallery, New York.

of the original box and is now a flat shape. If you reassemble the cube, or box, the reconnected planes (the sides, top, and bottom) once again make volume. If you make a representation of the box seen from below eye level with one of its corners turned toward you, it will be composed of only three visible planes. Even if you draw only these three planes, the illusion of three-dimensionality remains (Fig. 100). If you erase the interior lines, leaving the outer outline only, you have again changed volume into a flat shape (Fig. 101).

The key word here is *plane*. By connecting the sides, or planes, of the cube, you make a *planar analysis* of the box. You make shape function as plane, as a component of volume.

In Clarence Carter's painting *Siena* (Fig. 102), an illusion of volume is conveyed by the use of connecting shapes or planes. A monumental effect is achieved by seemingly simple means; the smaller, connected shapes of the stairs lead to the middle ground occupied by the two smaller buildings set at an angle. Smaller, fainter steps climb to the larger, more frontally placed building in the background. Carter achieves an architectural unity by interlocking planes, by the progression of small to larger shapes, and by the distribution of lights and darks.

In the human figure, planes are, of course, much more complex and subtle than those of a geometric volume, but Henry Moore has used interlocking planes to create the effect of rounded volumes in his *Family Group* (Fig. 103). The figures have been dehumanized by this imposition of an illusionistically three-dimensional grid. Larger, heavier, more dimensional forms are indicated by dark line, while secondary, less important planes are drawn with a fainter line.

103. Henry Moore.
Family Group. 1951.
Chalk and watercolor,
17 × 20″ (43 × 51 cm).
Collection D.B. Wilkie,
Christchurch, New Zealand.

104. Edward Ruscha. *Chop.* 1967. Pencil, 13¼ × 21⅞" (34 × 56 cm).
Fort Worth Art Museum, Texas.

We have one more way to transform shape into volume: modeling.
Modeling is the change from light to dark across a surface to make a
shape look volumetric. By means of modeling Edward Ruscha converts
what is normally conceived of as a flat image into a floating, dimensional
shape (Fig. 104). The word "Chop" appears to be a ribbon unwinding in
space. Ruscha's intent of divorcing the word from its semantic function is
further enhanced by such an unexpected presentation.

You can clearly see the modeling technique in Fernand Léger's pen-
cil drawing (Fig. 105). Fig. 106 reduces the Léger composition to shape. By
comparing the two you can see how modeling transforms shapes into
volume. The shading from light to dark is more pronounced on the wom-
en's forms. A spatial contradiction is the result of the combination of flat,
cutout shapes with illusionistically rounded forms. Léger has also used
contradictory eye levels; for example, we see the women from one van-
tage point, the rug and floor from another—as if we were floating above
the scene—and the table tops from yet another. The composition is
structured by means of repetition, repetition of volumes and shapes.

Another means the artist uses to create a sense of volume is over-
lapping shapes. In Diego Rivera's *Study of a Sleeping Woman* (Fig. 107), the
figure of the woman is constructed by a progression of forms, one over-
lapping the other from feet to the dark shape of the hair. The viewer's eye
level is low; we look up to the figure. The full, organic shapes are given
volume by limited use of modeling concentrated at those points of maxi-
mum weight. The compact, compressed form is well suited to the pro-
portions of the paper. The simple volumes are the primary means by
which a feeling of monumentality and timelessness is achieved.

The following problems will help you think about shape and vol-
ume in new ways. Remember to change the size and shape of your for-
mat to help further your compositional abilities.

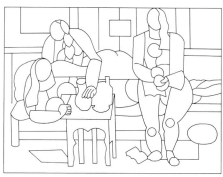

left: **105.** Fernand Léger.
Three Women. 1920.
Pencil, 14½ × 20″ (37 × 51 cm).
Rijksmuseum Kroller-Muller,
Otterlo, Netherlands.

above: **106.** Shape analysis of Figure 81,
Fernand Léger's *Three Women.*

107. Diego Rivera. *Study of a Sleeping Woman.*
1921. Black crayon on white laid paper,
24 × 18″ (61 × 46 cm).
Fogg Art Museum, Harvard University,
Cambridge, Mass. (Bequest of Mela and Paul J. Sachs).

left: 108. Shape as plane. Student work.
Conté crayon, 24 × 18 (61 × 46 cm).

above: 109. Planes into volume. Student work.
Charcoal, 18 × 24″ (46 × 61 cm).

 Problem 3.7
Shape as Plane and Volume

Using paper bags, a stack of boxes, or bricks as subject, draw the edges of planes rather than the outside outline of the objects. Concentrate on the volumetric aspect of the objects, that is, on how shapes connect to create volume. In one drawing use line to define planes. You may wish to develop a focal point using shading in one small area of the drawing (Fig. 108). The second drawing should be primarily tonal, more volumetric where planar change is indicated by the use of white, gray, or black shapes (Fig. 109).

 Problem 3.8
Planar Analysis

With your own face as subject, make a planar analysis in a series of drawings. Begin by drawing the larger planes or groups of planes; then draw the smaller units. Work from the general to the specific.

After you have become familiar with the planar structure of your face, construct a three-dimensional mask from cardboard or bristol board. The sculptured mask should be life size, made to fit your face. Keep a sketch pad handy to redraw and correct the planar relationships. This interplay between stating the form two-dimensionally and making a three-dimensional model will strengthen your understanding of the process involved in creating the illusion of volume.

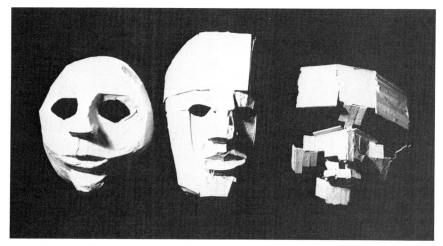

110. Planar analysis. Student work. Cardboard.
Masks: $7 \times 6\frac{1}{2}''$, $9 \times 7''$, $7 \times 6\frac{1}{2}''$ (18 × 17 cm, 23 × 18 cm, 18 × 17 cm).

Cut out the planes and use masking tape to attach them to one another. Making a three-dimensional analysis is an involved process. Look for the most complex network of planes. Note how the larger shapes can be broken down into smaller, more detailed groups of planes.

When you have completed this problem, you will have gained a real insight into how larger planes contain the smaller planes and how large planes join one another to create a volume.

Paint the mask with white paint. You have now deemphasized the edges of the planes to create a more subtle relationship between them. Place the mask under different lighting conditions in order to note how different light emphasizes different planes (Fig. 110).

Problem 3.9
Rubbed Planar Drawing

Read through all the instructions carefully before beginning to draw. Spend at least an hour on this drawing.

Use a 6B pencil that is kept sharp at all times. To sharpen the pencil properly, hold the point down in contact with a hard, flat surface. Sharpen with a single-edge razor blade, using a downward motion. Revolve the pencil, sharpening evenly on all sides. Use a sandpaper pad to refine the point between sharpenings. Draw on white charcoal paper.

Use a model and warm up with several line gesture drawings to acquaint yourself with the pose. Use a light line to establish proportions and organizational lines. Again, as in the head study, analyze the figure according to its planar structure. Begin drawing the largest planes. What are the figure's major masses? Upper torso, lower torso, upper legs, lower legs, head? Work from the general to the specific. Determine where the figure turns at a 90-degree angle from you and enclose that plane. Look for the major volumes of the body and draw the planes that make up these volumes. After you have drawn for three or four minutes, rub the

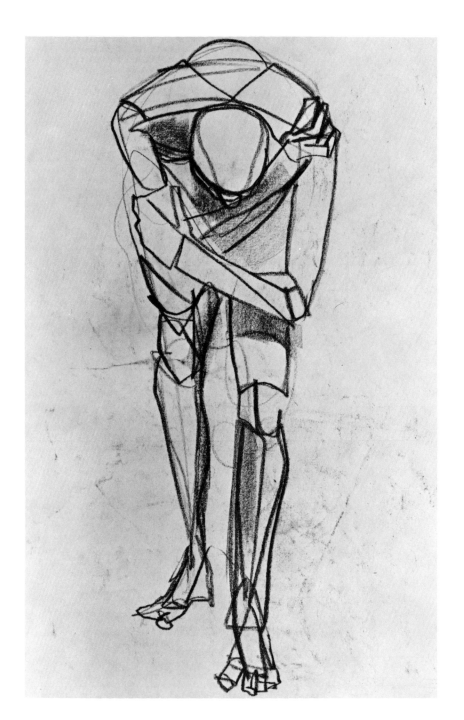

111. Planes grouped according to their larger organizations. Student work. Charcoal, 24 × 18″ (61 × 46 cm).

drawing with a clean piece of newsprint. Replenish the newsprint squares often. Rub inward toward the figure. Two warnings: Do not rub the drawing with your fingers, because the oil from your hands will transfer to the paper and make splotchy marks. Do not rub the drawing with a chamois skin because it removes too much of the drawing. Redraw, not just tracing the same planes, but correcting the groupings. Alternate between drawing and rubbing. Continue to group planes according to their larger organization (Fig. 111).

This technique is different from the continuous movement of the gesture and overlapping-line drawings. Here you are attempting to place each plane in its proper relation to every other plane. Try to imagine that the pencil is in contact with the model. Keep your eyes and pencil moving together. Do not let your eyes wander ahead of the marks.

When viewed closely, this drawing might resemble a jigsaw puzzle, each plane sharing common edges. When you stand back from the drawing, however, the planes begin to create volume, and the result will be a more illusionistically volumetric drawing than you have done before. The rubbing and redrawing give the planes a roundness and depth (Figs. 112 and 113).

This exercise is actually an exercise in seeing. Following the instructions will help you increase your ability to concentrate and to detect planes and groups of planes that are structurally related.

Problem 3.10
Basic Volume

The preceding problems provided you with some experience in drawing a volumetric form. For this problem use a different subject for each drawing—landscape, still life, figure in an environment. Think in terms of basic volumes. Render the subject in a quick, light, overlapping line; then impose volumes regardless of the actual forms in the still life. You will have to force volumes to fit the subject; for example, you might choose either a cylinder or a cube to represent the upper torso of a figure. Remember to register which volumes are actually there and which ones are implied. Look for repeating volumes to help unify your composition. As in the planar analyses, you should go from the large to the small, from the general to the specific. Remember there are two bridges between shape and volume: When shapes are stated as planes they appear volumetric, and modeling over a shape creates volume.

left: **112.** Planar rubbed drawing. Student work. Charcoal pencil, 18 × 24″ (46 × 61 cm).

right: **113.** Planar rubbed drawing. Student work. Charcoal pencil, 24 × 18″ (61 × 46 cm).

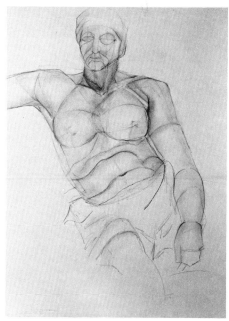

Problem 3.11
Modeling and Overlapping

Arrange several objects in deep space. Then draw these objects, exaggerating the space between them. Arrange large and small shapes on your paper, overlap shapes, and use different base lines for each object. In your drawing try to distinguish between foreground, middle ground, and background.

Think in terms of the different levels of negative space—horizontal space between the objects, vertical space above them, and diagonal space between them as they recede into the background. Imagine that between the first object and the last there are rows of panes of glass. Due to the cloudy effect of the glass, the last object is more indistinct than the first. Its edges are blurred, its color and value less intense, its texture less defined. A haze creates a different kind of atmosphere between the first and last object. The illusion of depth through atmospheric effects such as those just described is called *aerial perspective*.

An extension of the preceding problem is to model negative space. Use a still life or figure in an environment and concentrate on the differ-

below left: **114.** Modeled negative space. Student work. Charcoal, 24 × 18″ (61 × 46 cm).

below right: **115.** Modeled negative space. Student work. Charcoal, 24 × 18″ (61 × 46 cm).

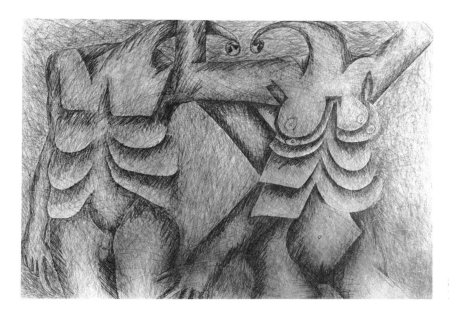

116. Ambiguous space.
Student work.
Pencil, 19 × 25″ (48 × 64 cm).

ent layers of space that exist between you and the back of the still life or figure. Make the shapes change from light to dark; model both positive and negative space; different lights and darks will indicate varying levels. This modeling of negative space is a plastic rendering of the subject, an illusionistically three-dimensional description of objects in the space they occupy. Your drawing should show a feeling for the different levels of space. Note in the student drawings (Figs. 114, 115) values of gray and black are not confined to a single object; they cross over both positive and negative forms.

SUMMARY: Different Kinds of Space

A shape is two-dimensional if it has an unchanged or unmodulated value, color, or texture over its entire surface. Uniformity in color, value, or texture will make an otherwise volumetric form appear flatter. A form outlined by an unvarying line creates a two-dimensional effect.

Shapes functioning as planes, as the sides of a volume, give an illusion of three-dimensionality. Shapes can be given dimension by tilting them, truncating them, making them move diagonally into the picture plane.

When both flat, two-dimensional shapes and three-dimensional volumes are used in the same drawing, the result is ambiguous space (Fig. 116). If a shape cannot be clearly located in relation to other shapes in the drawing, ambiguous space again results.

If a line delineating a shape varies in darkness or thickness, or if the line breaks, that is, if it is an implied line, the shape becomes less flat. Imprecise edges, blurred texture, and the use of modeling tend to make a shape appear volumetric. Modeling, the change from light to dark across a shape, transforms it into volume, creating the illusion of three-dimensionality.

C H A P T E R 4

Value

Value is the gradation from light to dark across a form; it is determined both by the lightness and darkness of the object and its natural color—its *local color*—and by the degree of light that strikes it. This chapter is concerned not with color, or hue, but with value, the range from white to black as seen in the scale in Fig. 117. An object can be red or blue and still have the same value. What is important in determining value is the lightness or darkness of the color. This approach is an achromatic one.

117. Value scale, from 100 percent white to 100 percent black.

| 1 | 2 | 3 | 4 | 5 | 6 | 7 | 8 | 9 | 10 |

It is difficult to learn to separate color from value, but it is an essential task in art. We have two good examples of this separation in everyday life—in black-and-white photography and in black-and-white television.

If you squint your eyes while looking at an object or at color television, the colors diminish and you begin to see patterns of light and dark instead of color patterns. When the value is the same on both the object and its background, you easily lose the exact edge of the object; both object and negative space are united by the same value. Although value can be confined to a shape, it can also cross over a shape and empty space; it can begin and end independently of a shape as in William Bailey's still life (Fig. 118). Bailey depicts the objects' actual values, their local values. But artists can reject actual appearance and create their own value patterns, their own kind of order. The three rabbits in the accompanying figures illustrate this point. All three figures are of an isolated cen-

118. William Bailey. *Manhattan Still Life*. 1980. Oil on canvas, 3′ 4″ × 4′ 2″ (1.02 × 1.27 m). General Mills Collection, Minneapolis.

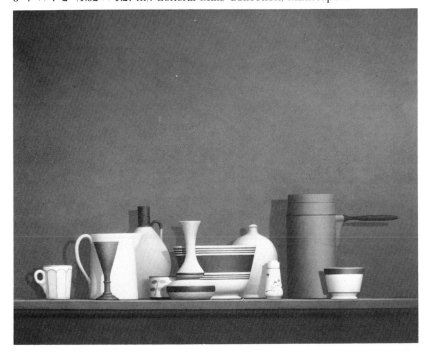

tralized image in an empty space. The first two suggest a ground by use of cast shadow. The Renaissance artist Albrecht Dürer was governed by actual appearances in his careful rendering (Fig. 119); texture, lighting, and careful notation of details and of structure testify to his close, accurate observation. The value patterns are dark with small areas of contrasting whites. The young hare's alert pose is reinforced by his angular placement on the page and by the tilt of his ears.

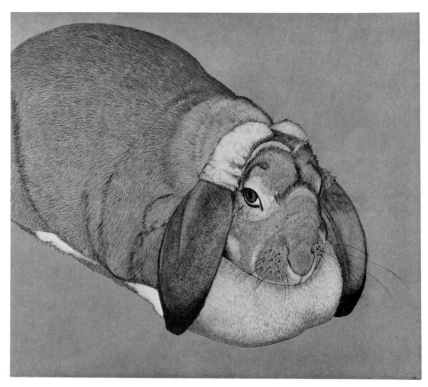

Wayne Thiebaud's rabbit (Fig. 120), on the other hand, is absolutely stabilized within the picture plane; it is strangely isolated, its forms generalized. Value is gently modulated from white to gray. Repeating, undulating shapes ripple across the surface. The rabbit seems to be sitting in a pool of light; its cast shadow is the darkest, most clearly defined shape in the composition. The value patterns are theatrically exaggerated by this intense light. As if to point out how crucial value is to the composition, the shadow cast by the ear reads as a value scale. Whether Thiebaud actually set up artificial lighting or invented it in the drawing, his manipulation of lights and darks is an intense and personal one.

Beth Van Hoesen has chosen a middle value range for her print (Fig. 121). The gray background decreases sharp value contrasts. The transition from white to black is very subtle; the rabbit's curved forms grow faintly darker as they recede into space. Because of eye contact with the rabbit, we feel identification with the subject.

As you have seen, the same subject can be treated by a different value range with strikingly different results. Each of the three rabbits is done in a different medium, yet value is the primary means used to organize the compositions.

Value describes objects, the light striking them and their weight, structure, and spatial arrangement. Value can also be expressively descriptive. So value has two functions: It is objectively as well as subjectively descriptive. Tom Blackwell's *Hi Standard's Harley* (Fig. 122) is a study in representational clarity. A wide range of values, all visually accurate, from the dull, dark, rubber tire to the highly reflective metallic and plastic surfaces, ties the composition together. The picture plane is crowded with minute shapes in the middle ground and larger, simpler value shapes in the foreground and background. Blackwell, in true Photorealist style, faithfully recorded the value patterns that a camera sees.

122. Tom Blackwell.
Hi Standard's Harley. 1975.
Acrylic on panel,
22 × 15″ (56 × 38 cm).
Collection Louis and Susan
Pear Meisel, New York.

123. José Luís Cuevas.
Autoretrato como Rembrandt. 1962.
Lithograph, 15¾ × 21½″ (40 × 55 cm).
Courtesy Galeria de Arte
Mizrachi S.A., Mexico City.

Unlike Blackwell, José Luís Cuevas employs a subjective approach in his *Autoretrato como Rembrandt* (Fig. 123). Cuevas has subordinated appearance to expressive content. The whites and blacks are more extreme; the blacks in the background project the whites into stark relief. Cuevas' work has a surreal quality. The eyes in the stuffed head confront the viewer in a way that is evocative of Rembrandt's haunting eyes. The darkness of the eyes seem to penetrate the viewer; a concentrated stare relays the inward examination that also formed the basis of the psychological portraits by the Dutch master. We are reminded of the stretch of time and sensibility that separates today's world from the 17th century.

In the graphic arts there are two basic ways to define a form—by line or by placement of two values next to each other. Most drawings are a combination of line and value as in Robert Straight's *Crossfire* (Fig. 124).

124. Robert Straight.
Crossfire. 1974.
Pastel and mixed media,
27 × 40″ (68 × 102 cm).
Location unknown.

125. Mary Bauermeister.
Drawing No. 16, Three Pergaments.
1964. Ink and collage,
19½ × 23½″ (50 × 60 cm).
Courtesy Galeria Bonino,
New York.

Ways of Creating Value

Lines can be made to create value. Mary Bauermeister in Figure 125 has
created value shapes by density, or closeness, of lines and by pressure
exerted on the drawing tool. The busy, complex design is activated by
short, squiggly lines that congregate as if by some magnetic force. The
darker, heavier, less electrically charged lines stabilize and quieten the
otherwise fractured surface.

A drawing may be exclusively tonal, as in the 19th-century artist Georges Seurat's small drawing for *La Parade* (Fig. 126). The subtle value range is a result of brilliant control over the medium. The same texture throughout the confined shapes produces a relatively flat space. The composition is evocative of an Egyptian frieze with its top and bottom borders; horizontal/vertical format; staggered, rigidly defined levels of space; and frontal disposition of the figures. The theatrical lighting throws the audience in relief while flattening the on-stage figures.

Tonal quality can also be made by smudging, rubbing, and erasing or by washes made with wet media as in the Robert Rauschenberg work (Fig. 127). Here large areas of wash unify the disparately scaled images and tie the large combine into a cohesive whole.

above: 126. Georges Seurat. *Ensemble* (study for *La Parade*). 1887.
Pen and ink, 5 × 7⅜" (13 × 19 cm).
Courtesy Sotheby's, London.

right: 127. Robert Rauschenberg. *Untitled (Combine).*
1973. Mixed media, 5 × 2' (1.52 × .61 m).
Fort Worth Art Museum, Texas
(Benjamin J. Tillar Trust).

Tonal variation can also be effectively achieved by stippling. Guillermo Meza uses this technique in his pen-and-ink drawing *Giantess* (Fig. 128), in which the figure with its exaggerated forms dwarfs the small island in the background. A powerful plasticity is the result of careful modeling from light to dark. Eye level—the figure is seen from an ant's eye view—is a major contributing factor in establishing scale.

Cross-hatching is another means of creating value. In his still life (Fig. 129), Giorgio Morandi constructs an ordered arrangement using cross-hatching. Background and foreground are uniformly cross-hatched, thus flattening the space. The bottles are defined by groups of angled lines, which indicate planar change; the still-life contours are strengthened, and thus flattened, by outline. Morandi's value patterns create an other-worldly effect; the objects seem strangely isolated and lonely.

left: 128. Guillermo Meza. *Giantess*. 1941.
Pen and ink, 25⅝ × 19⅞″ (65 × 50 cm).
Museum of Modern Art, New York (Gift of Edgar Kaufman, Jr.).

right: 129. Giorgio Morandi. *Nature Morte au gros traits*. 1931.
Etching, 9⅝ × 13¼″ (25 × 34 cm).
Courtesy Harriet Griffin Gallery, New York.

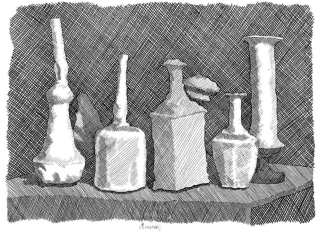

Arbitrary Use of Value

Artists sometimes ignore the natural laws of value, such as the way light falls across a form, and use value *arbitrarily*—to create a focal point, to establish balance between parts, to call attention to a particular shape, or otherwise to organize the composition. These uses of value are based both on the artist's intuitive responses and the need to comply with the demands of the design. In other words, arbitrarily stated values are light and dark patterns that differ from local values.

In *Portrait of a Man* (Fig. 130) Rico Lebrun focuses attention on the subject's face by use of value. The gestural suggestion of the body with its massive bulging shapes is an intriguing foil to the treatment of the head. Darker, heavier lines, which direct the eye to the head, also carry the message of gravity and weight.

130. Rico Lebrun. *Portrait of a Man.* 1939. Ink and chalk. Private collection.

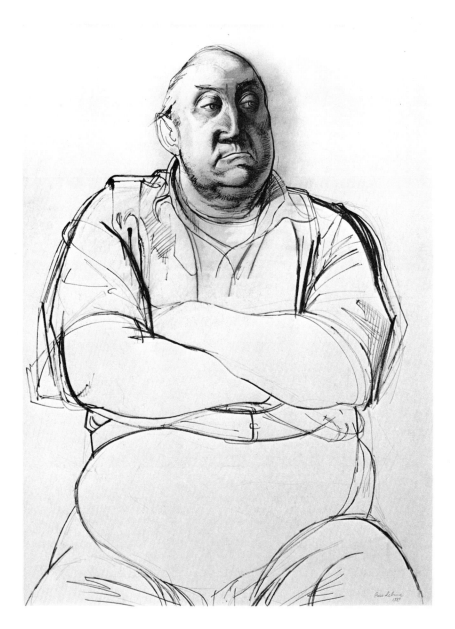

Problem 4.1
Using Value Arbitrarily

Choose a still life or model as your subject, from which you are to make two drawings.

In the first drawing fill the page using background shapes. (Remember continuous overlapping lines will create some repeated shapes.) Using black, white, and two shades of gray, arbitrarily distribute values within the defined shapes. Continue the values to enclose shapes, and keep the values flat, unmodulated. Lead the viewer's eyes through the picture plane by the location of dark shapes. Add grays, establishing a secondary pattern. Base your decisions according to compositional demands rather than on the actual appearance of the subject (Fig. 131).

In the second drawing rather than using only flat shapes and values, model some of the shapes to give them a more volumetric appearance. Again you can direct the eyes of the viewer through the picture plane by the distribution of these modeled areas. You should have a major focal point and minor focal areas. A combination of flat shapes and modeled volumes in the same drawing results in ambiguous space (Fig. 132).

Descriptive Uses of Value

Value can be used to describe objects in physical terms of structure, weight, light, and space.

below left: 131. Arbitrary use of value. Student work.
Ink, charcoal, pencil, collage; 15 × 15″ (38 × 38 cm).

below right: 132. Flat shapes and modeled value. Student work.
Pencil, 18 × 24″ (46 × 61 cm).

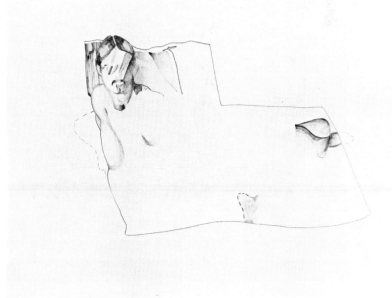

above: 133. James Casebere. *Boats.* 1980. Black-and-white photograph, 16 × 20″ (41 × 51 cm). Courtesy Sonnabend Gallery, New York.

below left: 134. Planar reduction. Student work. Charcoal. Image: 17½ × 8″ (44 × 20 cm).

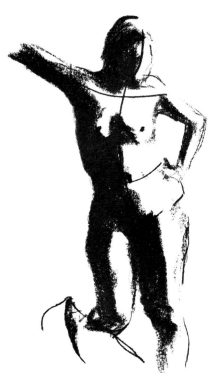

Value Used to Describe Structure

Value can describe the structure, or planar makeup, of an object. Light reveals structure, but values can be distributed according to an analysis of an object's planes; that is, value describing structure need not depend on the natural laws of light. In James Casebere's photograph (Fig. 133), the planar structure is pronounced. Light does, in fact, make a differentiation between adjoining planes. There is, however, more than one light source, one from the upper right and another from the lower right.

 Problem 4.2
Using Value to Describe Structure

In this drawing you are to reduce the figure to two values—black and white—and to two basic planes—front and side. Carefully examine the figure to determine where head, arms, legs, and upper and lower torso face you and exactly where these forms turn away from you at a 90-degree angle. In other words, imagine the figure to be composed of only two planes, front and side. Draw a line separating the planes, placing a flat value within the planes that recede, leaving the rest of the figure white (Fig. 134). Here you are using value to describe both the structure of the figure and its recession into space.

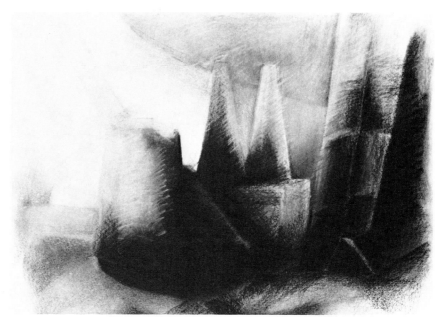

left: 135. Value used to describe plane. Student work.
Pen and ink. Image: 15 × 7″ (38 × 18 cm).

right: 136. Danielle Fagan. Example of value used
to describe weight. 1979. Conté crayon,
18 × 24″ (46 × 61 cm). Collection Sandra Fergason-Taylor.

 Problem 4.3
Using Value to Describe Planes

Use a skull or head as subject and make a drawing that emphasizes the planar aspects. Do you remember the drawings on planar analysis in Chapter 3? In this drawing you are to group lines within the planes to create value. A change of line direction indicates a change of plane. Make your marks change directions just as the planes change. Make the strokes go vertically for those that are parallel to you and diagonally for those planes that turn into space. This change in direction will emphasize the juncture of planes and will be more illusionistically dimensional than the preceding problem (Fig. 135).

Value Used to Describe Weight

The weight, or density, of an object can be defined by value. We sense the pressure of gravity in all objects in real life. The artist frequently enforces this sense by placing darker values at points of greatest pressure or weight or at places where the greatest tension occurs. In Danielle Fagan's conté crayon drawing (Fig. 136), the outer edges are fuzzy; the interior forms seem dense and weighty.

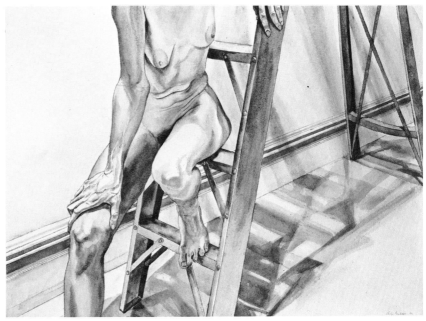

137. Philip Pearlstein. *Female Model on Ladder.* 1976.
Sepia wash on paper, 29½ × 41″ (75 × 104 cm). Private collection, Seattle.

Philip Pearlstein, in his *Female Model on Ladder* (Fig. 137), uses value to describe weight and gravity. Darker lines and value shapes appear along the hip line, at the juncture of hand and knee, along the stress line at the shoulder, under the breasts, and along the right side of the legs. The folds in the lower torso are indicated by a darker line, emphasizing the torsion in the pose. Pearlstein's lasting interest in the structure of the figure is here fortified by the ladder in its complex pattern of cast shadows. Figure and ladder are analogous forms; the pose of the model reiterates the triangularity of the ladder shapes. The ladder is a visual metaphor for the framework of the figure.

Pearlstein's work could be a compendium of the uses of value. He uses value to describe weight, to reveal structure by light, to organize the picture plane by means of repeating gray and white shapes, and to indicate the figure's turn into space. The spatial progression in this drawing is an unusual one; it penetrates the plane from left to right rather than from the more conventional bottom to top progression. And the expressive quality of the work is conveyed primarily by means of value—a cool, detached, analytical approach to a figure in an environment. The headless figure reinforces the impersonal theme of model in a studio.

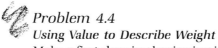

Problem 4.4
Using Value to Describe Weight

Make a first drawing beginning in the imagined center of the figure. Revolve your drawing tool to make a heavy, weighty mass of tangled line, moving outward from the central core. Exaggerate the model's weight; double the mass. The outside edge of the figure should be fuzzy and ill defined, while the center should be darker.

Make a second drawing, beginning exactly as above, filling the form from the inside out. Now as you reach the outer edge of the figure, lighten your marks. Using a sharper, more defined line, make contact with all the vertical and horizontal contours of the figure. Imagine that you are coating the figure with thin webbing or that you are wrapping it in line like a mummy. As the body's surface changes so does the line change.

Value Used to Describe Light

Light falling on an object makes patterns that obey certain rules. If light falls from one direction onto the object, the value patterns created can reveal the structure of the object, its volumetric and its planar aspects; for example, a sphere under a single light source will have an even change in value over its surface. In the graphic arts, modeling—the gradual transition from light to dark to create spatial illusion—is called *chiaroscuro.* This gradual value change can readily be seen in Fagan's still-life drawing in Figure 138.

Cylinders, cones, and organic volumes change gradually from light to dark over their surfaces, while cubes, pyramids, and other angular forms change abruptly from light to dark on their surfaces; that is, their planes are emphasized by light (Fig. 139).

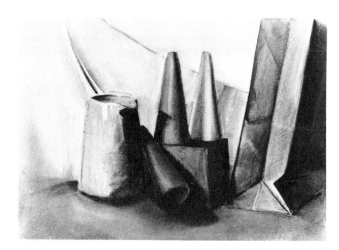

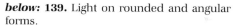

left: **138.** Danielle Fagan. Example of value used to describe light. 1979. Conté crayon, 18 × 24″ (46 × 61 cm). Courtesy the artist.

below: **139.** Light on rounded and angular forms.

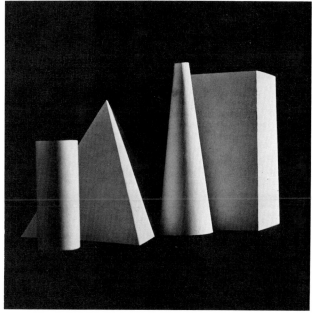

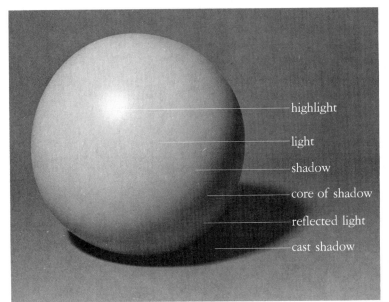

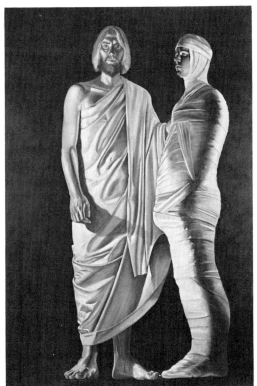

above left: **140.** Six categories of light as it falls over a form.

above right: **141.** Alfred Leslie. *Raising of Lazarus.* 1975. Oil on canvas, 9′ × 6′ (2.74 × 1.83 m). University of Virginia Art Museum, Charlottesville.

Generally light as it falls over a form can be reduced to six categories: highlight, light, shadow, core of shadow, reflected light, and cast shadow (Fig. 140). Within a single form or volume we may see parts of it as light against dark and other areas as dark against light. Some areas may seem to disappear into the background; that is, if a light-valued object is set against a light background, the edge of the object will disappear. Values can cross over both objects and negative space, causing the edge of the object to seem to disappear.

Multiple light sources can result in ambiguous space because the form revealed by one light may be canceled by another. We see this effect in *Raising of Lazarus* (Fig. 141) by the realist painter Alfred Leslie. The figure on the left is hit by a strong raking light, creating complex value patterns on the drapery, while the figure on the right is illuminated by two bright sources, one in front, one in back of the figure. This double lighting flattens the wrapped figure and diminishes its volumetric aspect.

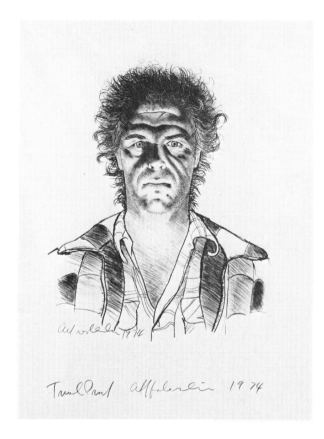

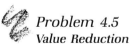

left: **142.** Alfred Leslie. *Alfred Leslie.* 1974.
Lithograph, 40 × 30″ (102 × 76 cm).
Publisher Landfall Press, Inc., Chicago.

above: **143.** Value reduction to two values.
Student work. Acrylic, 18 × 24″ (46 × 61 cm).

In another work by Leslie, his self-portrait (Fig. 142), underlighting produces striking contrasts, which result in a very different mood from that produced by natural light. There is a sense of drama, even of apprehension, as we view the drawing. This tense effect is gained by Leslie's use of value. The stylized hair and shirt contrast with the visual accuracy of the facial features.

Problem 4.5
Value Reduction

Set up a still life of several objects with nonreflective surfaces. Study the subject carefully, and on a value scale from one to ten (see Fig. 117) find its midpoint value. Squint your eyes to reduce color effects, so that you see only patterns of light and dark. This drawing is to be a value reduction. You are to reduce all values in the subject to either black or white. Note both the actual values of objects and the light patterns on them and classify these values as either black or white: Values from one to five will be white, from six to ten black.

Draw the subject lightly in pencil; then use black acrylic or ink to make everything that is darker than the midpoint value a flat, unmodulated black. Erase the pencil lines, leaving the rest of the drawing white. Values will cross over objects and negative space; value will not necessarily be confined to an object. The finished drawing will be spatially flat, very dramatic, and somewhat abstract (Fig. 143).

left: 144. Value study on toned paper.
Student work. Charcoal,
25 × 19″ (64 × 48 cm).

above: 145. Light range limited
to no more than six values.
Student work. Pencil,
19 × 25″ (48 × 64 cm).

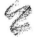 ## Problem 4.6
Four Divisions of Value
Carefully observe the light patterns on a still life. Coat your paper with charcoal with an even value four or five on the value scale (see Fig. 117). If necessary go over the paper twice to create a smooth-textured drawing surface.

Choose four divisions of value—the gray of your paper, a darker gray, white, and black. The actual light patterns on the subject will govern your decisions. Try to divide accurately the values in the subject according to the light patterns on it. Indicate the blacks and dark grays with compressed charcoal and erase the whites with a kneaded eraser. Now begin to model the values. Values should again cross over objects and negative space as in Figure 144.

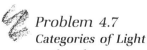 ## Problem 4.7
Categories of Light
In this drawing you are to use a value range of six to depict the categories of light referred to in Figure 140. Set up lighting conditions, using only one light source, so that you have a highlight, light, shadow, core of shadow, reflected light, and cast shadow. After carefully observing the actual light patterns on the still life, make four value scales of six

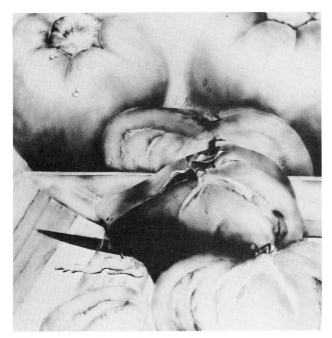

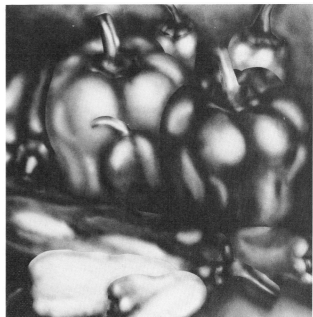

left: **146.** Light close value study. Student work. Watercolor, 30 × 30″ (76 × 76 cm).

right: **147.** Dark value study. Student work. Watercolor, 30 × 30″ (76 × 76 cm).

values each, using these techniques: scribbling, stippling, cross-hatching, and making parallel grouped lines. Density, or closeness of marks, and amount of pressure exerted on the tool are the means to value change. Now choose one of the value techniques and draw the still life with six values (Fig. 145). Use no more than six values and make the transitions gradual and smooth; try to match accurately the actual values in the still life in your value scale.

It is taxing to train the eye to see actual patterns of light and dark, but it is a rewarding exercise. Your ability to see will be enhanced, and your power of concentration will be multiplied in doing these problems.

 Problem 4.8
Tonal Drawings

Using fruit or vegetables as your subject, make two all tonal drawings. In the first use a light value scale to organize your drawing as in Figure 146. In the second expand the value scale to include more darks as in Figure 147. In these two student drawings note how within a single form or volume we may see areas as light against dark or as dark against light. In your drawing allow values to cross over both objects and negative space so that occasionally edges seem to disappear.

left: **148.** Jim Dine. **1935 USA (11/→) 2 AWLS.* 1974.
Litho and drawing on paper. From *The Museum of Drawers*,
Kunsthaus Zurich.

right: **149.** Value used to describe space. Student work.
Pencil, 12 × 12″ (30 × 30 cm).

Value Used to Describe Space

As in depicting light, artists may comply with nature to describe
space as it actually appears, or they can promote the feeling of space by
the use of value. Spatial depiction has many manifestations; there is no
single way to indicate space. The handling of space is a result of the
artist's view, tempered by culture and personality. One approach to the
depiction of space is to use a progression of values from light to dark. In
Jim Dine's companion drawings (Fig. 148) we see an expressive handling
of space. The awl on the left seems to occupy a deep space, one that
seems to pulsate. Lighter grays frame the edges; a dense black describes
the deepest space. The awl on the right occupies an uneasy space; an
ambiguous relationship exists between the tool and its background. The
spatial difference between tool and handle is apparent at the top of the
drawing, but the bottom of the tool lies on the surface of the picture
plane.

 Problem 4.9
Using Value to Describe Space

In a drawing of a landscape, focus on a spatial progression. Try to
indicate at least three distinct levels of space—foreground, middle
ground, background. Keep in mind the fact that you are trying to de-
scribe space; the objects in the landscape are of secondary interest. Re-
member that values may begin and end independently of a shape; values
may cross over both positive and negative space. The student chose a
cloud study for a solution to this problem in Figure 149.

Expressive Uses of Value

The most exciting aspect of value is its use as a forcefully expressive tool. You have read about the principles of value, the observation of natural appearances, and how this observation can help you use value. Your attitude as an artist, your intellectual and emotional responses, are the primary determinant of how you use value. Actual appearance can be subordinated to expressive interests. Value is a strong determinant in the depiction of emotions. An example is pathos. Striking contrasts of light and dark help to achieve the special *angst* of Howard Warshaw's *Red Man* (Fig. 150). Fluid lines and layered washes envelop the somewhat transparent form. This expressive style is in contrast with Arshile Gorky's portrait of his mother (Fig. 151). A gentle light and subtle tonal modeling result in a classical detachment. A sense of enduring presence is relayed by the comfortable placement of the figure and by the stable geometric shapes in the background. Gorky has used a close value scale as a unifying device to organize his drawing.

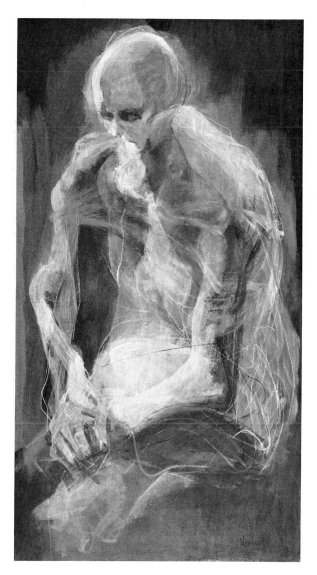

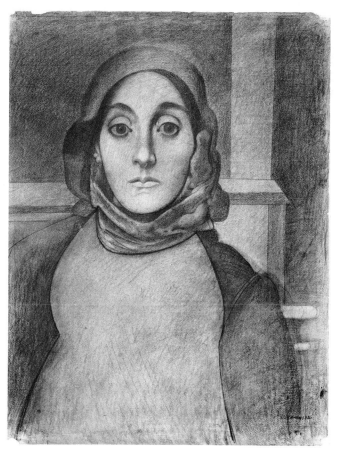

left: **150.** Howard Warshaw. *Red Man.* 1967.
Acrylic on paper, 5′ 5″ × 3′ (1.65 × .91 m).
Courtesy Frances Warshaw, Carpinteria, Calif.

below: **151.** Arshile Gorky. *The Artist's Mother.* 1930.
Crayon, 24 × 18½″ (61 × 47 cm).
Art Institute of Chicago (Worcester Sketch Fund Income).

Alice Neel's *Loneliness* (Fig. 152) is a highly personal expression. The empty room, the chair, the bleak view from the window, the facing empty windows, the black shade half-drawn—all are metaphors for death; and Neel has used stark value contrast to reinforce her message. The viewer is gripped by the theatricality of the subject and startled by the artist's simplicity of means.

A final look at the way value can create mood is through the use of *value reversal.* This technique creates unusual spatial effects. In Claes Oldenburg's study (Fig. 153), the chalk lines defining the vacuum cleaner are drawn on a dark ground. This gives the effect of a photographic negative, of space being mysteriously reversed. The commonplace object becomes ghostlike and supernatural. We are presented with an eerie vanishing act.

below: **152.** Alice Neel.
Loneliness. 1970.
Oil on canvas,
6′ 8″ × 3′ 2″ (2.03 × .97 m).
Collection Arthur M. Bullowa,
New York.

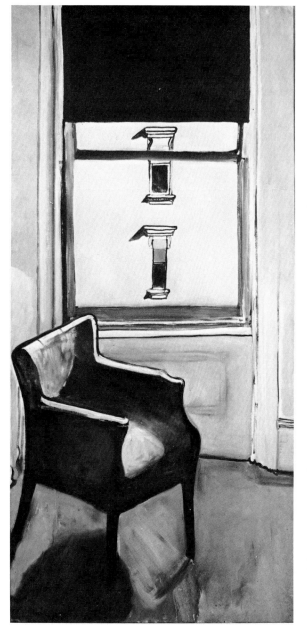

below: **153.** Claes Oldenburg.
Plan for Vacuum Cleaner, From Side. 1964.
Chalk and wash on gray paper, 40 × 26″ (102 × 66 cm).
Courtesy the artist.

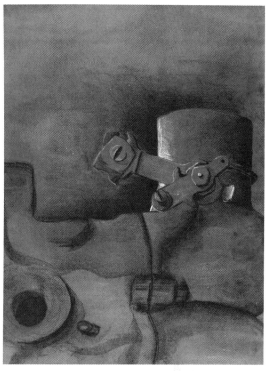

above: **154.** Descriptive value: objective.
Student work. Conté crayon, 18 × 24″ (46 × 61 cm).

right: **155.** Descriptive value: subjective.
Student work. Conté crayon, 24 × 18″ (61 × 46 cm).

Problem 4.10
Value Reversal

Using a subject of your choice, do a drawing in which the value patterns are reversed. Draw on either toned paper or on a neutrally colored paper (gray or tan). Use a white medium—conté crayon, chalk, or white ink. Reverse values, using white for black; you can achieve a range of whites by layering washes or by the amount of pressure placed on the drawing tool. Try for the effect of a photographic negative as in the Oldenburg drawing.

Problem 4.11
Value Used Subjectively

In these drawings you are to subordinate visual appearances to emotive content. Make two drawings of the same subject. In the first, render the subject objectively and descriptively; record appearances as impersonally as possible. In the second drawing, draw the object subjectively. Project a feeling onto the subject, using a value range that will underscore your attitude. In figures 154 and 155 the student chose a machine part as subject. In the objective drawing two impersonal views of the machine are overlaid; a middle value range predominates. In the second, subjective drawing, value sets the mood. The student has taken an extreme point of view, a close-up one, so that the machine seems to loom as if in a landscape. The toned paper, the somber values, the strategically placed whites all contribute to the expressive quality of the drawing.

Problem 4.12
Value Used to Express Emotive Content

Explore the expressive uses of value through three drawings in which the patterns of light and dark convey your emotional intent rather than describe actual appearances. The subject may be a recognizable object or an abstracted image.

In the first drawing use dark tones to evoke a somber mood (Fig. 156). In the second drawing use a lighter value range with gradual transitions between values to organize your composition. Try to produce a feeling that will be reinforced by lighter tones (Fig. 157).

In the third drawing use highly contrasting values applied with a wet medium. Try for a dramatic effect using a stark contrast in values. Figure 158 is a student's response to this problem. A grid format is unified by dark values that cross over both figures and negative spaces.

156. Value used to establish mood.
Student work.
Charcoal,
18 × 24″ (46 × 61 cm).

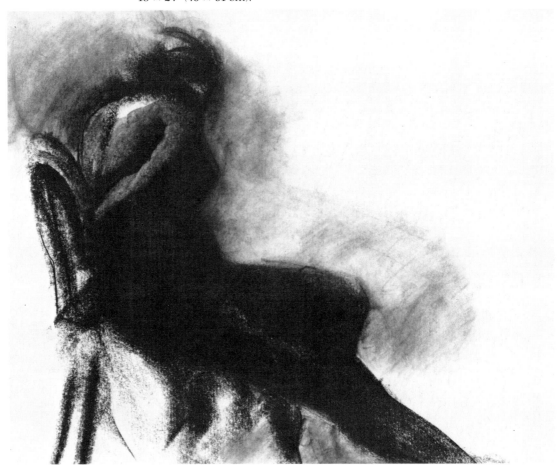

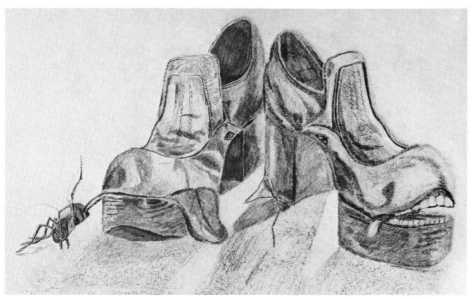

157. Close value range. Student work.
Vine charcoal, 13 × 22″ (33 × 56 cm).

158. High-contrast study. Student work.
Lithographic crayon with turpentine, 19 × 25″ (48 × 63 cm).

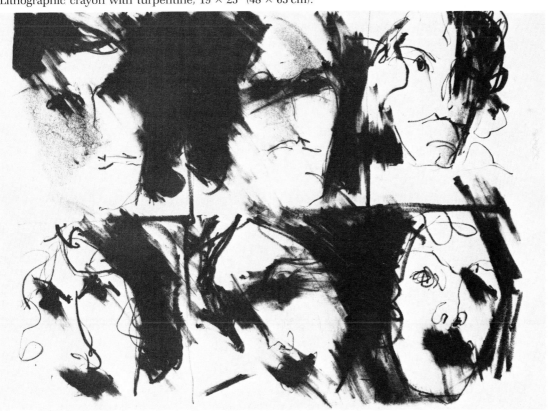

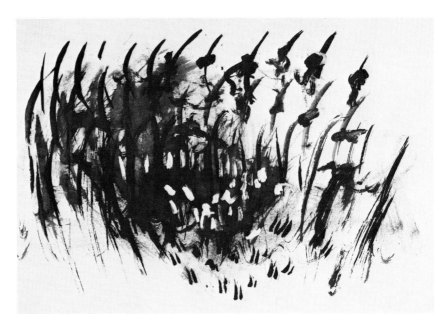

159. Stream-of-consciousness statement. Student work. Brush and ink, 18 × 24″ (46 × 61 cm).

Problem 4.13
Value Used to Create Abstract Patterns

Create some stream-of-consciousness visual statements. Let your thoughts flow. Choose a drawing medium that will be responsive to the emotions you are experiencing. Patterns of light and dark will be divorced from any actual object, but they should be related to feelings. Figure 159 seems to reflect the movement, or stream, of the student's thoughts.

SUMMARY: Spatial Characteristics of Value

Of all the art elements, value has the greatest potential for spatial development. When value defines light, structure, weight, or space, it is being used three-dimensionally. A combination of these approaches may result in ambiguous space.

If more than one light source is used, each source may cancel volumetric qualities revealed by another. As a result, the drawing may have a sense of ambiguous space. A combination of flat value and modeled value also produces ambiguous space.

Flat patterns of light and dark confined within a given shape make the space seem shallow. Uniform lines within a shape keep the shape flat. In the same way, a uniformly textured surface pattern has a tendency to flatten.

On the other hand, volumes with gradual transitions from light to dark are seen as three-dimensional. When value defines the edges of planes and these planes behave according to the rules of perspective, the resulting space is illusionistic. Movement from the foreground in a stepped progression of value planes produces a three-dimensional space. Irregular lines to build lights and darks make a drawing more dimensional than do uniform patterns of line.

CHAPTER 5

Line

Frequently an artist's line quality is the most indicative element of his or her style. Line is the one art element that can most easily stand alone and is the carrier of the artist's intent. Just as an artist's sensitivity determines the kind of value patterns chosen, an artist's personality is the strongest determinant of the quality of line used. In the last chapter you read how value must be compatible with the feeling and meaning of a work. In the same way, the type of line an artist uses must correspond in character to the basic content and mood of the work.

You have had considerable experience already in using line in problems in the preceding chapters. You have used gestural line, structural line, organizational line, analytical measuring line, directional line, outline, scribbled, tangled, and wrapping lines, continuous overlapping lines, cross-hatched lines, and lines grouped to make value. This chapter deals with line quality, with the ways line can be used both objectively and subjectively as a carrier of meaning.

Determinants of Line Quality

A first step in becoming sensitive to line is to recognize the inherent qualities of various linear drawing tools. While materials sometimes can be made to work in ways contrary to their nature, recognizing the advantages and limitations of a medium is an important first step in learning to draw. From everyday experience we are acquainted with some linear tools that move effortlessly to create line: pencil, felt-tip marker, ball-point pen, and pen and ink. And we have used some media that produce a grainy, abrasive line: charcoal, chalk, and conté crayon. China markers and lithographic pencils contain grease and can easily be smudged or dissolved. (See Guide A on materials for further discussion of drawing media.)

The surface on which a line is drawn is another strong determinant of the quality of that line. An example is the comparison between a line drawn on glass and one drawn on brick.

In the print *Dedalus* (Fig. 160) by Mimmo Paladino, the lines are incised, or cut, into linoleum and printed. This produces a "negative" line. Instead of the line's lying on the surface there is a reversal in the relationship between the line and its background. The gouged lines vary from the rather flowing line describing the seated figure to the primitively gouged and scratchy lines throughout the composition. Line not only describes edge, but it also furnishes texture and value in the otherwise dark design.

The quality of incised line is different from the painted lines used throughout Rodney Alan Greenblat's room installation (Fig. 161). His background as a graffiti artist is evident in this work. The living room furniture is gaudily decorated with line drawings on cloth, plaster, wood, and paper.

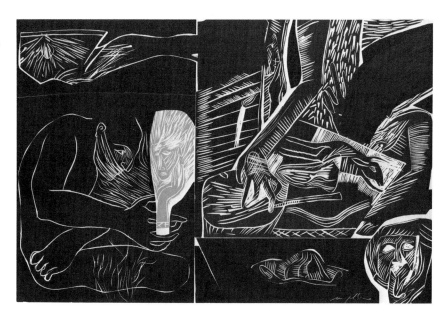

160. Mimmo Paladino. *Dedalus.* 1984. Linocut, 3' 2¼" × 4' 5¼" (.97 × 1.35 m), edition of 65. Courtesy Waddington Graphics, London.

above: **161.** Rodney Alan Greenblat.
Installation at Gracie Mansion Gallery,
New York. 1983.
Mixed media.

right: **162.** Leonard Baskin. *Ajax: Ink.*
1962. Ink, 40 × 26″ (102 × 66 cm).
Collection H. Shickman Gallery,
New York.

The surface that receives the mark affects the line quality just as does the tool that makes it, so the student must learn to assess both implement and surface. It is difficult, for example, to make a clean, crisp line with pen and ink on newsprint because of the paper's absorbency.

The strongest determinant of line quality, however, is the sensitivity of the artist. Leonard Baskin's intense involvement with pen and ink allows him to use line as the primary carrier of his meaning; line is the means by which he emphasizes his sometimes brutal subjects. In Figure 162 he uses line to depict the essence of the mythic greek warrior Ajax.

left: **163.** Pablo Picasso.
Jeune Homme au Masque de Taureau,
Faune et Profil de Femme.
March 7, 1934.
Etching, 8¾ × 12⅜″ (22 × 31 cm).
Courtesy Edward Totah Gallery,
London.

right: **164.** Henri Matisse.
Nude with Face Half-Hidden. 1914.
Transfer lithograph printed in
black, 19¾ × 12″ (50 × 30 cm).
Museum of Modern Art, New York
(Frank Crowninshield Fund).

The arrogant stance, the extreme weight shift—note the stress on the weight-bearing leg—the muscular strength, and the implied physical movement in the drawing are conveyed by line alone.

An artist's linear style is like handwriting; just as we are able to identify a person's handwriting, familiarity with an artist's style makes the work identifiable. Picasso's subjects along with his drawing style make his work easy to recognize. The combination of well-controlled contour line along with a characteristic expressive, somewhat decorative scribble are hallmarks of Picasso's virtuosity. In Figure 163 duality, a favorite theme for Picasso, is the subject. Opposite poles—male/female, man/beast, reveler/contemplator—are depicted, each with an appropriate line quality. The *anima*, the female figure on the left, emerges from a deep recess, certainly an appropriate representation of the unconscious. This figure is drawn in a complex network of lines while the adjacent figure is simply and delicately presented. We see the man/beast in a transitional state; the lines are more tentative, not so exuberantly drawn as in the third figure where the Minotaur reigns. In the Minotaur the frenzied, swirling, thick lines describing a drunken, Dionysian state overpower the man part of the figure with its delicately drawn upper torso and arms. The Minotaur myth is here given an updated, 20th-century, Jungian interpretation.

Another artist whose line quality is a trademark of his style in Henri Matisse (Fig. 164). His line fits his wish to make art that is as "comfortable as an armchair." He effects a relaxed, intimate mood through lyrical line.

By economical means Matisse relays a wealth of information. The contour line emphasizes the voluminous aspects of the figure by its change in weight; the darks follow the bulging parts. A lighter line traces the concave area between breast and stomach; the heavier, weightier line defines the convex forms. Matisse changes the pressure on the drawing tool for maximum effect.

Ben Shahn and George Grosz are 20th-century social commentators with different views of the human condition; their art reflects these differences. Shahn's indignation at injustice is aptly stated by his heavy lines like those of an editorial cartoon. In the brush drawing in Figure 165 he depicts the news analyst Ed Murrow slaying the dragon, Senator Joseph McCarthy. The linear quality is jagged; the figures are likewise contorted. Lines convey the tension of the subject matter. The heroic figure of Murrow contrasts with the scratchily drawn, defeated McCarthy. Exaggerated lines are appropriate for exaggerated commentary.

There are no heroes in Grosz' work (Fig. 166). His caustic accusations are conveyed by his crabbed line. The dominant "willful possessors" fill the composition, crowding out the common people. Disparity in size (note the difference in scale between the crippled veteran and the bankers in the foreground) and disparity in line quality (in the depiction of the "bad guys" and "good guys") are extreme. The child is insubstantial; the table edge cuts through its foot, rendering its form transparent. The regimentation of society is shown in the geometric, severely ordered cityscape. Even the background figures are statically placed along a horizontal/vertical axis. The idea of a world gone askew is reinforced by the angularity of the three figures at the table. Grosz' subjects do not invoke sympathy; indeed, he presents them for condemnation.

left: **165.** Ben Shahn.
Ed Murrow Slaying the Dragon of McCarthy. 1955. Brush drawing,
12¼ × 9½" (31 × 24 cm).
Location unknown.

right: **166.** George Grosz.
Exploiters of the People,
from the series for *The Robbers*
by Friedrich von Schiller. 1922.
Lithograph. Print Collection,
The New York Public Library (Astor,
Lenox and Tilden Foundations).

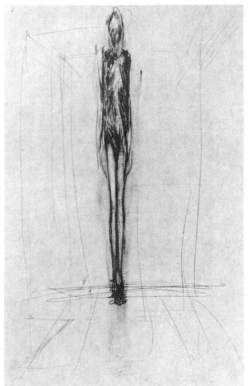

above: 167. Henry Moore. *Row of Sleepers.*
1941. Pencil, wax crayon, watercolor wash,
pen and black ink,
21¼ × 12⅝" (55 × 32 cm).
Collection British Council, London.

above right: 168. Henry Moore.
Reclining Figure. 1935–36. Elm wood,
length 42" (107 cm).
Wakefield Metropolitan District Council
Art Gallery and Museums, Yorkshire, England.

right: 169. Alberto Giacometti.
Standing Female Nude. 1946.
Pencil, 19⅝ × 12⅝" (50 × 32 cm).
Location unknown.

far right: 170. Alberto Giacometti.
Walking Man. c. 1947–49.
Bronze, height 27" (69 cm).
Hirshhorn Museum and Sculpture
Garden, Smithsonian Institution,
Washington, D.C.

Both Shahn and Grosz portray passionate convictions, and the linear technique of each artist helps carry his message.

Henry Moore is a contemporary sculptor whose drawings relay the same message as his sculpture. His art explores the idea of weight and mass (Figs. 167 and 168). Moore's subjects are connected to the earth from which they seem to emerge. His drawings are studies in the sculptural aspects of a form; his line feels around the volumes, encasing them

as if they were cocoons. His figures, both sculpted and drawn, have a roundness and solidarity that makes them resemble mountains. They are in sharp contrast to Alberto Giacometti's weightless figures (Figs. 169 and 170).

Giacometti's analytical, nearly transparent line drawing is in complete accord with his sculpture. His sculpture, unlike Moore's, is linear; in both drawings and sculpture he makes use of attenuated line. Space penetrates and diminishes his subjects, unlike Moore's sculptures where even the voids seem substantial. We see the same ideas operative in both drawing and sculpture.

Artists from prehistoric times to the present have left a rich storehouse of various types of line. In the 20th century they range from the childlike scribbles of Cy Twombly (Fig. 171) to well-controlled line of Richard Oginz (Fig. 172). Twombly's line is intuitively stated, seemingly uncalculated. The drawing resembles a doodle, that unaffected, lackadaisical drawing exercise that appeals to all ages.

left: **171.** Cy Twombly. *A.* 1956.
Oil and pencil on canvas,
4′ 2″ × 5′ 3″ (1.3 × 1.6 m).
Location unknown.

below: **172.** Richard Oginz.
When Clients Come to Call. 1983.
Ink on paper, 11 × 30′ (3.35 × 9.14 m).
Collection the artist.

Oginz' meticulously stated drawing is highly skillful, very complex in its composition. Line is used to convey spatial information and to outline numerous geometric forms. The drawing is unified by the connecting diagonal lines. The images—the fish, the mechanical arm, the snake—spill out over the composition in unexpected ways. The various geometric forms, too, are in a state of disarray, yet the line quality conveys a feeling of control. Line's integral role is especially apparent when the drawing is seen in real life since it is 11 feet high and 30 feet long (3 × 9 m). Oginz makes a humorous visual interpretation on the disruption in an artist's studio "when clients come to call."

Types of Line

Line can be used to produce a mood of lightness, gaiety, and movement, as in the Etruscan mural in Figure 173. This fresco has delicacy and weightlessness. The repeating curvilinear line establishes a rhymthic pattern appropriate for the dancer's swaying movement. The composition is unified by the dotted pattern and scalloped shapes. The faintest lines are those describing the dancer's arms and face.

In the prehistoric Tassili drawing on rock (Fig. 174), outline economically yet emphatically delineates the giraffe, while a delicate line appropriately describes the leaping gazelles. There is no question of the importance of the giraffe; scale shifts radically throughout the work. Line is used sparingly yet effectively.

left: **173.** *Dancing Woman,* detail of fresco, Tomba del Triclinio, Tarquinia. Etruscan. c. 470 B.C.

right: **174.** *The Large Giraffe.* Adjefou, from Tassili-n-Ajjer, Algeria. Prehistoric. Fresco, 5' 2⅜" × 3' 5" (1.6 × 1.05 m).

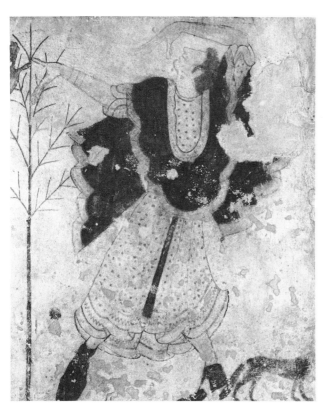

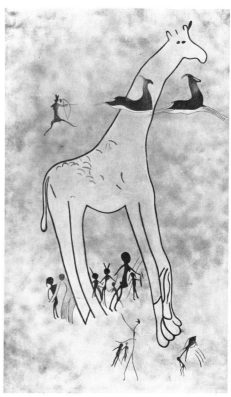

Seldom does an artist confine the use of line to one type, however, as attested by William T. Wylie's humorous drawing (Fig. 175). A variety of line types is used throughout the composition; even the sign in the drawing points out the role of line for an artist—"Suite out a line, sweet out a line" (Sweet Adeline). Wylie's works are filled with both visual and verbal puns. His dual role as artist/magician and artist/dunce is a favorite one.

Careful observation of other artists' work—recognizing the different types and functions of line—as well as experimentation in your own work will further your drawing ability.

Contour Line

Chapter 2 discussed basic approaches to drawing. As you may recall, in contrast to the quick, immediate gestural approach, is the slower, more intense contour approach. Contour involves an inspection of the parts as they make up the whole. Contour, unlike outline, is spatially descriptive. It is plastic, emphasizing the three-dimensionality of a form.

Juan Gris' *Portrait of Max Jacob* (Fig. 176) is a masterly use of contour; every line is fluently drawn. Slow and accurate observation is the key. The composition is subtly unified by a sidewise figure-eight shape; the clasped hands find their echoes in the bow tie and in the eyes. The form builds from the hands to the head. The geometric framework of a

left: **175.** William T. Wylie. *Mr. Unatural Eyes the Ape Run Ledge.* 1975. Colored pencil and wax on paper, 36 × 28¾″ (91 × 73 cm). Collection Robert and Nancy Mollers, Chicago and Houston.

right: **176.** Juan Gris. *Portrait of Max Jacob.* 1919. Pencil, 14⅜ × 10½″ (37 × 27 cm). The Museum of Modern Art, New York (Gift of James Thrall Soby).

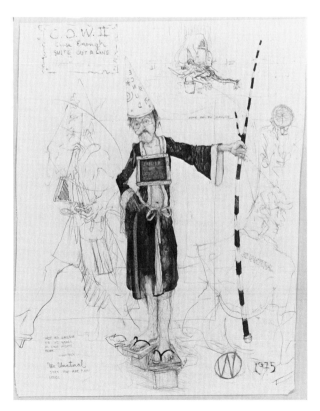

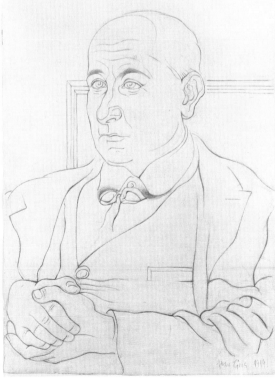

background shape interrupts further upward movement. The lightly stated, sensitive curve of the head directs us back to the ears where yet another set of curving lines leads us to the tie; the V of the vest points to the hands. We are again at our starting point.

Not only is the composition contained; we feel that the sitter himself is self-contained. Contour line is here used to describe change of plane, change of texture (between shirt, vest, coat, for example), change of value (note the ridge line of the nose), change of color (between eye and pupil). This pure contour has been drawn with sensitivity and precision. Gris has used a contour of varying width. Heavier, darker lines create accents (usually where the line changes direction the mark is darker); lighter lines describe the less dominant interior forms.

Five variations of contour line will be discussed: slow, exaggerated, quick, cross-contour, and contour with tone. The same general instructions given in Chapter 2 for blind contour are applicable for all types of contour. For review here are the steps in contour drawing:

1. Use a sharp-pointed implement (such as a 2B pencil or pen and ink).
2. Keep your eyes on the subject you are drawing.
3. Imagine that the point of your drawing tool is in actual contact with the subject.
4. Do not let your eyes move more quickly than you can draw.
5. Keep your implement in constant contact with the paper until you come to the end of a form.
6. Keep your eye and hand coordinated.
7. You may begin at the outside edge of your subject, but when you see that line turn inward, follow it to its end.
8. Draw only where there is an actual, structural plane shift or where there is a change in value, texture, or color.
9. Do not enter the interior form and draw nonexistent planes or make meaningless lines.
10. Do not worry about distorted or inaccurate proportions; they will improve after a number of sessions dedicated to contour.
11. Use a single, incisive line.
12. Do not retrace already stated lines and do not erase for correction.
13. Keep in mind line variation in weight, width, and contrast.

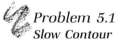

Problem 5.1
Slow Contour

Using a plant or figure as subject, begin on the outside edge of the form. Where the line joins with another line or where the line turns inward, follow, keeping in mind that you are actually touching the object being drawn. Exactly coordinate eye and hand. Do not look at your paper. You may only glance briefly for realignment when you have come to the end of a form. Do not trace over already stated lines. Draw slowly; search for details. Try to convey a spatial quality through variation in pressure and in width of line. Make several drawings, spending as much as an hour on a single drawing. With practice your drawings will be accurate in proportion and detail (Fig. 177).

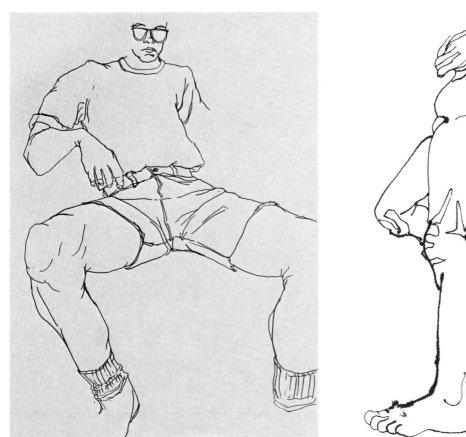

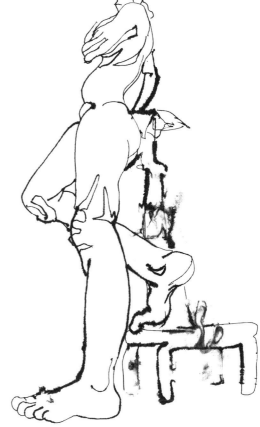

left: **177.** Slow contour. Student work. Pencil, 24 × 18″ (61 × 46 cm).

right: **178.** Exaggerated contour. Student work. Ink, 24 × 18″ (61 × 46 cm).

 ## Problem 5.2
Exaggerated Contour

In the blind contour line exercises in Chapter 2 you were warned to avoid intentional distortion. Exaggerated contour line takes advantage of these distortions. It even intentionally promotes them (Fig. 178).

Your subject in this problem is a model standing or seated on a high stool. Lightly dampen your paper before you begin to draw. Use pen and ink. Begin by drawing the feet of the model. Use a contour line. Draw until you have reached the middle of the page (you should be at knee level on the figure). Now you must radically reduce the scale of the figure in order to fit it in the remaining space. The resulting drawing will look like an ant's-eye view. There should be a monumental feeling to the figure. Note the different kind of line quality that is a result of the dampened paper. You will have a darker line along those forms where you exerted more pressure or where you have lingered, waiting to draw. This line of varying width is one you should intentionally employ from time to time.

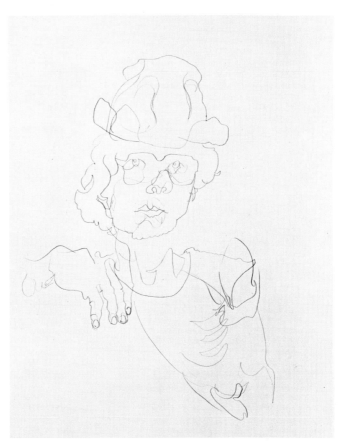

179. Quick contour. Student work.
Charcoal pencil, 24 × 18″ (61 × 46 cm).

 Problem 5.3
Quick Contour

The quick contour line technique is a variation of basic contour drawing. It requires less time than the more sustained contour drawing, and you may look at your drawing more frequently than in a slow contour. The inspection of forms, however, is just as intense. Quick contour drawing might be considered a shorthand version of slow contour drawing. A single, incisive line is still the goal; however, the movement of the line is faster, less determined. In quick contour drawing you are trying to catch the essence of the subject.

In the student drawing (Fig. 179) note the speed with which the figure was drawn. Hands and glasses seem to have been drawn more slowly and deliberately, while the lines describing the shoulder were drawn more quickly. No doubt that area of figure was less interesting to the student, while the complex areas of hand and eyes were more challenging. Note also the lines of varying width and how they seem to give a spatial feeling to the drawing that would be absent in a contour line of maintained width.

Do several quick contour drawings. Experiment with different media, keeping in mind the importance of a single, precise line. Do several drawings of the same subject; a self-portrait would be a good choice. Begin with a one-minute drawing, then a three-minute one, then a five-minute drawing.

Problem 5.4
Cross-Contour

Cross-contour lines describe an object's horizontal contours, or cross-contours, rather than its vertical edges. They emphasize an object's turn into space. You are familiar with contour maps which describe the earth's land surface. Henry Moore's air-raid shelter drawings are excellent examples of this technique (see Fig. 167).

Draw a draped fabric. Keep your implement continuously in contact with the surface of your paper. Carefully observe the drapery's cross-contours and indicate accurately its undulating shape (Fig. 180). By grouping the cross-contour lines more closely, you can control the value changes across the form.

The cross-contour line technique is particularly effective for teaching yourself to see the complex spatial changes that occur across a figure. Repeat the problem using a model; imagine that the line is a thread that wraps the shape horizontally, encasing its mass (Fig. 181). Another recommended exercise is making detailed cross-contour studies of legs, arms, front torso, back torso.

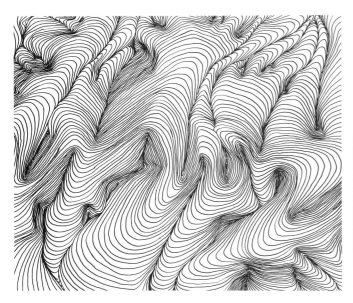

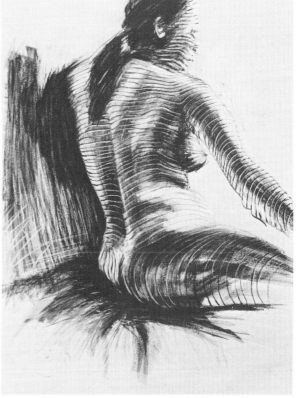

left: 180. Cross-contour. Student work. Ink, 24 × 28″ (61 × 71 cm).

below: 181. Cross-contour. Student work. Charcoal and chalk, 24 × 18″ (61 × 46 cm).

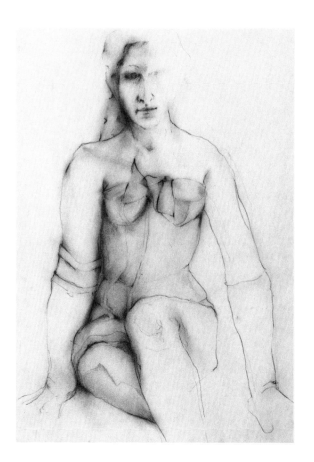

182. Contour with tone. Student work. Charcoal pencil, 24 × 18″ (61 × 46 cm).

Problem 5.5
Contour with Tone

After you have mastered the art of contour drawing, you can add value or tone. Be selective in your placement of value. In the student drawing (Fig. 182) value is used to indicate the figure's turn into space and to indicate light source. Do a drawing that is primarily contour; add value for focal development.

Problem 5.6
Contour of Maintained and of Varying Width

Line width and variation have been mentioned throughout the book. In this problem, experiment with different found implements, creating contour line of various widths by turning the implement as you draw and by changing pressure on the implement. Keep in mind the spatial differentiation that comes from the use of thick and thin and dark and light lines. Note that a line of varying width is generally more subjective than a line of maintained, or unvarying, width. Do two slow-contour drawings, one in which you keep the line the same all along its length and another in which you vary the line. Compare the spatial and emotive effects in the two drawings by Sandra Ferguson Taylor (Figs. 183 and 184). The manner in which an artist varies the line is very personal, and the line quality will change from artist to artist.

Mechanical Line

Mechanical line is an objective, nonpersonal line that maintains the same width along its full length. An example would be an architect's ground plan in which various lines indicated different materials or levels of space (see Fig. 1).

Steve Gianakos uses a number of drafting techniques in his work (Fig. 185). The carefully plotted arcs and angles are structurally meaningless; however, they do seem to make some tongue-in-cheek remark on architectural drawings. The gorillas have satirical, autobiographical significance for Gianakos, who studied industrial design. Note the mechanical application of line; each individual line is unvarying, deliberate, and controlled.

left: **183.** Sandra Ferguson Taylor. Example of contour with maintained line width. 1984. Pencil, 18 × 24″ (46 × 61 cm). Courtesy the artist.

right: **184.** Sandra Ferguson Taylor. Example of contour with varying line width. 1984. Pencil, 18 × 24″ (46 × 61 cm). Courtesy the artist.

185. Steve Gianakos. *Gorillas # 10.* 1983. Ink and colored pencil on paper, 3′ 4″ × 5′ (1.02 × 1.52 m). Courtesy Barbara Gladstone Gallery, New York.

Problem 5.7
Using Mechanical Line

Draw multiple views of an object—top, bottom, sides—using mechanical line. You may keep the views separate, or you may overlap and superimpose them. Keeping in mind that mechanical line remains the same throughout its length, use a drawing tool that will produce this kind of mark, such as pencil, felt-tip marker, ball-point pen, or lettering pen.

Structural Line

Structural lines indicate plane direction and reveal planar structure. Structural lines build volume and create a three-dimensional effect. Although a drawing can be made using only structural lines, these lines are usually found in combination with either organizational line or contour line. Structural lines can be grouped and are then perceived as value.

Jacques Villon's *Baudelaire avec Socle* (Fig. 186), is based on sculpture. Villon enhances the three-dimensional effect by a buildup of planes using a blocky, Cubistic approach. The background is flattened out by an overall texture and is further flattened by intersecting horizontal and vertical lines. The head is set at an angle, and the structural lines are also set at angles to each other. The empty white base and blank table are in contrast with the complex planar analysis.

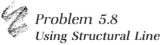

Problem 5.8
Using Structural Line

Incorporate several views of your hand into a single composition. Use structural lines to indicate the change of planes, to create values, and to build volume. You can use parallel lines, cross-hatching, or grouped cross-contour lines as in Figure 187. Remember, the more closely the lines are massed, the darker the value.

Lyrical Line

Pierre Bonnard, Edouard Vuillard, Henri Matisse, and Raoul Dufy use lyrical, decorative line. Lyrical lines are like arabesques; they can be ornately intertwined or flow gracefully across the page. Contour line and decorative line can be combined to produce a lyrical mood, as in Matisse's *Nude in the Studio* (Fig. 188). In this pen-and-ink drawing, references to space reverberate throughout the composition. We see the model, her back reflected in a mirror in the background, a door to another room, and a window to the outside. In the lower right corner there is a drawing of the scene just described—a two-dimensional space of a three-dimensional space—and a notation of the artist's hand holding the pen, another reference to a real space.

Generally, the more deliberately controlled a line, the more objective it is. The more spontaneously a line is stated, the more subjective it is. Lyrical line falls under the subjective category and is characterized by sensitivity of expression.

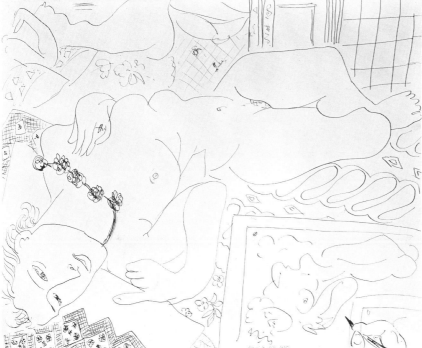

left: 186. Jacques Villon.
Baudelaire avec Socle. 1920.
Etching, 16⅓ × 11″ (42 × 28 cm).
The Art Institute of Chicago
(Gift of Frank B. Hubachek, 1974).

right: 187. Käthe Kollwitz.
Hand Studies. c. 1891. Pen and
ink and wash, 11¼ × 9″ (29 × 23 cm).
British Museum, London
(reproduced by courtesy of the
Trustees).

below: 188. Henri Matisse.
Nude in the Studio. 1935.
Pen and ink,
17¾ × 22⅜″ (46 × 57 cm).
Location unknown.

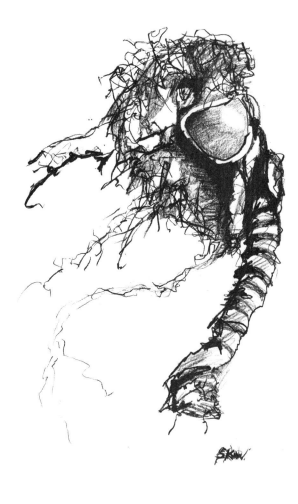

left: **189.** Lyrical line. Student work. Ink, 24 × 18″ (61 × 46 cm).

right: **190.** Crabbed line. Student work. China marker. 24 × 18″ (61 × 46 cm).

 Problem 5.9
Using Lyrical Line

Choose an article of clothing as the subject of a lyrical drawing. Use an implement that is free-flowing; either brush and ink or pen and ink would be appropriate. Try drawing in time to music (Fig. 189).

Constricted, Aggressive Line

A constricted line makes use of angular, crabbed, assertive marks. Such marks are aggressively stated. They may be ugly and scratchy, carriers of a bitter expression; they convey the feeling of tension (Fig. 190).

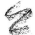 *Problem 5.10*
Using Constricted, Aggressive Line

Look back at the drawing by Grosz (see Fig. 166). Draw a scene that depicts a situation toward which you feel great antipathy. Use constricted, aggressive lines to convey a strong, negative feeling. Try to fit your drawing style with a bitter mood.

Calligraphic Line

Calligraphy, or handwriting, is highly developed in Eastern art. Calligraphic line makes use of free-flowing, continuous movement. *Jittoku* (Fig. 191), an 18th-century Japanese ink-and-brush drawing, combines calligraphy with an image. Both image and writing are a result of a brilliant calligraphic approach. Instrument, media, surface, and technique are welded in this drawing. Calligraphy is related to gesture; the variations of the line encompass the full range from bold to delicate, from thick to thin. The marks are sweepingly graceful.

Gaston Lachaise's draped figure (Fig. 192) is Oriental in feeling. The calligraphic flourish of the marks and the control of the brush determine the quality of the line.

Mark Tobey was influenced by Eastern calligraphy and adapted the technique in his linear intertwinings (Fig. 193). These overall textural patterns he called "white writing." Space is created by the layering of calligraphic marks, black, white, and gray.

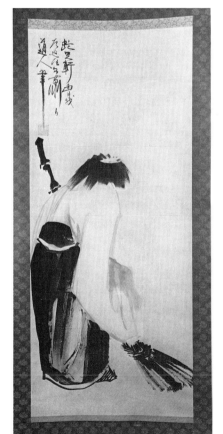

left: **191.** Soga Shohaku. *Jittoku.* Mid-18th century. Sumi ink, 4′ 1⅛″ × 1′ 9″ (1.25 × .54 m). Dallas Museum of Art (Gift of Mr. and Mrs. Lawrence S. Pollock).

below left: **192.** Gaston Lachaise. *Draped Figure.* 1906–10. Brush and wash, 8½ × 5¾″ (22 × 15 cm). Fort Worth Art Museum, Texas (Estate of Isabelle Lachaise).

below right: **193.** Mark Tobey. *Calligraphy in White.* 1957. Tempera, 35 × 23¼″ (88 × 59 cm). Dallas Museum of Art (Gift of Mr. and Mrs. James H. Clark).

Problem 5.11
Using Calligraphic Line
Practice writing with ink and a bamboo-handled Japanese brush. Change scale, making the transitions of the marks gradual and graceful. Apply different amounts of pressure to create flowing motions. Turn the brush between your fingers as your write. Experiment with the way you hold the brush; sometimes hold the handle near the end, sometimes closer to the brush. Using still life as a subject, build the objects out of written words, layering them, obscuring their legibility, only occasionally allowing them to be read.

Implied Line

An implied line is one that stops and picks up again. The viewer conceptually fills in the breaks. Walter Piehl, in his drawing *Trick Roping* (Fig. 194), does not explicitly enclose all shapes. The shapes are implied through use of the broken lines.

Implied line results in an interchange between positive and negative shapes. It brings the negative space into the implied positive shapes, creating spatial ambiguity. This lost-and-found line requires a viewer's participation since line and shape must be filled in mentally.

194. Walter Piehl, Jr.
Trick Roping. 1973.
Pencil and wash,
25¾ × 20″ (65 × 51 cm).
Minnesota Museum of Art, St. Paul.

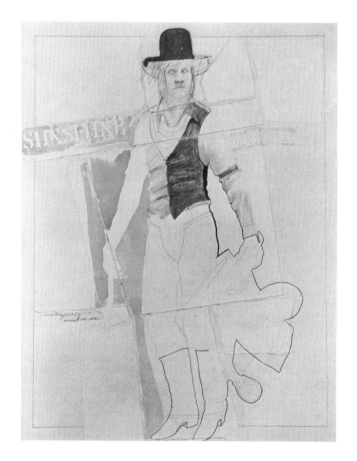

Problem 5.12
Using Implied Line

Choose a figure as subject for an implied-line drawing. Begin drawing along the left side of the figure; leave the right side empty. Create implied shapes. Be conscious of the pressure on your drawing tool, lightening the pressure as the line begins to break. The lines should change from light to dark along their length. Use a minimal amount of line to suggest or imply shape.

Blurred Line

Blurred lines are smudged, erased, or destroyed in some way, either by rubbing or by erasure. They are frequently grouped to form a sliding edge; they are not as precisely stated as implied lines. Blurred and smudged lines are much favored by present-day artists because they create an indefinite edge, thereby resulting in an ambiguous space.

Marcia Isaacson in *Bellsmith's Family Members* (Fig. 195) uses blurred and erased lines to build the connected forms of the woman and dog. The lines that are grouped in a single direction create a volumetric buildup. At the edge where two forms meet, Isaacson uses erasure. The blurred lines serve to tie the two figures together and create a spatial ambiguity between the woman and the dog. The insistently drawn pencil lines contrast with the accurately rendered focal point of the woman's face. It is confusing as to which figure is in front and which recedes. Not only do we sense a spatial ambiguity between woman and dog, we also feel at loss as to how to interpret the family relationship suggested in the title of the drawing.

195. Marcia Isaacson.
Bellsmith's Family Members. 1970.
Pencil, 29¼ × 41½″ (74 × 105 cm).
Minnesota Museum of Art, St. Paul.

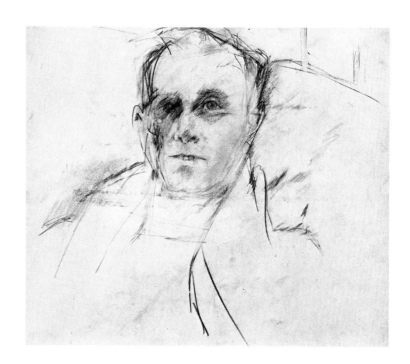

196. Larry Rivers.
Portrait of Edwin Denby III. 1953.
Pencil, 16⅜ × 19¾″ (42 × 50 cm).
Museum of Modern Art, New York.
(Anonymous gift).

Larry Rivers, in his portrait of Edwin Denby III (Fig. 196), combines a gestural approach with blurred lines to contrast with the more precisely stated half-face of his friend.

197. Erased and blurred line.
Student work. Pencil, 12 × 10″
(30 × 25 cm).

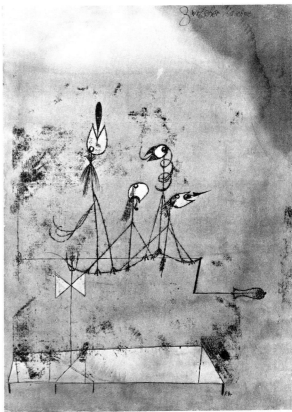

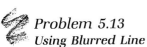

Problem 5.13
Using Blurred Line

With a soft pencil and a white plastic eraser make a drawing in which you use blurred, smudged, and erased line. Use the eraser as a drawing tool, making sweeping motions that go counter to the pencil marks. Erase and blur the already established lines. Alternately redraw and erase until the drawing is finished. You might choose a single object and repeat it several times as in Figure 197. The student chose recognizable objects (ribbons and a box of tissues), but the final result seems quite abstract.

Whimsical Line

A playful, whimsical line quality is appropriate for a naïve, childlike subject. This subjective type of line is intuitive and direct. The whimsical line may change width arbitrarily. Whimsy is more a feeling than a technique. The line used in Marc Chagall's drawing *To Charlie Chaplin* (Fig. 198) is compatible with the playful treatment of his subject. Exaggeration and unexpected juxtapositions play a part in creating a whimsical mood.

Paul Klee was a master of whimsical line. While his drawings are appealingly naïve, they incorporate sophisticated, formally organized devices. Klee combines geometric abstraction with fantasy in his drawing *Twittering Machine* (Fig. 199).

left: **198.** Marc Chagall.
To Charlie Chaplin. 1929.
Pen and ink, 16⅞ × 11″ (43 × 28 cm).
Location unknown.

right: **199.** Paul Klee.
Twittering Machine. 1922.
Watercolor, pen, and ink;
16¼ × 12″ (41 × 30 cm).
Museum of Modern Art, New York
(Purchase).

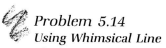

Problem 5.14
Using Whimsical Line

Klee's suggestion to take a line for a walk is a good one with which to conclude these problems dealing with line. Choose a subject toward which you adopt a light-hearted attitude. Use a line that reinforces your playful mood. The figure is a particularly good subject since caricature-like distortions can be whimsical. You might use pen and ink or a felt-tip marker. Try turning the tool between your fingers as you draw. The resulting line quality can be unpredictable and playful. Remember it is a whimsical mood that you are trying to convey. In the student drawing (Fig. 200) the line quality seems particularly well adapted to the playful subject.

SUMMARY: Spatial Characteristics of Line

Although each problem in this chapter has generally been confined to the use of one kind of line, most artists do not limit their line so severely. You should experiment, employing several linear techniques in the same drawing.

Subjective lines are generally more dimensional than objective lines. This is because a subjective line changes width, changes from light to dark, and is more suggestive of space than a flat line of maintained width. Outlining makes shapes appear flat; contour line is more dimensional than outline.

A contour line of varying width and pressure is more dimensional than one of uniform weight. A discontinuous, or broken, line is more spatial than an unvarying one.

When line is stated primarily horizontally and vertically, that is, when it remains parallel to the picture plane, a shallow space results. If, however, lines penetrate the picture plane diagonally, a three-dimensional space is produced. Generally, a buildup of lines is more volumetric than a single line.

If lines are grouped in a single direction to create value, the resulting space is flatter than if the lines are not stated uniformly. Lines that create a repeating pattern of texture make a flatter space than those stated less predictably.

Again a reminder: You must analyze all the lines in a drawing in order to determine the entire spatial effect. Look at the line's spatial characteristics. Is it dark, light, thick, thin? Analyze the line quality in terms of contrast, weight, thickness, and movement, and determine what information concerning edge the line defines.

Finally, line is the most direct means for establishing style. It is, as we have said, as personal as handwriting. And like handwriting it should be practiced, analyzed, and refined throughout your drawing career.

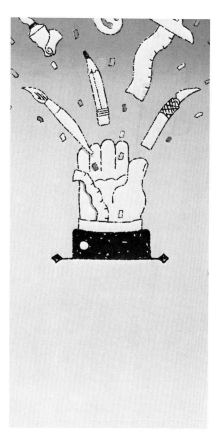

200. Whimsical line. Student work. Silkscreen, 18 × 6½″ (46 × 17 cm).

CHAPTER 6

Texture

Art depends on the strong relationship between the senses of sight and touch, between our visual sense and our tactile sense. We can imagine how a surface feels simply by looking at it, and we can also imagine how a surface looks by touching it. This mental sight-and-touch relationship is vital in all the arts, but it is especially important in the graphic arts, where we must rely on visual textures more than on actual tactile ones. Painting and sculpture are far more tactile than the graphic arts.

Texture, however, does play a highly active role in the graphic arts. The emphasis in drawing is more on visual textural effect; the contrasts between rough and smooth, between coarse and glossy, or between soft

and hard can be communicated without actually using glossy or rough media. Janet Fish in her drawing of fruit (Fig. 201) conveys the idea of various tactile surfaces. She has used pastels to suggest the crinkly plastic wrapping with its strong reflective surface, under which are oranges with their pebbled skin. The illustration is at second remove from the actual work (we see a reproduction of another reproduction, a print of a photograph), and even though the actual drawing is in color, the tactile element still comes through.

The textural quality in the pencil drawing by Sy Ross (Fig. 202) depends on the surface texture on which it is drawn, the texture inherent in the medium and the artist's control of that implement. A white pencil is the sole medium, yet Ross achieves a diversity of textures by his handling of the tool. These linear effects are even more noticeable since the marks are on dark paper; the value reversal points out the many changes in textural quality throughout the work. The textural quality of a work depends on the surface on which it is drawn, any additions made to the surface, the texture inherent in the medium, and the way the artist controls the medium.

Texture, like line and value, is a key art element. Even more than the other elements it gives information about materials and media. There are three basic categories of texture: actual, simulated, and invented. Of course, texture in its most literal meaning refers strictly to the sense of touch. This is the category of actual texture. For the artist, however, the visual appearance of a work, its surface quality, is most important. While this type of texture may have only a subtle tactile quality, it has a visual quality that contributes to the textural character of the work. We see how important texture is in Henry Whiddon's ink drawing of grass (Fig. 203). The drawing can be read on two levels—one as referring to a field of grass and the second, and most important, as a formal means; that is, the use of texture to organize the picture plane. While the blades of grass overlap, the uniformity of the lines creating the textural pattern tends to compress the space. The swaying linear motion activates the surface in a continuous-field composition.

201. Janet Fish. *Mixed Fruit.* 1973. Pastel on paper, 21¾ × 37½" (55 × 95 cm). Courtesy Robert Miller Gallery, New York.

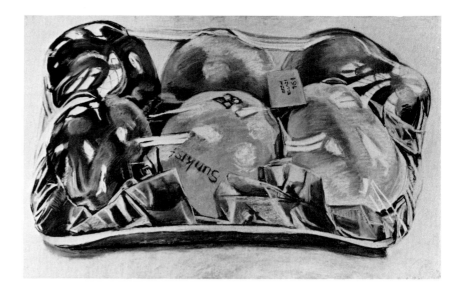

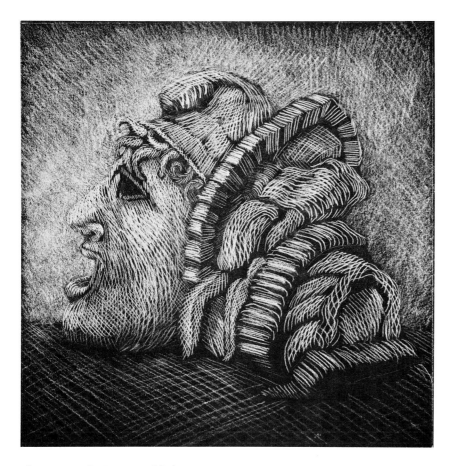

above: **202.** Sy Ross. *Untitled.* 1983.
Pencil on colored construction paper, 17½ × 18″ (44 × 46 cm).
Courtesy Serra di-Felice Gallery, New York.

below: **203.** Henry Whiddon. *Grass Series: SEBO.* 1980.
Ink, 20 × 32″ (51 × 81 cm). Courtesy the artist.

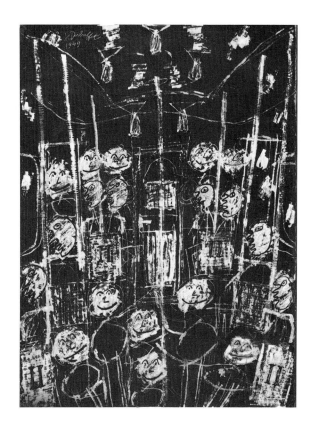

204. Jean Dubuffet. *Subway.* 1949.
Incised ink on gesso, on cardboard;
12¾ × 9¼″ (32 × 23 cm).
Museum of Modern Art, New York
(Joan and Lester Avnet Collection).

Actual Texture

Actual texture refers to the surface of the work (smooth or rough paper, for example), the texture of the medium (such as waxlike crayons, which leave a buildup on the surface), and any materials, such as fabric or paper, added to the surface.

In his work *Subway* (Fig. 204), Jean Dubuffet aims for a rugged textured effect. On the surface he masses gesso, plaster mixed with a binding material, on top of which he paints ink. The images are then scratched into the surface, a technique called *grattage.* Thus the actual texture of the surface combines with the incised shapes to carry out Dubuffet's primitive intent.

Pattern painters, such as Roger Brown, are greatly dependent on texture in their work. An example of the texture of the tool dominating the work is Brown's *Celebration of the Uncultivated—A Garden of the Wild* (Fig. 205). The pillowlike, softer shapes that create a repeating pattern in the background were made by an airbrush. A fuzzy, diffused edge is characteristic of this medium, which allows the artist a great deal of control over the thickness or thinness with which the paint is applied. The plants are flat, dark shapes that form a frieze along the bottom half of the painting. The background cloud/leaf shapes are modulated from light to dark within the individual shapes, and the shapes lighten as they meet the plants. The softness of the billowing forms contrasts with the precisely delineated plants; this textural reduction provides unity in the work.

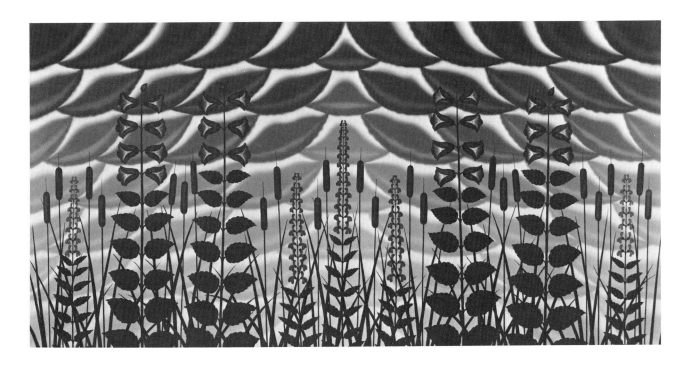

An example of the actual texture of a medium, one not easily recognizable without knowledge of the technique used, is *Smoke Drawing* (Fig. 206) by Otto Piene. Texture is created by holding the paper above a candle flame and controlling the carbon deposits that collect on the paper. This technique is called *fumage*. A stencil blocks out the white areas. By shifting the stencil and by controlling the thickness of the carbon deposits, overlapping dark and light circles are created. We sense a deeper space in the center of the work where the carbon deposits are thicker and where the circles seem to collide.

205. Roger Brown. *Celebration of the Uncultivated— A Garden of the Wild.* 1980. Oil on canvas, 5 × 10′ (1.52 × 3.05 m). Montgomery Museum of Fine Arts, Alabama.

206. Otto Piene. *Smoke Drawing.* 1959. Smoke, 19⅞ × 28⅛″ (50 × 71 cm). Courtesy the artist.

The style of the abstract expressionist painter Willem de Kooning can in large part be recognized by observing his textural surface. In his drawing *Woman* (Fig. 207) multiple blurred lines create a spatially ambiguous effect. De Kooning uses a similar technique in his thickly painted canvases. Implicit in de Kooning's drawing is a statement about the richness and ambiguity of woman. Texture, then, not only conveys information about the artist's medium but also gives information about subjective and expressionistic intent as well.

Finally, any real material added to the surface of the work also comes under the category of actual texture. We can divide such additive materials into two classifications: collage and assemblage. *Collage* is the addition of any flat material, such as paper or fabric, to the surface of a work. A term for pasting paper to the picture plane is *papier collé*. *Montage* is a technique that uses pictures or parts of pictures to create a composition. *Photomontage*, as its name implies, uses only photographs. Works using these techniques usually remain flat, although they can be built up in relief.

207. Willem de Kooning.
Woman. 1952.
Pastel and pencil, 21 × 14″ (53 × 36 cm).
Private collection, Boston.

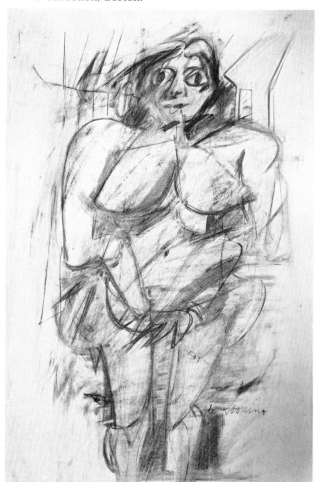

208. C. Kenneth Havis.
Self-Portrait, or That Personal Object Belongs to Me.
1979. Mixed media, height 16″ (31 cm).
Courtesy the artist.

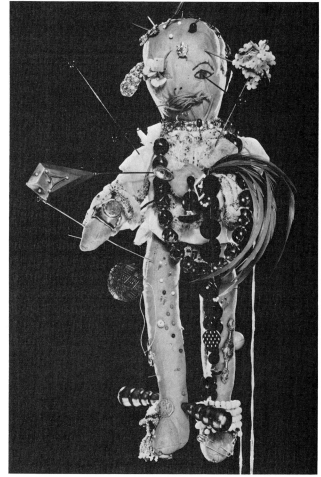

Assemblage is dimensional material attached by any means—glue, nails, wire, or rope, for example. Assemblage is not flat. Depending on the dimensional items added to the surface, an assemblage may range from a low relief to a free-standing, three-dimensional composition as in C. Kenneth Havis' contemporary fetish (Fig. 208).

Collage is widely used in 20th-century art. In Wilfred Higgins' composition (Fig. 209) the collage elements operate on two levels. They make flat shapes and values that become part of the total piece, and they remain autonomous; that is, they are still read as alien materials on the picture plane.

Suzanne Siegel pokes fun at the values of a consumer society in her photomontage *Our Lady of Strenuous Exercise* (Fig. 210). She uses religious illustrations and magazine ads to counteract the intended use of the original imagery. The feminist message is couched in a traditional format.

211. Tom Wesselmann. *3-D Drawing for Still Life # 42.* 1964.
Charcoal with real objects, 4′ × 5′ × 8″ (1.22 × 1.52 × .2 m).
Archer M. Huntington Art Gallery, The University of Texas at Austin
(Lent by James and Mari Michener).

Assemblage can combine both two- and three-dimensional ele-
ments. In Tom Wesselmann's charcoal *3-D Drawing for Still Life #42* (Fig.
211), which includes real objects, we have difficulty distinguishing the
real from the drawn. Without seeing the actual piece we can only specu-
late which objects are dimensional and which ones are illusionistically
dimensional. We can see that the shelf is an actual dimensional plane
that juts out from the wall, but are both bottles or only the one with a
drawn label real? This confusion is intended and is a result of the same-
ness of texture throughout the composition.

Another artist well known for his assemblages is Joseph Cornell. His
intimately scaled, well-crafted works are shadow box glimpses into a
private, intense world. In Figure 212 the dimensionality of the twigs com-
bines with a scale model of a building enriched by drawn architectural
ornament to produce an intricate and delicate "setting for a fairy tale," as
its title informs us. Cornell contrasts the actual texture of the twigs with
the simulated texture of the architectural embellishment. The discrep-
ancy in scale between the real and the drawn gives the work its surreal
quality.

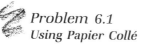

Problem 6.1
Using Papier Collé

For this problem, reassemble old drawings to create a new work.
For example, you might tear up old figure drawings and rearrange the

212. Joseph Cornell. *Setting for a Fairy Tale.* 1942–46.
Box construction, 11⅜ × 14½ × 4″ (29 × 37 × 10 cm).
Peggy Guggenheim Collection, Venice
(The Solomon R. Guggenheim Foundation).

pieces to make a landscape. Pay attention to the shapes of the torn paper and to the marks drawn on them. Paste the torn paper on a piece of supporting paper and redraw, integrating the *papier collé* into the work.

 Problem 6.2
Using Collage

In this drawing attach one element of collage, such as paper, fabric, or sandpaper; any flat material may be used. The collage piece may be of any size, but it should be highly tactile. Simulate the texture of the collage in two other areas of your drawing. Try to make the collage element indistinguishable from the drawn texture when viewed from a distance. Trick the eye into believing there are three pieces of collage.

 Problem 6.3
Using Assemblage

Combine various three-dimensional objects to build an assemblage. If you choose to make a *bas-relief,* a low relief of limited depth, you should use a sturdier surface than paper for the support; backing board will provide a stable ground. Having made the assemblage, paint the surface a solid color and incorporate drawing on some of the areas. (Painting the assemblage a solid color will help integrate the diverse three-dimen-

above left: 213. Robert Indiana.
The Great American Dream: Freehold.
1966. Conté crayon stencil rubbing,
40 × 26″ (102 × 66 cm).
Courtesy the artist.

right: 214. Jasper Johns.
Study for Skin I. 1962.
Charcoal on paper, 22 × 34″
(56 × 86 cm). Collection the artist.

above right: 215. Robert Rauschen-
berg. *Canto XXI,* "combine drawing"
for Dante's *Inferno.* 1959–60.
Gouache, collage, graphite,
red pencil, and wash;
14½ × 11½″ (37 × 29 cm).
Museum of Modern Art, New York
(Anonymous gift).

sional elements.) Be aware of the value changes that occur under different lighting conditions.

Crossover Texture

Related to both actual texture and simulated texture is the transfer of a texture from one surface to another, a technique called *frottage*. This transfer can be made by taking a rubbing from an actual textured surface or by transferring a texture from a printed surface onto the drawing. Transferred textures cannot clearly be categorized as actual texture or simulated texture because they possess elements of both; they belong to a *crossover* category.

In the rubbing *The Great American Dream: Freehold* (Fig. 213) Robert Indiana centralizes a large heraldic image for Americans. The rubbing movement diagonally from right to left creates an overall texture that flattens the space. Small areas of lighter value activate the space and break the otherwise insistent textural surface. The image is made static by its central placement and by the enclosed shapes, especially the closed circle. Such complete balance in the positioning of the image permits no movement. The stars above the image are likewise symmetrically placed, as is the rectangular shape of the word "freehold." Heraldry is a branch of knowlege that deals with family pedigrees and describes proper armorial insignia. Indiana's rubbing makes a droll comment on democracy by creating a heraldic emblem for Americans.

Another example of transfer can be seen in Jasper Johns' *Study for Skin I* (Fig. 214). Oily handprints and prints from three views of the face, front and sides, were pressed onto the paper, and charcoal was then wiped over the greasy images. The charcoal collected more densely in the grease-receptive spots to create an x ray-like image. The insert on the lower right suggests a laboratory report. The texture is a result both of the medium and of the transferred "skin."

Transfer from a printed surface is a popular contemporary technique. The image to be transferred is coated with a solvent and then laid face down onto the drawing surface and rubbed with an implement such as a wooden spoon, brush handle, or pencil. The directional marks made by the transfer implement provide additional textural interest in a drawing. Robert Rauschenberg uses this technique in his silkscreens and drawings. In *Canto XXI* (Fig. 215), based on Dante's *Inferno*, Rauschenberg combines rubbed transfer with gouache, collage, graphite, red pencil, and wash. The marks made by the implement in transferring the images provide textural unity for the composition. The overall sameness of line direction has the effect of flattening out the images. At the same time the streaked lines build on one another to make an agitated surface, creating a nervous movement throughout the work. Dante's *Inferno* is given a modern interpretation; war, quite literally, is hell. Texture along with image are the carriers of meaning.

Technology has introduced a technique claimed by artists—photocopy. This immediately accessible process depends on the texture inherent in the medium and the texture of the object being photocopied.

216. Drawing with photocopy and transfer. Student work.
Mixed media, 30 × 42" (76 × 107 cm).

 Problem 6.4
Using Crossover Textures

Choose several highly textured and patterned items. Make an arrangement of these objects and duplicate them on a photocopy machine. (You may compose directly on the duplicator.) Make at least five different compositions. Incorporate sections from each into a larger drawing. Use several textures from the crossover category, such as photocopy and transfer, in this drawing. Integrate these images into your composition by the use of other media. In the student drawing (Fig. 216) textural washes are used to unify the transfers and photocopies. The lightly gridded background spatially unifies the figures and the car; the negative space is read as a racetrack and the art historical figures become flagmen and jockeys in a cross-century race.

Simulated Texture

Simulated texture, as its name implies, is the imitation of a real texture. It has traditionally been used to represent actual appearance, and many contemporary artists continue to use texture in this way. Simulation can range from a suggested imitation to a highly believable trick-the-eye (*trompe-l'oeil*) duplication. In Tschang-Yeul Kim's *Waterdrops #23* (Fig. 217) we see a contemporary handling of this *trompe-l'oeil* technique. The

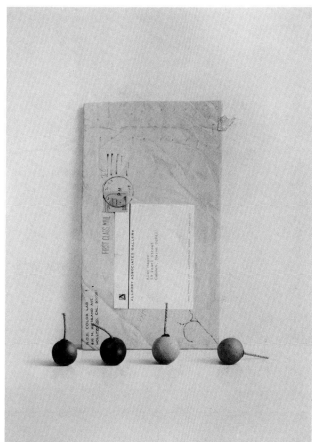

left: **217.** Tschang-Yeul Kim. *Waterdrops # 23.* 1976. Oil on canvas, 39⅜ × 28¾″ (100 × 73 cm). Private collection.

right: **218.** Alan Magee. *Smoke Balls.* 1981. Watercolor, 18 × 13½″ (46 × 32 cm). Collection Linda Bacon, Ross, Calif.

illusionistic drops are standing on the picture plane in a highly orderly fashion. We question whether the picture plane is horizontal or vertical. If the surface is vertical, the drops are about to fall; if the surface is horizontal, the drops are resting on the canvas. The artist has not disguised the texture of the canvas ground; he has, however, created an extremely illusionistic image on that ground.

In Alan Magee's *Smoke Balls* (Fig. 218) we see another realistic transcription of the objects. Magee's intent is to present objectively the textured surfaces of the packet and of the smoke balls. The objects in this still life occupy a shallow but believable space; Magee has duplicated a two-dimensional object (the letter) and three-dimensional objects (the smoke balls). Conceptually what is their relationship? The real function of smoke balls or smoke bombs is both to form a screen and to threaten danger. By placing the package from his gallery behind the potentially active balls, we equate the two; the envelope screens the message of rejection or acceptance of the artist.

219. Georges Braque.
Still Life on a Table. 1913.
Collage, 18½ × 24¾″
(47 × 62 cm). Private collection.

The achievement of an imitation of real textures, or *trompe l'oeil*, usually results in the illusion of a three-dimensional image. This simulation, however, can result in a more abstract, two-dimensional space as in Georges Braque's still life (Fig. 219), where the texture of the wood grain is imitated, not real.

 Problem 6.5
Using Simulated Texture
Choose as your subject a textured, two-dimensional surface, such as a floor, a broken sidewalk, a cracked asphalt street, a highly textured wall, or a woven fabric. Tape off an area 3 by 4 inches (8 × 10 cm) on your chosen surface. Exactly duplicate this found composition, enlarging it threefold to a 9-by-12-inch (23 × 31 cm) format, using whatever medium is appropriate for an accurate rendering. Be sure to take into consideration the changes that will occur as a result of the enlargement.

Invented Texture

Invented, or decorative, textures do not imitate textures in real life; the artist invents the textural patterns. Invented textures can be nonrepresentational line-and-dot patterns as in the textured shapes of Miguel Condé's ink drawing in Figure 220. They also may be abstracted, conventionalized textures to symbolize actual textures. Condé, for instance, uses symbolic texture for hair and fabric.

220. Miguel Condé. *Untitled.* 1975.
Pen and ink on 18TH century paper, 8 × 11½″ (20 × 29 cm).
Courtesy the artist.

Neil Welliver's etching *Brown Trout* (Fig. 221) uses conventionalized texture. We have no difficulty interpreting the groupings of parallel lines as rocks and water. The artist has invented textures of lines and dots to symbolize, or refer to, actual textures.

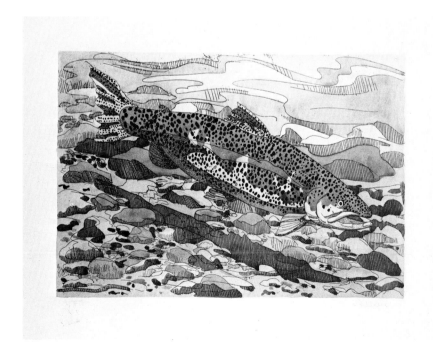

221. Neil Welliver.
Brown Trout. 1975.
Etching hand-colored with watercolor, 26½ × 36″ (67 × 91 cm).
Courtesy Brooke Alexander, Inc.,
New York.

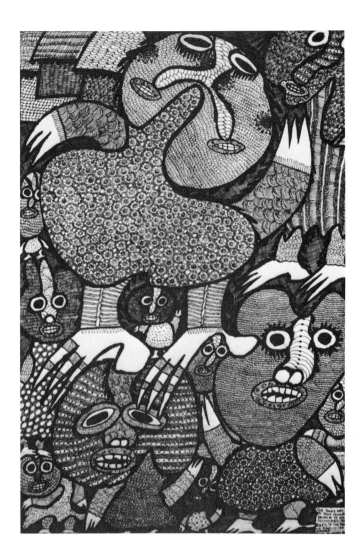

222. Michael Abyi.
*The Twins Who Killed Their Father
Because of His Properties.*
Ink on fabric,
33 × 22″ (84 × 56 cm).
Collection Claudia Betti.

Even more abstract are the textures in Michael Abyi's lively ink drawing on fabric (Fig. 222). His decorative line-and-dot patterning is used over the entire surface of the work. In this texture-filled composition, empty space is crowded out. The compact design is made up of repeating shapes and repeating textures that defy logic. The work's complexity is in keeping with its mythic subject, *The Twins Who Killed Their Father Because of His Properties.*

James Rosenquist's work is a good one with which to conclude the discussion of texture. In his lithograph *Iris Lake* (Fig. 223) he combines all three kinds of texture—actual, simulated, and invented. Texture is, in fact, the subject of the work. The image on the left is an example of invented texture; the image in the center simulates crushed paper; and the third image makes use of actual texture in the marks and rubbings. The pictorial space is ambiguous because the illusionistically three-dimensional elements are placed in a flat, white field. Are the shapes on top of the plane or are they holes in its surface? The black vertical lines reinforce this ambiguity.

223. James Rosenquist. *Iris Lake.*
1974. Lithograph,
3′ ½″ × 6′ 2″ (.93 × 1.88 m).
Courtesy Multiples, Inc., New York.

 Problem 6.6
Using Invented Pattern

Choosing an abstract subject, do a drawing that uses invented texture. Make a nonrepresentational line-and-dot patterning to create a variety of textured shapes. Organize your drawing so that similar shapes and textures attract one another.

 Problem 6.7
Using Conventionalized, or Symbolic, Texture

Represent various surfaces in an imaginary scene by means of conventionalized or symbolic texture. In Lois Werner's etching (Fig. 224) a variety of symbolic textures are indicated. Try to avoid the predictable in your inventions; do, however, aim for symbolizing real textures.

224. Lois Werner.
Bird Lady's Maiden Flight. 1982.
Etching, 5 × 8″ (13 × 20 cm).
Collection Claudia Betti.

225. Romare Bearden.
Eastern Barn. 1968.
Glue, lacquer, oil, and paper
on composition board,
4′ 7½″ × 3′ 8″ (1.41 × 1.12 m).
Whitney Museum of American Art,
New York (Purchase).

 Problem 6.8
Using Composite Textures

With a saltine cracker as your subject, repeat the image three times
in the same drawing. In one image render the texture of the cracker as
accurately as possible; simulate the cracker's surface. Keep in mind that
along with a change of scale comes a change in thickness. You might note
cast shadows along the edge of the cracker and its craters to help empha-
size its volumetric aspect. In the second image use invented texture to
symbolize the cracker's surface. Transform the third image by textural
change, using whatever means you choose. Do not use any image smaller
than 8 inches (20 cm). Maintain size and scale in the three images. You
might choose to draw on a long narrow piece of paper in either a hori-
zontal or vertical format.

SUMMARY: Spatial Characteristics of Texture

Generally, uniform use of textural pattern and invented texture results in
a relatively shallow space. A repeated motif or texture that remains con-
sistent throughout a drawing tends to flatten it.

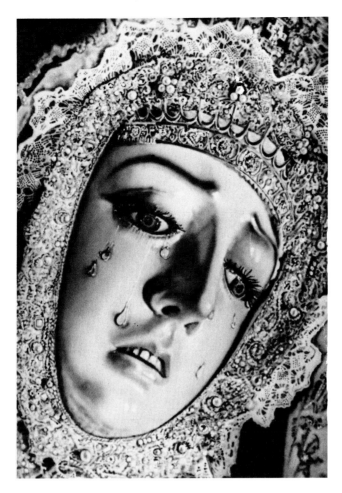

226. Audrey Flack.
Dolores of Córdoba. 1971.
Oil on canvas,
5′ 10″ × 4′ 2″ (1.78 × 1.27 m).
Courtesy Louis K. Meisel Gallery,
New York.

The use of simulated and invented texture in the same drawing results in arbitrary space, as does a combination of simulated texture and flat shapes. For example, in Romare Bearden's collage *Eastern Barn* (Fig. 225), the modeled hands in the center of the picture contradict the spatially flat shapes.

Simulated texture is illusionistically more dimensional than invented texture. If sharpness of textural detail is maintained throughout the drawing, space will be flatter. Diminishing sharpness of textural detail results in a three-dimensional space. Objects in the foreground that have clearer textural definitions than those in the background usually indicate an illusionistic space. In the Audrey Flack painting *Dolores of Córdoba* (Fig. 226) there is a sharper focus on the face, and especially on the tears, than on the surrounding headdress. The complicated texture around the face is somewhat blurred. This blurring, by contrast, emphasizes the sharpness of the details in the face.

In summation, simulated texture is generally more three-dimensional than invented texture. Repeated patterns or textural motifs result in a flatter space. Spatial ambiguity can result from a use of simulated and invented texture in the same work.

CHAPTER 7

Color

Color, more than any other element, sparks a direct, immediate response from the viewer. Color evokes associations and memories. Children intuitively seem to understand not only the aesthetic function of color but its symbolic significance as well. Even at the physical level we are affected by color. Certain colors make our heartbeats quicken while other colors are calming. We know that color need not be tied to an imitation of the real world; rather it can be used by artists and nonartists alike both psychologically and symbolically.

Attitudes toward color are culturally revealing. At certain periods of time people have expressed decided color preferences; for example, in

144

the 1960s Americans generally preferred clear, intense colors associated with advertising and television. In the 1980s Victorian color schemes for houses were making a popular return, a break from the preference for all-white houses that prevailed for many years. Even geography plays a part in color preference; certain colors seem to be right for specific climates, such as pastel colors in California and tropical towns or the rich range of grays in New York City.

Color Media

A word about color media and their application is in order before beginning a discussion of the terms and properties of color. Some appropriate color media for the beginning student are oil pastels, colored pencils, colored conté crayons, oil sticks, wax crayons, water-soluble colored felt-tipped pens, colored chalk, colored ink, and watercolor or acrylic for washes.

Experiments with color application should be based on the knowledge and experience you have already gained. Powdered media whether colored or not are applied in the same way. Colored pencils are used just like ordinary pencils. Of course, you have more options with color.

Avoid filling a shape with a single color unless you desire a flat, coloring book effect. Experiment with layering colors, with combining multiple colors to build a rich surface. Pastels can be smudged and layered. Do not neglect to combine media; you can incorporate charcoal, pencil, conté crayon, china markers, and ink with any and all of the colored media.

A good example of a mixed media drawing is Oldenburg's study for *The Stake Hitch* designed to dominate the barrel-vaulted central court of the Dallas Museum of Fine Arts (see Plate 1, p. 149). The drawing and the actually installed stake sculpture are dramatic, dynamic, and humorous at the same time. Oldenburg, in his highly recognizable style, has done a loose drawing using chalk and charcoal; fingerprints and smudges remain on the surface. Color, wet media applied only to the stake and rope, directs the viewer's attention to the monumental form. A message of weight and density is conveyed by selective placement of color. The tension at the top of the rope is less than at the spot where the rope is anchored by the stake.

Oldenburg applied the colored wash with a minimal number of strokes. Sometimes the charcoal marks are on top of the wash; at other times they lie under the transparent color. The artist has defined the planes of the stake with two values, one dark, one light.

The tip of the stake is installed in the museum's basement under the gallery floor. Along with the obvious suggestions of Texas cowboys and tent stakes, Oldenburg might be setting up the viewer to make a verbal pun: "having a stake in art." In the drawing, the stake-point on the lower level is analogous in shape to a pencil, and we conclude that the drawing is drawing itself. Oldenburg achieves multileveled layers of meaning by a most economical and conceptual drawing approach.

Because color is such an eye-catching and dominant element, do not forget what you have already learned about the role of shape, value,

line, and texture. Color can be used to develop a focal point; it can be used to lead the eye of the viewer through the picture plane; it can be used to create space. Look at other artists' drawings and incorporate new ideas and techniques into your own repertoire. Develop your own personal response to color.

Problem 7.1
Using Color Media

Choose two values of the same hue, in pastel or chalk. Make a drawing and place the accent with a wet media wash in no more than three areas. Use a still life with a plant or a vase of flowers as subject.

Color Terminology

Our discussion of color begins with some definitions and terms. Color has three attributes: hue, value, and intensity.

Hue is the name given to a color, such as violet or green.

Value is the lightness or darkness of a color. Pink is a light red, maroon a dark red. As noted in the chapter on value, a change of values can be achieved by adding white, black, or gray. A color can also be heightened, darkened, or modified by mixing or overlaying two or more hues. Note the modification of the yellow shapes in Richard Lindner's multimedia drawing (see Plate 2, p. 149). His value range of yellows is the result of layering thin transparent washes and of modeling with pencil and crayon. For Lindner, color is physical, dynamic, and vivacious.

Intensity refers to the saturation, strength, or purity of a color. The colors in Wayne Thiebaud's *Candy Ball Machine* (see Plate 3, p. 150) are so intense that they could have been derived from color television. It is as if the blues had been turned up to a high level of brilliance.

The *color wheel* is a circular arrangement of twelve hues (see Plate 4, p. 150), although one can imagine an expanded gradation of color. These twelve colors are categorized as primary, secondary, and tertiary. The *primaries* (red, blue, and yellow) cannot be obtained by mixing other hues, but one can produce all the other hues by mixing the primaries. *Secondaries* (green, orange, and violet) are made by mixing their adjacent primaries; for example, yellow mixed with blue makes green. *Tertiaries* are a mixture of primary and secondary hues; yellow-green is the mixture of the primary yellow and the secondary green.

Local color and *optical color* are two terms artists use in describing color. *Local color* is the known or generally recognized hue of an object regardless of the amount or quality of light on it, for example, the red of an apple, the green of a leaf. Elizabeth Butterworth's *Scarlet Macaw* (see Plate 5, p. 151) is an illustration of local color. The bird is meticulously observed and rendered according to the rich colorations of its plumage. The local color of an object will be modified by the quality of light falling on it. Bright sunlight, moonlight, or fluorescent illumination can change a color. If, for example, we imagine the macaw under moonlight, the intense red, the local color of the bird, might change to a deep red-violet, and we would call this its *optical*, or perceived, color. The distinction

between local and optical color is that one is known (conceptual) and the other is seen (perceptual).

Problem 7.2
Using Local Color

In this problem you are to duplicate as closely as you can the actual, or local, color of an object. In verbal descriptions of the color of an object, it is usually enough to name a single hue, as in "a red apple." But an artist must describe the apple more accurately, using more than one hue.

The subject of this drawing will be, in fact, a red apple. Tape off a segment on the surface of the apple—a rectangle 2 by 3 inches (51×8 cm). Using pastels, make a drawing of this selected area, enlarging the section to 18 by 24 inches (46×61 cm). Use a buff-colored paper; manilla paper is a good choice. The drawing will be a continuous-field composition, focusing on color and textural variations.

Examine the portion of the apple to be drawn very carefully, analyzing exactly what colors are there. You may see that there is an underlying coat of green, yellow, maroon, or brown. Tone your paper accordingly and build the surface of your drawing using layers, streaks, dabs, and dots of pastels. The longer you draw and look, the more complex the colored surface will appear. Sustain this drawing over several drawing sessions. If you extend the drawing time to several days, you will find the apple itself has undergone organic changes and will have changed colors as a result. Adjust your drawing accordingly.

Color Schemes

Color schemes require a special terminology. Although there are other kinds of color schemes, we will discuss only monochromatic, analogous, complementary, and primary color schemes. A *monochromatic color scheme* makes use of only one color with its various values and intensities. An *analogous color scheme* is composed of related hues—colors adjacent to one another on the color wheel, as for example, blue, blue-green, green, yellow-green. Analogous color schemes share a color; in the example just given, the shared color is blue. In most instances the shared color will be a primary.

Complementary color schemes are based on one or more sets of complements. Complementary colors are contrasting colors, which lie opposite each other on the color wheel. Blue and orange, red and green, yellow-green and red-violet are complements.

Complementary colors in large areas tend to intensify each other. Small dots or strokes of complementary hues placed adjacently neutralize or cancel each other. The viewer blends these small areas of color optically and views them as a grayed or neutralized tone.

We might think of Jim Dine's *Red Glove* (see Plate 6, p. 151) as a complementary color scheme, if we consider the flesh tones and glove to fall within the red-orange range. The background is a monochromatic blue. The figure seems to be drowned in a wash of blue with the chalky

flesh tones emerging from the blue field. Background and foreground tones are mutually modified.

Not only does a color scheme organize a work by directing the eye of the viewer (like attracts like), but a color scheme is also the carrier of meaning in a work. The California artist William T. Wiley uses a primary color scheme in *Your Own Blush and Flood* (see Plate 7, p. 151). Not only do we find a primary color scheme and a primary triad (yellow, red, and blue), we find triads abounding in the work. Triangular forms are everywhere: three-pronged, forked limbs, a triangular table top; on one of the three central blocks are three symbols, one of them a triangle. There are three cut logs behind the bucket. Are we to surmise, then, that the three-color scheme has symbolic meaning? Much of Wiley's work relies on paradox, on something being two things at once. Wylie learned from Zen Buddhism that opposites are reconciled when seen as a part of a continuous chain. (Are not the fans and spirals a visual metaphor for this chain? And since the palette has an analogous shape to the fans, can Wylie be giving us a clue as to the important role of art in the continuity of life?) Wylie's work is full of contradiction, complexity, humor, and metaphor. So engaging is it that we don't escape easily; he traps us into attempting to interpret the allegory.

Wylie directs us through his allegorical maze by both shape and color; the reds call our attention from one object to the next, while the complicated blue value patterns unify the jumbled composition. The crystalline colors are in keeping with the fragmented, broken quality of the images. The brittle, jagged edges echo the fragmentation inside the picture plane. Is Wylie saying this is just a part, a fragment, of the greater picture, metaphorically speaking? He presents clues for interpretation grounded in the triangular forms; he offers reconciliation through the triad.

We have by no means exhausted the number of color schemes available to the artist. The chosen color scheme contributes to the overall mood and meaning in a work. Not only are these color schemes related to aesthetics and to the psychology of color, but they must suit the demands of the artist's own personal vision.

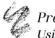 *Problem 7.3*
Using a Monochromatic Color Scheme

Choose a black and white photograph, one that has wide value range. Enlarge the photograph to a drawing with no dimension smaller than 18 inches (46 cm). Duplicate the values, using a monochromatic color scheme; for example, convert the photograph to an all-blue or an all-red drawing. Carefully match the values in the photograph, noting the value variations within a given shape. Use a wet medium such as watercolor, colored ink, or acrylic paint.

Before beginning the actual drawing, analyze the photograph to determine the number of values used; then make a value scale for your chosen color. Mix the full range of values in separate containers before applying the color to the paper; in other words, do not mix the values on the paper. You are to be in control of the values before placing them in the drawing.

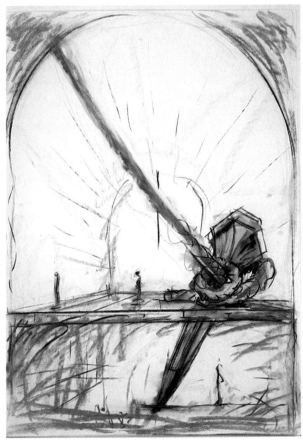

Plate 1. Claes Oldenburg. *Study for The Stake Hitch in the space of the Dallas Museum of Art,* with figures for scale. 1983. Charcoal, chalk and watercolor, 40¹⁄₁₆ × 29³⁄₁₆″ (102 × 74 cm). Collection of the artist.

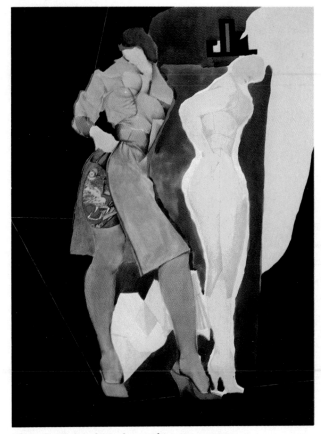

Plate 2. Richard Lindner. *Skirt Open.* 1964. Watercolor, pencil, crayon and collage, 31¾ × 23¾″ (79 × 59 cm). Private collection.

149

Plate 3. Wayne Thiebaud.
Candy Ball Machine. 1977.
Gouache and pastel on paper,
24 × 18″ (61 × 46 cm).
Collection John Berggruen,
San Francisco.

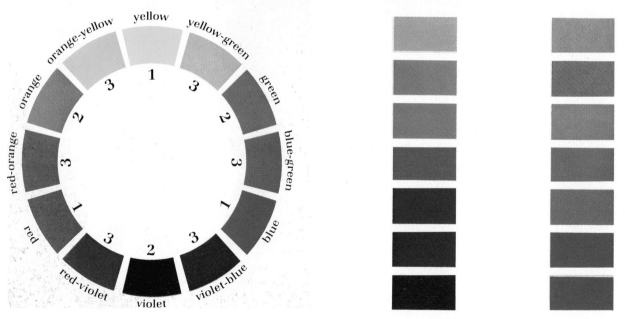

a. Hue b. Value c. Intensity

Plate 4. The major elements of color: hue (as expressed in the color wheel), value, and intensity.

150

Plate 8. Lucas Samaras.
Untitled. 1962. Pastel.
15½ × 19″ (39 × 48 cm).
Courtesy The Pace Gallery,
New York.

Plate 9. Willem de Kooning. *Woman.*
1952. Pastel, pencil and charcoal,
14 × 12⅜″ (33 × 31 cm).
Los Angeles County Museum of Art
(purchased with funds provided by
the estate of David E. Bright, Paul
Rosenberg & Co., and Lita A. Hazen).

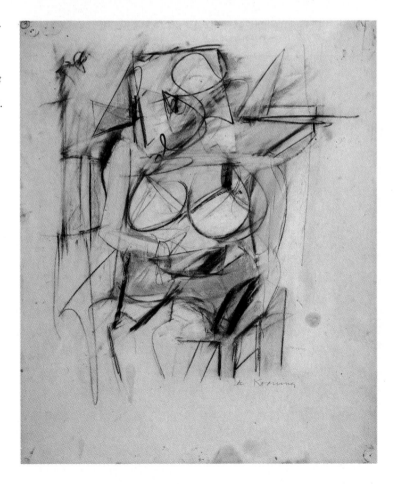

Problem 7.4

Using a Complementary Color Scheme

Draw a landscape with colored pencils or oil-based crayons. Use a complementary color scheme, a color scheme of opposites, with no fewer than three values of each complement. You can mix the opposites to change intensity and use white to change value. You will be using color arbitrarily.

Arrange your composition so that in some areas the complements intensify each other. In other parts of the drawing, by using dabs of color, make the complements neutralize each other. Experiment with various intensities and values and their relationships with their opposites.

By changes in value and intensity, you can make a color appear to advance or recede, expand or contract. Can you reverse the expected function of color? For instance, can you make a red shape appear to recede rather than to come forward as you would expect?

Warm and Cool Colors

Colors can be classified as warm or cool. Warm colors, such as red, orange, or yellow, tend to be exciting, emphatic, and affirmative. In addition to these psychological effects, optically they seem to advance and expand. Cool colors—blue, green, or violet—are psychologically calming, soothing, or depressive, and unemphatic; optically they appear to recede and contract. These characteristics are relative, however, since intensity and value also affect the spatial action of warm and cool colors. Intensely colored shapes appear larger than duller ones of the same size. Light-valued shapes seem to advance and expand while dark-valued ones seem to recede and contract.

We can observe some of these effects in the Lindner drawing (see Plate 2, p. 149). The yellow triangular shape adjacent to the figure's right leg seems to be closer to the viewer than the adjoining shapes, all of which are darker and less intense. The red strips on either side of the figure abruptly halt the recession of the figure into space; in addition, the repeated figure is ambiguously located. Since this shape is somewhat smaller than the central figure, we read it as occupying a background space, but since this secondary figure is a light, intense yellow, it seems to come forward. (Note the spatial relationship between the three feet.) Lindner's complex and contradictory spatial arrangement is primarily a result of his use of color—warm and cool, intense and dull, dark and light—to perform spatial functions.

Lucas Samaras' pastel drawing demonstrates how color conveys not only a sense of space but also mood (see Plate 8, p. 152). His work has a deep, troubling attraction. Warm colors are predominant in the interior space; a cold blue sky defines the looming mountain seen through the window. We are confronted with a psychically disturbing image. The intense blue halo and a blood red moon, oozing yellow light, form a tight primary triad atop the stark mountain. The background space is flipped forward; it advances even into the room. We sense the outside sneaking in. Look at that intense, light blue form creeping over the window sill.

The complementary patterning of reds and greens activates the dense purple wall and reinforces the somber mood of the drawing. We are firmly placed directly in front of the window, yet the intrusion of a tabletop in the lower left tells us we are suspended above the table. The saturated red of the table seems to swallow the small, dark purple vase. The red and greens of the flowers meld with the wall pattern, thereby fusing the distance between foreground and background. A seemingly simple composition forces a complex interpretation of space. The final effect of this window-into-space is that the window opens not outward but inward to an internal landscape. Samaras' attack is a frontal one; he forces us to see his drawing as a set of interlocking contradictions— torrid and somber, warm and cool, in and out, dead and alive, dimensional and flat, patterned and plain, equivocal and straightforward, large and small—and color is his primary ally.

 Problem 7.5
Using Warm and Cool Colors

In this problem you are to use two sources of light, one warm and one cool. Seat the model in front of a window from which natural, cool light enters. On the side of the model opposite to the window, place a lamp that casts a warm light. Alternate the light sources; draw using the natural light for three minutes; then close the window shade and draw using the warm artificial light for three minutes. Continue this process until the drawing is completed.

Use colored pencils or pastels and no fewer than three warm colors and three cool colors. There will be areas in the figure where the warm and cool shapes overlap; here you will have a buildup of all six colors. Work quickly, using short strokes, overlapping color where appropriate. Focus on drawing the light as it falls across the form. You are to draw the light, in the negative space and on the figure. Do not isolate the figure; draw both negative and positive forms. Try to imagine the light as a colored film that falls between you and the model. Do not use black for shadows; build all the value changes by mixing the warm and/or cool colors.

Note how the short strokes unify the drawing and limit the space. By concentrating on the quality of light, you will find that you can achieve atmospheric effects.

How Color Functions Spatially

The spatial relationships of the art elements and the ways each element can be used to produce pictorial space is a continuing theme in this text. Color, like shape, value, line, and texture, has the potentiality to create relatively flat space, illusionistically three-dimensional space, or ambiguous space.

You have seen in the Lindner drawing (see Plate 2, p. 149) that when flat shapes of color are used, when colors are confined to a shape, a flatter space results. But when colors are modeled from light to dark, as in the Dine drawing (see Plate 6, p. 151), a more volumetrically illusionistic space results. Dine's *Red Glove* is an interesting combination of dif-

ferent kinds of space. At the top of the picture plane Dine has attached an actual three-dimensional glove, which strangely blocks out the figure's eyes (and her vision). It is as if Dine is forcing us to concentrate on the tactile quality of the drawing. There are four kinds of space in this mixed-media work: the actual dimensions of the glove, the illusionistic modeled volumes of the upper torso, the ambiguous spatial relationship between the implied shape of the legs and the background, and the two-dimensional space of the paper itself in the lower fourth of the picture plane.

Dine's drawing is on handmade paper, itself tactile and dimensional with its rough, raised, and pitted surface. The background wash is absorbed by the paper except in the lower right where drips of paint lie on the surface. The figure emerges from the paper much like a sculpture from a block of stone.

Colors contribute to a three-dimensional illusion of space not only when they are modeled from light to dark but when brighter colors are used in the foreground and less intense ones in the background. Thiebaud depicts a variety of texture in his *Candy Ball Machine* (see Plate 3, p. 150); the forms are modeled volumetrically with wet and dry media. Those nearest us are more distinct and focused; those farther away are blurred and indistinct, yet the color flattens the drawing. Although Thiebaud uses intense colors, his nuances are of an unexpected nature. Seemingly simple and direct, his work rewards a prolonged inspection. One discovers not only a fine drawing technique, unexpected color combinations, a rich textural surface, but a tongue-in-cheek message which, among other things, concerns colored dots of the most commonplace origin caught in the artist/magician's crystal ball.

When flat color shapes and modeled color volumes are used in the same composition, an ambiguous space results. Also when bright colors occur in the background of an otherwise three-dimensional shape, an ambiguous space results. Lindner has carried this behavior of color to its limit; in fact, it becomes the very essence of his style. Form is the thematic focus of his work (see Plate 2, p. 149).

When colors cross over shapes, a flattening takes place, making space ambiguous. This effect can be seen in Willem de Kooning's drawing (see Plate 9, p. 152). The colors and lines are slurred. Although the figures are conceptually monumental, they occupy a very ambiguous space. Occasionally in de Kooning's work a color is confined to a shape, as in the breasts of the two women, but generally, colors, values, lines, and shapes cross over both positive and negative space, creating an ambiguous space. De Kooning's women, in spite of their ambiguity, convey a spontaneous physical immediacy and presence. This physicality is the result of his unabashed use of sweet, sensual colors.

Influences on Contemporary Attitudes Toward Color

Because our current attitudes toward color have been shaped by earlier artists, a quick survey of some innovations in their treatment of color during the last hundred years is in order.

We might begin with what has been called the "revolution of the color patch," the revolutionary way the Impressionists applied color. With Impressionism in the late 19th century, artists began depending on more purely visual sensations. Their concern was the way light in its multiple aspects changes forms, and their approach was scientific in many respects. Recording the stimulation of the optic nerve by light, they began working outdoors directly from nature, using a new palette of brighter pigments and purer colors, applying them in broken patches. Dark shadows were eliminated, local color was ignored, and local values or tones were abstracted to create atmospheric effects.

The Impressionists were innovators in color application, applying it in perceptible strokes unlike the smooth, brushed surface that characterized most earlier works. The outlines of objects were blurred in order to make them merge with their backgrounds. Volumes were diminished in favor of describing the effect of light over a form. These quick, broken strokes, suggesting the flicker of light, resulted in a sameness or uniformity in the overall texture that flattened the image and created a compressed space. Such strokes had the added bonus of allowing the artists to work more directly to keep pace with the changing light. The Impressionists saw that color is relative; when light changes, color changes.

The Post-Impressionists continued their predecessors' investigations into color. They used complementary colors in large areas to intensify each other and in small dabs to neutralize each other. They interpreted shadow as modified color, not simply as black or gray; and they made use of optically blended color. The viewer blends colors visually; a dab of red adjacent to a dab of green will be blended by the eye to appear gray. These complementary hues in small contrasting areas also made for greater luminosity and greatly enlivened the surface of the paintings.

Early in the 20th century a group of painters called the Fauves (Wild Beasts), who were familiar with the color advances of the Impressionists and Post-Impressionists, renounced the pretense of re-creating reality and began a subjective and symbolic investigation of color. They sought a heightened reality more exaggerated than actual appearances. The Fauves used flat, pure, unbroken color to further limit traditional perspective, depth, and volume.

Wassily Kandinsky, a contemporary of the Fauves, carried the freeing of color a giant step forward into abstraction. In placing emphasis on form and color, he left representation of objects behind. His goal was to infuse shapes that had no reference to recognizable objects with a symbolic and metaphysical intensity, and he saw that the most direct means of achieving that goal was through the use of color. His memoirs open with the sentence, "In the beginning was color."

Expressionists throughout this century—the German Expressionists before World War I, the Abstract Expressionists in the 1940s and 1950s, and the Neo-Expressionists in the 1980s—have all used color to underline their own emotional responses. Strong contrasting colors applied in thick slashing strokes give urgency to a charged content.

The Color Field artists in the 1960s saw that they could communicate essentially through color alone. Reducing their formal means, limiting shape, line, value, and texture, they depended on color to carry the

weight of the work both in form and in content. Certainly the Color Field painters can be said to be dealing with the physiological effects of color noted at the beginning of this chapter. The scale of these artists' works is so large that even our peripheral vision is encompassed. Envisioning the difference between a spot of red on a wall and an entire wall of red will enable you to understand better the concept of enveloping color. We are absorbed by the expanse of color and by the field of color in the painting; experience and vision are one.

The strategy of the Pop Artists in the 1960s and 1970s was to use technology and common objects in a man-made environment as sources of technique and imagery. They used advertising techniques and established a new palette based on color television and advertising layouts. Colors were intensified, often quite garish.

The Photorealists use film colors to establish their color. Taking their color schemes directly from the photograph, they present the viewer with an alternate means of establishing reality or verification. Image, color, and technique are derived from photography.

In contemporary art, color maintains its decisive role. All of the earlier uses of color are exploited—its representative, emotive, psychological, and symbolic impact—for its subjective and objective functions.

The overriding lesson that contemporary artists have learned is that color is relative. Through a lifetime of experimentation Josef Albers investigated the relativity of color. In his theoretical writing and in his work he offered ample proof that color is not absolute but interacts with and is affected by its surroundings. Since colors are always seen in a context, in a relationship with other colors, artists must make use of this knowledge of color relationships.

 Problem 7.6
Studying Influences on Contemporary Color Attitudes
Go to the library and find two or three examples of the historical styles that have formed our attitudes toward color (Impressionism, Post-Impressionism, Fauvism, German Expressionism, Abstract Expressionism, Color Field, Pop Art, Photorealism, and NeoExpressionism). Look at one book on Kandinsky and one on Albers.

Pay special attention to color relationships and to color application. Reread this section while looking at the art work from the period. You need not limit your search to drawings, because the artist uses color in much the same way whether the work is a painting, a drawing, or a print.

 Problem 7.7
Using Symbolic Color
Choosing an imaginary scene or event as a subject, establish a personal color symbolism in your drawing. Use color to enhance the subject both visually and symbolically. Consider what personal associations you have with the color along with its more universal symbolic significance. Try to weld message and color; aim for a formal and conceptual integration of color.

Use mixed media, such as colored pencils and ink. Choose media and technique that allow full expression for the development of your idea

Problem 7.8
Using Color-Field Composition

On a large format, one that is twice as wide as it is tall, divide the picture plane in half. On one side of your paper make a drawing using a recognizable subject; on the other side use a continuous field of color. Aim for the same feeling on both sides. On one side you can convey your message by using images and color; on the second side you are limited to color as the carrier of the meaning.

Using a medium of your choice, give careful consideration to the exact color you need, not only to the hue but to its proper value and intensity. You may layer the color in washes, you may build the color in overlapping strokes, or you may use a saturated single color. Try to achieve the effect you want by this continuous field of color. Think of the color in psychological and symbolic terms; determine what you think the physiological effects might be.

Look at some work by the Color-Field painters such as Mark Rothko or Barnett Newman. Make a list of adjectives describing the mood or feeling the work elicits.

SUMMARY: Spatial Characteristics of Color

In the 20th century we find art works that give the illusion of three-dimensional space, works that are relatively two-dimensional, and works that are spatially ambiguous. Color is one major determinant of spatial illusion.

When flat patterns of hue are used, when colors are confined to a shape, the shapes remain relatively parallel on the surface of the picture plane. On the other hand, when colors are modeled from light to dark, a more volumetric space results; and when bright colors are used in the foreground and less intense values are used in the background, color contributes to a three-dimensional illusion of space.

As a general rule, warm colors come forward and cool colors recede. This rule, however, is relative since the intensity and value of a hue may affect the spatial action of warm and cool colors.

When flat color shapes and modeled color volumes are used in the same composition, an ambiguous space results. When bright colors occur in the background of an otherwise three-dimensional work, the background will seem to come forward, flattening the picture plane to some extent. Also when colors cross over shapes, a flattening takes place, making space ambiguous.

CHAPTER 8

Spatial Illusion and Perspective

Chapters 3 through 7 dealt with the spatial relationships of the art elements and the ways each element can be used to produce pictorial depth, the illusion of space. Pictorial space may be relatively flat, illusionistically three-dimensional, or ambiguous, depending on how shape, value, line, texture, and color are used. In some drawings, images seem to jut out toward the viewer; in others the objects seem to recede; forms may appear volumetric or flat. Objects and figures may even seem to occupy a jumbled, fragmented, illogical space.

Space is an essential ingredient in all the visual arts. In architecture we are actually contained by the space of the building; in sculpture we move around the work to see it in its entirety; and in painting and in the graphic arts, where space is pictorial, we are presented with an illusion of space.

Our ideas about space have changed radically in the 20th century as scientific exploration of space has exceeded the most active speculations of the last century. Along with this new knowledge and discovery, the ways artists depict space have changed also. Our relationship to the world is no longer as human-centered as it was in Renaissance times, for example, when the humanistic philosophy that "man is the measure of all things" prevailed.

Our conception of an expanding universe and the new ideas of quantum mechanics have resulted in an ambiguous notion of space, so it is no wonder that many artists today use ambiguous space in their works.

This is not to say that an artist always predetermines the kind of space used in a work. Space can be intuitive, not accidental. This intuitive response comes not only from a cultural base but from a private, personal one as well. Other considerations, such as subject and intent, also enter into the decision.

You, as an artist, must have an understanding of space in order to analyze both your own work and the work of other artists. This understanding gives you wider choices in meaning and technique; knowing which techniques give the effect of two-dimensional, three-dimensional, or ambiguous space keeps you from making unintentional contradictions in your work. Knowledge of how the elements function will help you carry out your intention.

In this chapter you will take a look at perspective, that convention of representing three-dimensional objects as they recede into space on a two-dimensional surface. According to this convention, objects appear larger or smaller in relation to their distance from the viewer. This recession into space can be relayed by the artist according to certain rules. Some knowledge of perspective is invaluable to the artist, but it also has limitations. Perspective should be used as an aid in seeing, not as a formula to be substituted for visual acuity.

left: **227.** Judy Youngblood.
Foreign Correspondants #1. 1979.
Etching with aquatint and drypoint.
Image: 11¾ × 14¾" (30 × 37 cm)
on paper 20 × 26" (50 × 66 cm).
Courtesy the artist.

right: **228.** Judy Youngblood.
Foreign Correspondants #2. 1979.
Etching with aquatint and drypoint.
Image: 11¾ × 14¾" (30 × 37 cm)
on paper 20 × 26" (50 × 66 cm).
Courtesy the artist.

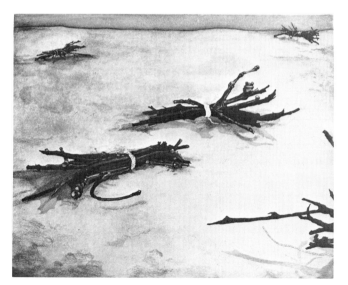
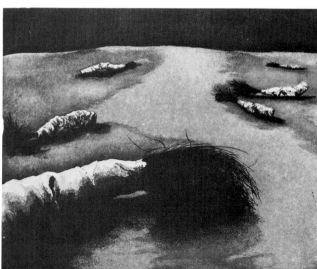

Eye Level and Base Line

One important matter that the artist must consider in the treatment of space is the use of eye levels. An *eye level* is an imaginary horizontal line that is parallel to the viewer's eyes. When we look straight ahead, this line coincides with the horizon. If we tilt our heads, if we move our *cone of vision*, or angle of sight, to a higher or lower position, this eye-level line will also change on the picture plane, thereby making the horizon line seem higher or lower.

Another important consideration is *base line*, the imaginary line on which an object sits. Base line and eye level are closely related. If all the objects in a given picture share the same base line, that is, if the base line remains parallel to the picture plane, space will be limited. If objects sit on different base lines, and if these lines penetrate the picture on a diagonal, the resulting space will be deeper.

In Judy Youngblood's suite of etchings *Foreign Correspondants*, horizon lines, eye levels, and base lines play a crucial role. The horizon is placed progressively lower in each print. In Figure 227 bundles of twigs are distributed in a random fashion. In Figure 228 the horizon line is slightly lower; the objects are situated on either side of a double curve leading into a deep space. Here the location of the viewer is somewhat ambiguous; the nearest object seems to be simultaneously seen from above and below. This figure of wrapped hair intrudes on the viewer's space; it is cut off by the lower left corner.

In Figure 229 the horizon line has been lowered considerably, and the stuffed sacks are less ominously placed; space is somewhat limited. In Figure 230 the bags have sprouted legs. (Twigs from Figure 227 seem to have combined with bags from Figure 229 to produce striding anthropomorphic figures.) These figures occupy different base lines on a low horizon. The figures seem to be standing on the "rim" of the horizon. Cast shadows connect the objects in a series of diagonal lines that penetrate

left: **229.** Judy Youngblood. *Foreign Correspondants #3.* 1979. Etching with aquatint and drypoint. Image: 11¾ × 14¾" (30 × 37 cm) on paper 20 × 26" (50 × 66 cm). Courtesy the artist.

right: **230.** Judy Youngblood. *Foreign Correspondants #4.* 1979. Etching with aquatint and drypoint. Image: 11¾ × 14¾" (30 × 37 cm) on paper 20 × 26" (50 × 66 cm). Courtesy the artist.

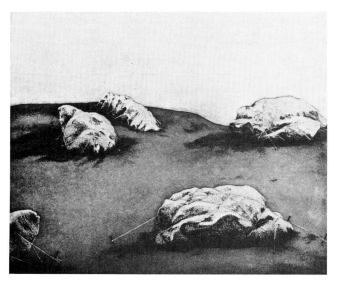

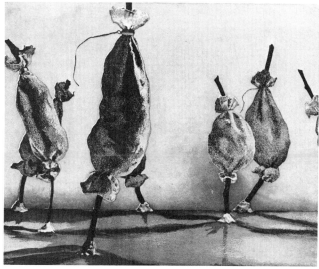

the picture plane. In the final etching in the suite (Fig. 231), the stuffed bags all hang from a line just outside the top of the picture plane. Space is activated by each bag's being a different size and by the bags' not being exactly aligned at the bottom of the print. Space is modeled from a rich black at the top of the composition to a lighter value along the bottom edge. Spatial depth is limited from foreground to background, but a tremendous sense of gravity is conveyed in the handling of the image. Value is of extreme importance as a conveyor of space in these prints. The suite is predominately tonal and the modeling of the space is deftly handled.

The images in the five prints are made from objects that are intimately associated with both the artist and her environment. Tableaux are arranged from which drawings and occasionally photographs are made. Spatial manipulation—variations in eye level and base lines—is of utmost importance in Youngblood's work.

Keep in mind that eye level is only one determinant of pictorial space. The space an artist uses is relative; it is not possible to determine the spatial quality of a work by eye level alone. In fact, the same eye level can result in a shallow or deep space depending on other determinants in the work, such as scale, proportion, texture, value, and color.

Problem 8.1
Using Eye Level and Base Lines

In your sketchbook invent some organic, bonelike forms. Try to imagine what they would look like from various angles as they turn into space. Concentrate on making them volumetric. Imagine a single light source; employ cast shadows to enhance the forms' three-dimensionality. Using several of the volumes that you have invented, do a series of drawings in which you employ different horizon lines. In the first, arrange the forms on a low horizon line. Take note of their base lines. Remember that if all the forms share the same base line, that is, if they are lined up along a single line parallel to the picture plane, space will be limited. Diagonals penetrating the picture plane will result in a more three-dimensional spatial illusion.

left: **231.** Judy Youngblood. *Foreign Correspondants #5.* 1979. Etching with aquatint and drypoint. Image: 11¾ × 14¾″ (30 × 37 cm) on paper 20 × 26″ (50 × 66 cm). Courtesy the artist.

right: **232.** Aerial perspective. Student work. Pencil, 15 × 15″ (38 × 38 cm).

In a second drawing raise the horizon line; locate it somewhere in the middle third of the picture plane. Be aware of manipulating the viewer's stance. Is the viewer seeing the forms from above or from below? Again, use a light source outside the picture plane to achieve the effect you desire.

In the remaining drawings of the series, experiment with placements of horizon lines.

Aerial Perspective

Depicting atmospheric conditions can convey a sense of depth. Aerial perspective is one means by which the artist creates spatial illusion. In *aerial perspective* objects in the foreground are larger and their details are sharp, while those in the background are diminished and less distinct. As the objects recede into space their color and value become less intense and their textures less defined. Note these effects in the *Foreign Correspondants* suite (see Figs. 227–231) earlier in this chapter.

Problem 8.2
Using Aerial Perspective

In a landscape drawing, distribute the forms so as to achieve a progression of space. Employ overlapping forms, diminution of size as the forms recede, blurring in focus from front to back, and change in texture from foreground to background as devices by which you can control space and create a sense of atmosphere (Fig. 232).

Linear Perspective

Perspective assumes a fixed point of view, so it is important that you remain relatively stationary in order to make a consistent drawing.

In order to use perspective it is necessary first to establish a horizon line. Imagine there is a pane of glass directly in front of you. This glass is perpendicular to your sight line. If you look up, the horizon line is below the direction of your sight; if you look down, the horizon line is above your sight line. The pane of glass always is perpendicular to your line of vision.

This pane of glass represents the picture plane; you are transferring the visual information seen through this imagined glass onto your drawing surface.

Your viewing position is of utmost importance in perspective. Two relationships are crucial: one, your distance from the subject being drawn, and two, your angle in relationship to the subject. Are you directly in the front middle and parallel to the subject, or are you at an angle to it?

The horizon line should always be located even if it falls outside the picture plane. Its position will describe the viewer's position—whether the viewer is looking up, down, or straight ahead.

Perspective hinges on the fact that lines that in reality are parallel and moving away from us appear to meet at some point on the horizon. That meeting place is called the *vanishing point*, or the point of convergence. Parallel lines of objects above the horizon line will converge downwards; those of objects below the horizon will converge upwards. Lines perpendicular and parallel to the picture plane do not converge unless the viewer is looking up or down, tilting the picture plane.

Once the horizon line has been determined, finding the vanishing point is relatively easy. Simply point with your finger, tracing the direction of the receding lines until you reach the horizon line. The vanishing point is located at the juncture of the traced line and the horizon line. True *one-point perspective* will have a single vanishing point in the middle of the picture plane.

If you are standing in front of a building parallel to the picture plane and you move to the right or left so that the building is seen at an angle, you will have changed to a *two-point perspective*. There are now two sets of parallel lines, each having a different vanishing point. There may be multiple vanishing points in two-point perspective; any number of objects set at an angle to the picture plane can be drawn, and each object or set of parallel lines will establish its own vanishing point.

Objects in *three-point perspective* have no side perpendicular to the picture plane, so there will be three sets of receding parallel lines, which will converge to three vanishing points, two sets on a horizon line and one set on a vertical line.

 ### Problem 8.3
Locating Vanishing Points
Cut six strips of paper $\frac{1}{4}$ by 11 inches (.6 × 28 cm). Use them to determine where the vanishing points fall on the horizon. Locate vanishing points and horizons in each of the illustrations in this chapter by laying the strips along the converging lines. Note that horizon and convergence points frequently fall outside the picture plane. Note whether or not the artist has taken liberties with a strict perspective in each of the drawings.

One-Point Perspective

A humorous introduction to the discussion of one-point perspective is the sketch by David Macaulay entitled *Locating the Vanishing Point* (Fig. 233), taken from his book *Great Moments in Architecture*. It certainly was a great moment in art when Renaissance artists discovered this new means of describing the visual world. One-point perspective is the device in which parallel lines (lines parallel in actual sight) located diagonally to the picture plane converge at a single point on the horizon (Fig. 234). This convergence point is called the vanishing point. The humor in Macaulay's drawing stems from the fact that the railroad tracks converge before they reach the horizon. This contradiction sets up a complicated response in the viewer who tries to explain (both logically and visually) this paradox.

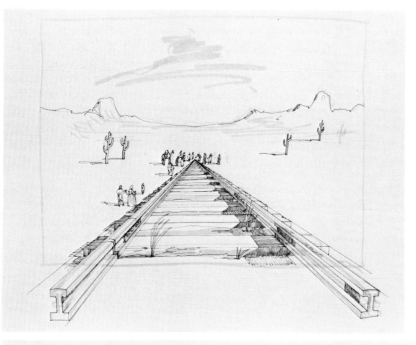

left: 233. David Macaulay. Final preliminary sketch for Plate XV, *Locating the Vanishing Point* (Macaulay's intentionally misplaced horizon line), from *Great Moments in Architecture* by David Macaulay. 1978. Ink and felt-tip marker.

below: 234. Diagram—One-point perspective superimposed on David Macaulay's final preliminary sketch for Plate XV, *Locating the Vanishing Point* (Macaulay's intentionally misplaced horizon line).

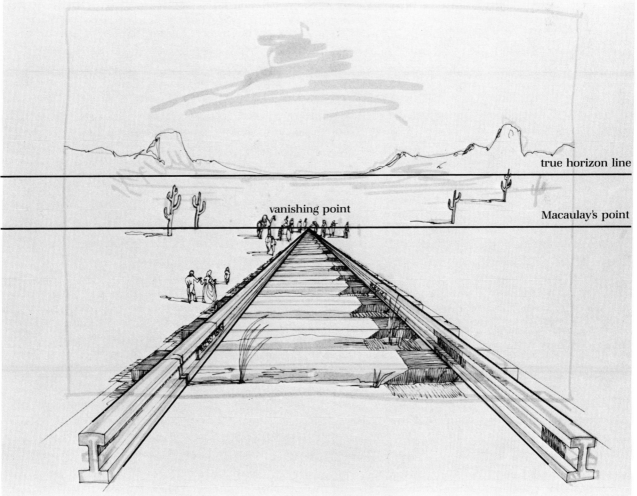

In addition to a point of convergence, other devices—overlapping, reduction in the size of objects as they recede, and blurring of detail in the distance—contribute to the sense of spatial recession.

An example of use of one-point perspective with a fixed, straight-on eye level is the painting *Henry Geldzahler and Christopher Scott* (Fig. 235) by David Hockney. The space is relatively shallow. The lines on the floor, the angle of the couch, the sides of the table all converge to a single point, the head of the seated man. Contradicting this one-point convergence is a series of parallel lines on the glass table pointing to the standing figure. The interior space is limited, and even though there is an outside window behind the central figure, our eyes are stopped abruptly by the flat wall and by the rigidly confining framework of the window. Space seems to exist on a limited number of planes. The psychological effect of Hockney's painting is slightly disturbing, and it is the artist's treatment of space that contributes to the uneasiness the viewer experiences.

 Problem 8.4
Using One-Point Perspective

In this problem and those following, it is important to position yourself so that your cone of vision encompasses both the height and width of your subject.

Station yourself directly in the center of a house, a building, or a room; your cone of vision will be the center of the drawing. If you place the picture plane too close to your line of vision, the objects in the foreground will be so large they will crowd out the objects in the distance. First, lightly establish the horizon line even if it is off the paper. Establish the height of the verticals nearest you. Draw them, and then trace the parallel lines to their vanishing point on the horizon line.

Use contour line. Create a center of interest in the center of the drawing. The depth of space is flexible; you may either create an illusionistically deep space or one that is relatively flat. Remember to

235. David Hockney. *Henry Geldzahler and Christopher Scott.* 1969. Acrylic on canvas, 7 × 10′ (2.13 × 3.05 m). Abrams Family Collection.

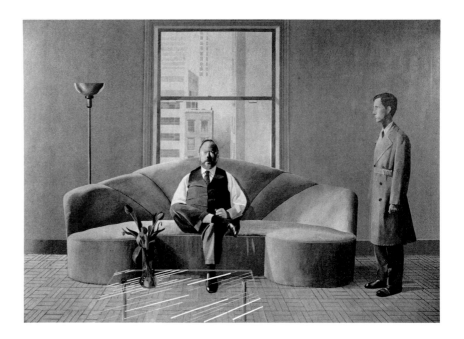

maintain a fixed point of view. It may be helpful to close one eye in tracing vanishing points.

Two-Point Perspective

A picture that uses two-point perspective has two vanishing points on the horizon, rather than the single point of convergence in one-point perspective. Two-point perspective comes into use when objects are oblique to the picture plane, that is, when they are turned at an angle to the picture plane. This is clear when we look at Edward Ruscha's *Double Standard* (Fig. 236). The verticals all remain parallel to the picture plane, but the two sides of the service station lead to two vanishing points, one to the right and the second to the left (Fig. 237). The vanishing point on

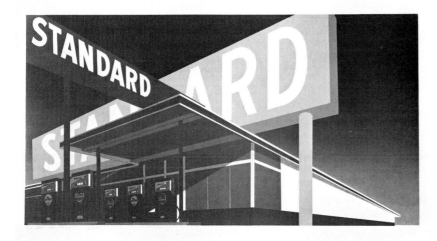

left: **236.** Edward Ruscha. *Double Standard (Collaboration with Mason Williams).* 1969. Color silkscreen printed on mold-made paper. Edition of 40. 25¾ × 40⅛″ (65 × 102 cm). Published by the artist.

below: **237.** Diagram—Two-point perspective superimposed on Edward Ruscha's *Double Standard.*

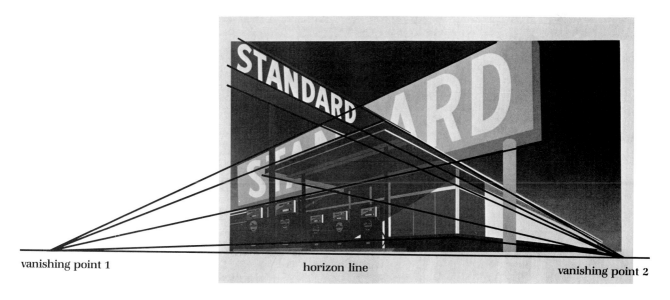

vanishing point 1 horizon line vanishing point 2

the right is at the exact lower right corner; the one on the left falls outside the picture plane. The horizon line coincides exactly with the bottom edge of the picture plane. (For two-point perspective, any number of objects may be oblique to the picture plane, and each object will establish its own set of vanishing points on the horizon line.) Conceptually, the form is well suited to the meaning in Ruscha's work. What better way to present a double standard than an X shape! Further, there is a play on words: "double standard" is equated with "moral dilemma," and certainly Ruscha indicates we have had a standard response to the question. The looming form of the building takes on mythic proportions as has our profligate use of nature (oil). The base line is at the exact bottom edge of the print. The scale of the building and the extreme upward view emphasize the ant's-eye view and diminish the scale of the implied viewer.

Thus you can see that perspective can be much more than a convention used to represent space; it can also play a dynamic role as a conveyor of meaning.

Problem 8.5
Using Two-Point Perspective

Choosing the same subject matter as in the preceding problem, change your position either to the right or to the left, so that you will be at an angle to the subject. (Remember that in two-point perspective, the subject must be seen obliquely.) Before using perspective in this problem, execute a quick free-hand sketch, depending on your perceptual ability. Then make a drawing in which you use one-point perspective. Compare the two drawings for accuracy and for expressive content.

Now draw the same view using two-point perspective. Again register the horizon line by checking your cone of vision. Estimate the height of the vertical nearest you, and draw it. This first step is crucial; it establishes the scale of the drawing, and all proportions stem from this meas-

238. Hugh Ferriss.
*Study for the Maximum Mass
Permitted by the 1916 New
York Zoning Law, Stage 4.* 1922.
Black crayon, stumped and varnished,
26¼ × 20″ (67 × 51 cm).
Cooper-Hewitt Museum,
The Smithsonian Institution's
National Museum of Design, New York
(Gift of Mrs. Hugh Ferriss, 1969).

urement. Next trace the vanishing points. Remember that you may have several sets of vanishing points (all falling on one horizon line) if you are drawing a number of objects that are set at an angle to the picture plane.

Three-Point Perspective

In addition to lines receding to two points on the horizon, if you are looking up (at a building, for example), parallel lines that are perpendicular to the ground appear to converge to a third, a vertical, vanishing point. In Hugh Ferriss' dramatic study for a skyscraper (Fig. 238), we can easily trace this third, vertical vanishing point. Each tower has its set of stacked parallel, horizontal lines receding downward to two points on the horizon line, while the vertical lines of each tower converge at a single point above the central tower (Fig. 239). The speed with which the lines con-

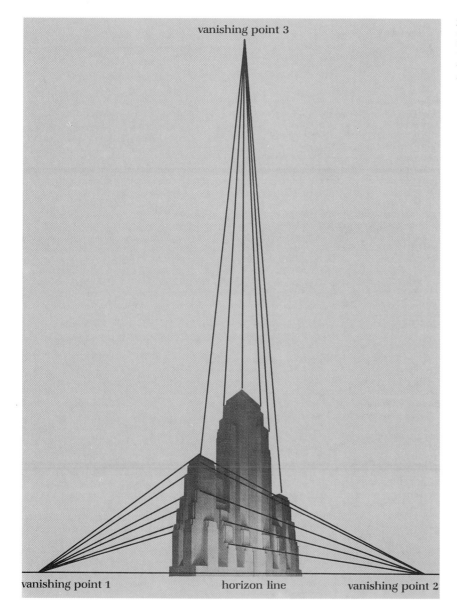

vanishing point 3

vanishing point 1 horizon line vanishing point 2

239. Diagram—Three-point perspective superimposed on Hugh Ferriss' *Study for Maximum Mass Permitted by the 1916 New York Zoning Law, Stage 4.*

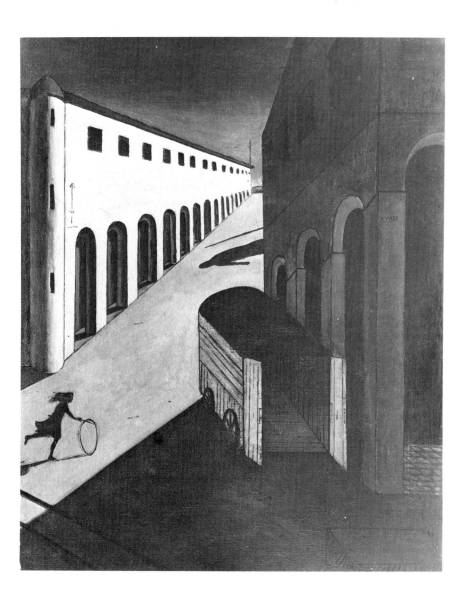

240. Giorgio de Chirico.
*The Mystery and Melancholy
of a Street.* 1914.
Oil on canvas,
34⅜ × 28½″ (87 × 72 cm).
Private collection, USA.

verge produces a sense of vertigo on the part of the viewer, not unlike the effect the tourist experiences in New York City looking upward at the vertical architectural thrusts. Ferris counters this pyramidal effect with rays of beacon lights, which converge downward. The cleanly modeled forms change in value, from light at the base to a flat dense black at the top, further emphasizing the building's verticality.

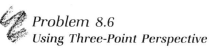 *Problem 8.6*
Using Three-Point Perspective
 Assume an ant's-eye view and arrange several objects on a ladder. Position yourself at an angle to the ladder so that your view is looking upward. Again, trace with your finger the vanishing points that will fall on the horizon line, and then trace a third vanishing point, the vertical one.

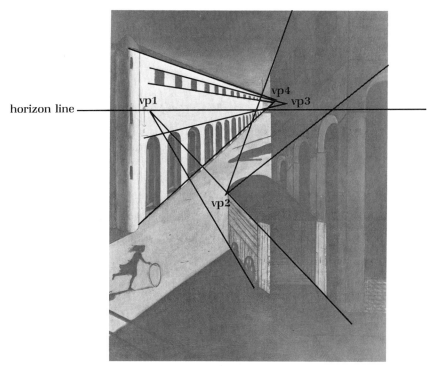

horizon line

241. Diagram—multiple perspective superimposed on Giorgio de Chirico's *The Mystery and Melancholy of a Street.*

Remember to keep in mind all three vanishing points even though they may fall outside the picture plane. The forms will be larger at the bottom of the ladder (and at the bottom of the picture plane). When you reach midpoint on your paper, check the scale and draw in the remainder of the ladder and objects. Employ some aerial perspective to enhance further the feeling of space.

Multiple Perspective

The extremely disorienting effect that can be achieved by changing eye levels and perspectives in the same painting is illustrated by Giorgio de Chirico's eerily disturbing *Mystery and Melancholy of a Street* (Fig. 240). In addition to the unreal lighting, sharp value contrasts, and extreme scale shifts, which contribute to the surreal, otherworldly atmosphere, the most jarring effect is produced by de Chirico's forcing the viewer to change eye levels from one part of the painting to the other. One eye level is used for the cart, another for the building in the foreground, another for the building on the left, and yet another for its openings. (The top windows and the top of the arched arcade should vanish to the same point as the other parallel lines in the building, but they do not.) In the diagram in Figure 241, you see four sets of vanishing points, which do not fall on the horizon line. The diagonals converge at dizzying rates within the picture plane. A troubling strangeness upsets what could be a classical objectivity.

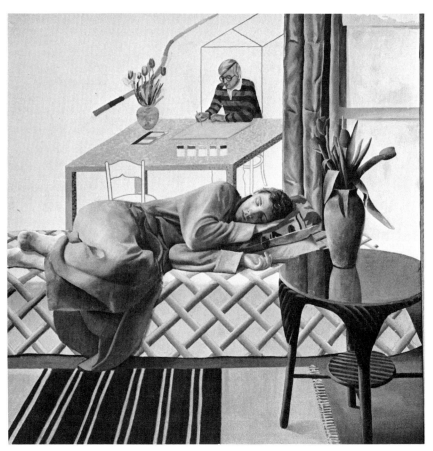

242. David Hockney. *Model with Unfinished Self-Portrait.* 1977.
Oil on canvas, 5 × 5' (1.5 × 1.52 m).
Collection Mr. Werner Böninger, Los Angeles.

A second painting, by Hockney, *Model with Unfinished Self-Portrait* (Fig. 242), combines multiple perspective in the same painting, but the effect is quite different from that in de Chirico's work. The foreground uses a consistent eye level and perspective. The objects and reclining figure seem to occupy a logical space; eye level remains constant throughout this section of the composition. But the self-portrait section, the top half of the painting, forces our eyes to shift radically. From the logically stated space of the figure on the bed, the eye level changes to a jolting bird's eye view of the desk. The desk top is in reverse, or *isometric,* perspective; that is, the parallel sides converge at a point toward the viewer. (This is an exact reversal of the railroad track example.) Still another eye level is used for the seated figure. And the smaller vase of flowers is seen from a different eye level than the desk or the seated artist. The stringent geometric shape behind the artist is a clue that Hockney is consciously playing games with perspective.

Problem 8.7
Using Multiple Perspective

Draw the interior of a room by using changing, or multiple, eye levels within the same drawing. The resulting space will be ambiguous. Use one eye level and perspective for a view through the window, another for a tabletop, and still another for objects on the table. The effect may be extremely disorienting or only slightly off balance, depending on the degree of change from one viewpoint to another and on your use of lighting effects.

Stacked Perspective

An ancient Egyptian mural (Fig. 243) and a 20th-century comic-strip-style painting by Öyvind Fahlström (Fig. 244) illustrate how parallel base lines create space that is predominately two-dimensional. These parallel base lines within the same picture plane give the effect of stacked panels or frames and encourage the viewer to read the page from top to bottom or from bottom to top in a sequential order. The parallel base lines call attention to the two-dimensionality of the picture plane.

below: **243.** Wall painting from Tomb 261, Thebes. c 1500 B.C., 29½ × 41¼″ (75 × 105 cm).

right: **244.** Öyvind Fahlström. *Performing Krazy Kat III.* 1965. Variable painting, tempera on canvas and metal with movable magnetic elements, 4′6½″ × 3′1½″ (1.38 × .93 m). Collection Robert Rauschenberg, New York.

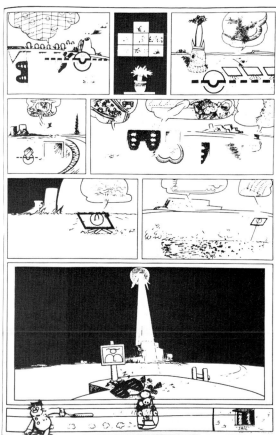

Both works use a number of common devices to maintain a relatively shallow space. Modeling is limited; value remains flat within a given shape. Repeated shapes organize the two compositions. There is a limited use of diagonals; shapes remain parallel to the picture plane on a horizontal/vertical axis. Outlines and invented textures in both works are made up of lines and dots.

The emphasis in the Egyptian painting is on positive shapes, which fill the grid but create little depth. The size and placement of figures are arbitrary; they fit a religious and social hierarchy rather than a visual reality. The Egyptian panel also uses a twisted perspective to show the salient features of profile and front torso; the head is in profile, the eyes are front view. It is impossible actually to assume the stance of the standing figures, especially that of the small figure in the top panel with head turned completely around.

Size and placement of images in the Fahlström piece are also arbitrarily determined. The contemporary work makes more use of negative space, indicated by horizon lines that vary slightly from frame to frame. There are also pronounced shifts in eye level.

Problem 8.8
Using Stacked Perspective

Set up a still life made up of several common objects. Place some of the objects on a table in front of a window; arrange the remainder on a windowsill. Use multiple parallel base lines. Draw two or three objects on each base line. Make use of repeated shapes, repeating values, invented texture, and outlining to create a relatively shallow space. Some of the objects may be parallel to the picture plane, others set at an angle to it.

245. David Macaulay. *Fragments from the World of Architecture,* from *Great Moments in Architecture* by David Macaulay. 1978.

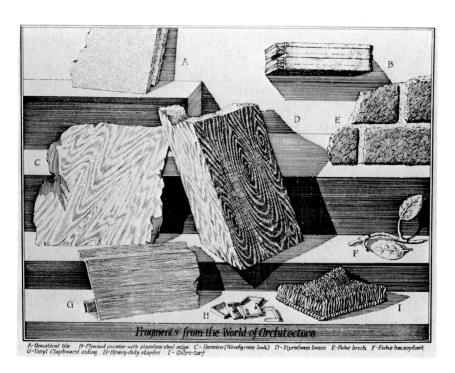

Scale and proportion may or may not change from panel to panel. Macauley's *Fragments from the World of Architecture* (Fig. 245) could be a suitable solution to this problem. For subject matter he has chosen common building materials—acoustical tiles, formica, fake brick, Styrofoam, and astro turf—all "archaeological finds" from the 20th century. They are stacked on various base lines in a two-point perspective drawing. Texture is meticulously handled. The volumetric depiction of the objects is in contrast with their strictly limited space.

Foreshortening

Perspective is concerned with representing the change in size of objects as they recede in space. *Foreshortening* is the representation of an object that has been extended forward in space by contracting its forms. Foreshortening produces an illusion of the object's projecting forward into space. The two techniques are related, but they are not the same thing. Foreshortening deals with overlapping. Beginning with the form nearest the viewer, shapes are compiled from large to small, one overlapping the next, in a succession of steps. In George Rohner's 20th-century version of Andrea Mantegna's 15th-century Christ (Fig. 246), we are presented with an example of extreme foreshortening. The forms are compiled one behind the other from foot to head. The leg on the left is more severely foreshortened than the one on the right where there is a side view. The leg on the left is compressed, each unit maintaining its own discrete shape; there is no flowing of one form into the other as we see in the other leg.

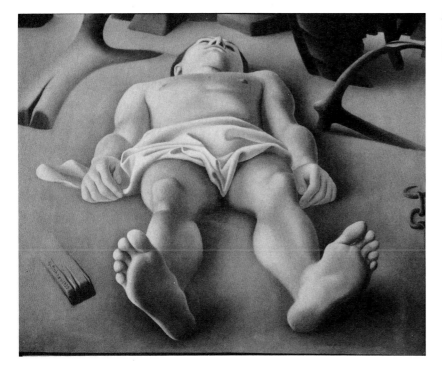

246. George Rohner. *Drowned Man.* 1939. Oil on canvas. 23¾ × 31⅝″ (60 × 80 cm). Courtesy Galerie Framond, Paris.

Foreshortening does not apply to the figure exclusively; any form that you see head-on can be foreshortened. In foreshortening, spatial relationships are compressed, rather than extended. Foreshortening heightens or exaggerates the feeling of spatial projection in a form, its rapid movement into space.

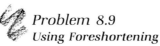

Problem 8.9
Using Foreshortening

Observing a model, combine four or five views of arms or legs in a single drawing. In at least one view employ foreshortening; that is, begin with the form nearest you, enclose that form, then proceed to the adjacent form, enclosing it. Be careful to draw what you see, not what you know or imagine the form to be. For example, in drawing the leg, break down the parts that compose the form: foot, ankle, calf, knee, thigh, hip connection. This is unlike a profile drawing where you are presented with a side view and each form flows into the next. Foreshortening describes the form's projection into space. In foreshortening a feeling of distance is achieved by a succession of enclosed, overlapping forms.

SUMMARY: Spatial Illusion

The type of space an artist uses is relative; it is seldom possible to classify a work as strictly two- or three-dimensional. As a drawing student you may be required to create a flat or an illusionistic or ambiguous space in given problem, but as an artist your treatment of space is a matter of personal choice. Mastery of the spatial relationships of the elements will give you freedom in that choice. Your treatment of space should be compatible with the ideas, subject, and feeling in your work. Along with shape, value, line, texture, and color, proficiency with spatial manipulation can help you make an effective personal artistic statement.

PART THREE

A
Contemporary View

CHAPTER 9

The Picture Plane

New ideas and concepts in art demand a new way of speaking about art. Art changes along with society, and language reflects such change. More traditional art vocabulary is still in use, but artists, critics, and teachers have found new terms to discuss today's compositional concerns. This chapter will introduce some of these new concepts.

In recent years artists have been subverting and otherwise transforming the conventions and aesthetics of earlier times, for example, the substitution of randomness for geometric order. That is not to say that one must not be familiar with former principles of compositional organization, but it is imperative to realize that these principles of design are not locked into place. They may be turned topsy-turvy; they may even be negated.

We confront crowded, disjunctive environments in the real world, so it is not surprising to find this kind of disorder in art as well. Art today encompasses the full gamut of personal expression; we find straightforward work alongside involuted work, the political alongside the comical, direct art statements alongside oblique ones. In other words, art, like life itself, is multidimensional in its pursuit of significance. And in art the means to this diversity go beyond the conventional compositional rules.

Assertion and Denial of the Picture Plane

Part 2 dealt with the way the art elements can be used to create spatial illusion and with some of the ways pictorial space can be controlled through eye level and perspective. As you have seen, treatment of space is a major concern of the artist. This chapter focuses on another contemporary concern, the picture plane and how to handle the problems it presents. Artists have always been aware of the demands of the picture plane—its size, shape, flatness, edges, and square corners. However, many innovations in form in 20th-century art have specifically and explicitly centered around the demands and limitations of the actual physical support or surface on which an artist works.

Concern with the demands of the picture plane has manifested itself basically in two ways: assertion of the picture plane and denial of it. Both approaches, however, emphasize the importance the picture plane has had on formal, compositional considerations. Form, the interrelationship of all the elements, is the way artists say what they mean. In art, form and meaning are inseparable; form is the carrier of the meaning. It is the design or structure of the work, the mode in which the work exists. It is an order created by the artist. In this chapter you will look at some of the specific ways recognition of the picture plane, both denial and assertion of it, has affected the form of contemporary art.

Dominance of the Edge

Perhaps the most obvious and visible denial of the right-angled picture plane has been the change of the traditional rectangular plane into different shapes. Frank Stella, an artist who illustrates this dominance of the edge, is known for his shaped canvases (Fig. 247), which challenge the traditional rectangular format. He uses a motif that reinforces the distinctive shape, that points out and affirms its alternately receding and jutting edges.

A more recent use of a shaped plane can be seen in Jonathan Borofsky's wall piece (Fig. 248). Recognizable subject matter complicates

247. Frank Stella. *Quathlamba.*
1964. Metallic powder
in polymer emulsion on canvas,
6′5″ × 13′7″ (1.96 × 4.14 m).
Private collection.

the decision to use a shaped canvas. Subject, meaning, and form must be welded into a tight unit. In Borofsky's work the literally divided head makes a forceful statement. We are all familiar with the concept of a divided self. This depiction confronts the viewer in an aggressive way, not only by the split canvas but by the monumental scale and expressionistic brush work. There are dozens of implications to be read into the dual image; divisiveness is the expected condition in today's world.

The next two examples also demonstrate the assertion of the picture plane, the dominance of the edge. The first example uses recognizable and illusionary imagery, the second a conceptual approach.

In the watercolor (Fig. 249), Yvonne Jacquette uses the airplane window as a border for the view outside the window. This window serves a triple function: It frames another image, it reiterates the size and shape of the picture plane, and it is a contemporary window into a contemporary space. Here the traditional Renaissance use of the picture plane as a "window into space" has been given a radically new 20th-century look. In this instance the two images, window and outside view, serve a contradictory function. The window border has a beginning and an end—we know where it stops and where it starts—whereas the image outside the window depicts a continuous space, quite literally a limitless one. This highly complicated and sophisticated statement is delivered in a rather simple and straightforward way; both form and image are carriers of a complex message.

left: **248.** Jonathan Borofsky. *Splithead at 2673047.* 1980. Acrylic on canvas (two shaped canvases), 11′1″ × 3′7″; 11′1″ × 2′6″ (3.38 × 1.09 m; 3.38 × 7.62 m). Private collection.

right: **249.** Yvonne Jacquette. *Airplane Window.* 1973. Watercolor, 12⅛ × 9″ (31 × 23 cm). Collection Mr. and Mrs. John F. Walsh, Jr., New York.

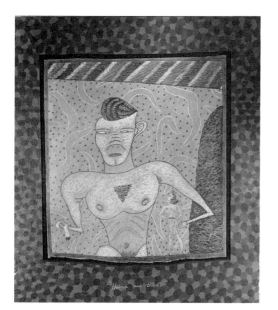

The second example that illustrates the assertion of the picture plane is Jim Nutt's *Thump and Thud* (Fig. 250). Here the drawing contains its own frame in the form of a decorative border. Inside that border is a figure whose frontality is reinforced by a vertical shape along the right side and a horizontal one along the top. Outline, closed shape, and a variety of invented textural patterns all contribute to the flatness of the drawing, which echoes the flatness of the picture plane. Spatial ambiguity is achieved by the discrepancy of scale between the central figure's hands and head and by the shift in scale in the tiny woman who stands on the ledge of the frame.

 Problem 9.1
Shaping the Picture Plane

Using cardboard, masonite, or heavy paper, make an irregularly shaped picture plane; that is, one that is not rectangular or round. You might choose to make a square with one corner cut off at an oblique angle, or you might choose a more radically different shape. If you use material other than paper, size it with gesso before drawing. You may use recognizable subject matter or a nonobjective image. Make image and format into a well-integrated unit. Frank Stella and Neil Jenney work with the shaped picture plane. Analyze their recent work according to image and shape, both by form and by content. Try to make the composition offer a reason for the irregular picture plane. The shape of the picture plane should govern the shapes within it.

252. Color photocopy drawing.
Student work. Mixed media,
18 × 24″ (46 × 61 cm).

Problem 9.2
Asserting the Flatness of the Picture Plane

Make two drawings that assert the limits and flatness of the picture plane. You might choose a common, everyday object as subject for the first drawing. Present the object frontally and enclose it with a patterned border. Use a conceptual approach. Combine solid value shapes, outlining, or invented texture within confined shapes, along with reverse perspective to emphasize the flatness of the picture plane. Think in terms of a modern icon (Fig. 251) (an *icon* is an object worthy of veneration).

In the second drawing, using a subject of your choice, concentrate on a more realistic depiction. Again, use a border to call attention to the flatness of the picture plane even though you have created a spatial illusion within the frame. The photocopy composition in Figure 252 presents the continuous surface of a ballroom floor with moving images of women's feet. The plane of the floor repeats the flatness of the picture plane, although the dancing feet deny a two-dimensional space. An abrupt value change in the border also calls attention to the flatness of the picture plane. This opposition between flat and illusionistic space relays a contemporary concern.

Negation of the Edge

A means of denying the traditional format is to negate the limitations of the edge—to make the viewer imagine that if the plane were

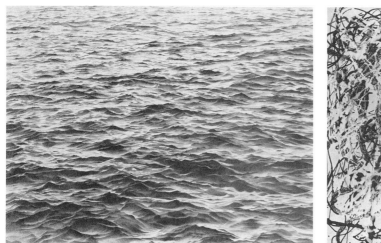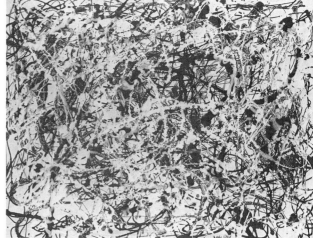

left: **253.** Vija Celmins. *Untitled (Big Sea #1).*
1969. Graphite on paper, 34⅜ × 45½″ (87 × 116 cm).
Collection Chermayeff and Geismar Associates, New York.

right: **254.** Jackson Pollock. *Composition.* 1948.
Casein on paper mounted on masonite, 22¼ × 30½″ (57 × 77 cm).
New Orleans Museum of Art, Louisiana (Bequest of Victor K. Kiam).

extended in any direction the image would also extend, unchanged. For example, if we imagine Vija Celmins' graphite drawing of the sea (Fig. 253) to encompass a larger view, it would still have the same continuous image over its surface; there would still be a continuous field of water. Celmins uses a recognizable subject and treats it illusionistically, but this continuous-field effect can be achieved with nonobjective forms as well. Jackson Pollock's work (Fig. 254) is less a composition than a process; the action of the artist while painting has been documented. Movement and time have been incorporated to result in a richly energized surface; the limits of the final piece seem somewhat arbitrarily chosen. (Note that the paint drips go off the paper on all four sides.) Again, we can imagine the field to be continuous.

If a recognizable subject is used, as in Stuart Caswell's *Chain Link Disaster* (Fig. 255), it must be one the viewer can imagine continues beyond the limits of the picture plane. In comparing the two works by Caswell and Pollock, it is as if Pollock's drips have metamorphosed into the tangled wire of Caswell's drawing. Both works are tense with implied motion; the lines are stretched across the surface. And in both works overlapping darks and lights bind the forms to each other in a complexly layered surface.

Jean Dubuffet's pen-and-ink drawing (Fig. 256) seems to be a third variation on the same theme. Here the repeated shapes and overall patterning create a texture that seems to continue beyond the confines of the picture plane. While there is a change in focus from top to bottom in both the Caswell and the Dubuffet, there is no single focal point, no one area that has priority over another, no center of interest. Both works illustrate the denial of the limits of the picture plane.

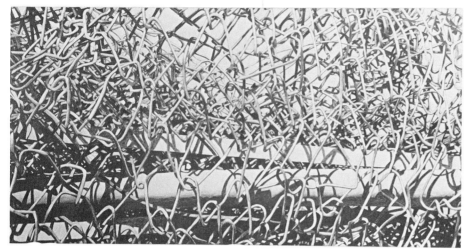

above: 255. Stuart Caswell. *Chain Link Disaster.* 1972.
Pencil, 22 × 28″ (56 × 71 cm).
Minnesota Museum of Art, St. Paul.

right: 256. Jean Dubuffet.
Storm on the Steeple. June, 1952.
Pen and ink, 18¾ × 23¾″
(48 × 60 cm). Museum of Modern Art,
New York (Gift of Mr. and Mrs.
Lester Francis Avnet).

Problem 9.3
Negating the Edge

Make two drawings that deny the limits of the picture plane, one using a recognizable, illusionistic image and the second using nonobjective imagery. Create an overall textured surface so that no segment of the drawing has precedence over another. There should be no dominant center of interest. Try to create the illusion that the image extends be-

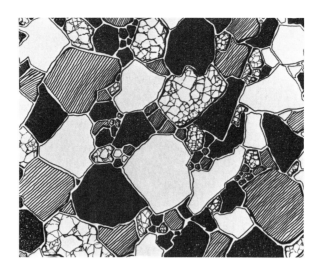

257. Variations of a form. Student work. Colored pencil, 9 × 12″ (23 × 30 cm).

yond the confines of the picture plane. In the student drawing (Fig. 257), shapes resembling flagstones serve as the motif. The use of line, value, and texture is consistent throughout the drawing. The shapes fill the picture plane with no priority of focus. We can easily imagine that the image extends beyond the edges of the paper.

Arrangement of Images

The importance of the relationship between positive and negative space has been emphasized throughout the book. In dealing with the demands of the picture plane, this relationship is again crucial. Positioning of positive and negative shapes is of utmost importance. By placement the artist may assert or deny the limitations of the picture plane.

Placement of an image calls attention to the shape and size of the plane on which it is placed. (Too small a shape can be dwarfed by a vast amount of negative space and too large a shape can seem crowded on a small picture plane.)

Center, top, bottom, and sides are of equal importance until the image is placed; then priority is given to a specific area. Centralizing an image results in maximum balance and symmetry, and if that centralized image is stated frontally, the horizontal and vertical format of the picture plane will be further reinforced.

In his print (Fig. 258) Claes Oldenburg centralizes a three-way plug. The image is made static by its placement; the stasis is further enhanced by the use of the enclosed shapes, especially the closed circles. Such complete balance in the positioning of the image permits no movement. Oldenburg, in typical, whimsical contradiction, makes the plug seem to levitate or float by bisecting the shape with a line. So now we interpret the image as suspended between sky and water, as being submerged midway between air and water. Several hints are dropped for this reading of the image—the triangular ship sail and the cursive writing in the water, "floating plug in sunset." Scribbles radiate from the sun in the upper half. These marks activate an otherwise static space.

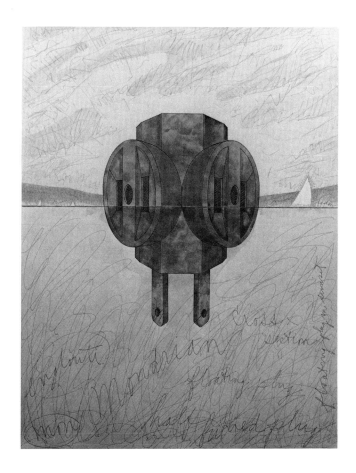

In some contemporary work the center is left empty. A void seems to crowd the images to the edge. This is especially true in Morris Louis' work (Fig. 259), in which attention to the edge is a dominant characteristic. We cannot classify the center space as simply leftover or empty space because it has a forceful power. It seems to squeeze the images in the painting down and out of the picture plane itself.

Don Scaggs encases his diary drawing in a vinyl packet (Fig. 260). An interesting interchange between positive and negative shapes takes place

above left: **258.** Claes Oldenburg. *Floating Three-Way Plug.* 1976. Etching and aquatint, 42 × 32¼" (107 × 82 cm). Published by Multiples Inc., New York.

below left: **259.** Morris Louis. *Alpha-Tau.* 1961. Acrylic on canvas, 8'5" × 19' 3⅞" (2.59 × 5.95 m). St. Louis Art Museum (Purchased with funds given by The Shoenberg Foundation).

above right: **260.** Don Scaggs. *Diary 17/18: Dad's Chuckles.* 1975. Mixed media, on paper, encased in vinyl envelope, 46 × 30" (117 × 76 cm). Courtesy the artist.

QUEEN VICTORIA....
TROUBLED BY FLIES

left: **261.** Dennis Corrigan.
Queen Victoria Troubled by Flies.
1972. Cronaflex, 13 × 10½"
(33 × 27 cm). Courtesy Associated
American Artists, New York.

right: **262.** Öyvind Fahlström.
Notes "150 Persons." 1963.
Tempera, collage, and ink;
18⅝ × 23¾" (47 × 60 cm).
The Art Institute of Chicago
(Gift of Mr. and Mrs.
Edwin A. Bergman).

in the center white space. At times this space appears to be an empty, negative space; at other times it seems to be a torso. The shapes along the edge press inward on the torso. We do not see the torso shape in its entirety; there is an implication that this form has been cut off, that the image continues beyond the confines of the border.

Another technique for asserting the picture plane is to crowd the picture surface with a great number of images. This device eliminates a priority of focus. Seemingly unrelated images of contradictory size, proportion, and orientation announce that the picture plane is not a place for a logical illusion of reality; rather, it is a plane that can be arranged any way the artist chooses as in the print by Dennis Corrigan (Fig. 261). Images are juxtaposed in odd ways in *Queen Victoria Troubled by Flies* where the incongruity of the subject matter is underscored by the large scale of the flies and the seemingly inexplicable image the queen is holding. Or does the figure recede into her bosom? Could the clownlike figure be a metaphor for the monarchy, "the puppet of the state"? The transformation of the queen's headdress into an insect form further confuses our interpretation.

Some artists seem to disregard accepted norms of taste and form and intentionally to break all rules. Such an artist is Öyvind Fahlström (Fig. 262). Viewing his *Notes "150 Persons,"* we are exhausted by the number of images, their scale and placement, and the difficulty of sorting out words and images. The artist gives no help in what we are to look at first. Positive shapes crowd out negative space. Some semblance of order is

introduced by the square segments, which read from left to right, but these give way to a burst of images that, for the most part, are unidentifiable. The result is a highly complicated, textured surface in which images are cut off at top, bottom, and sides. Fahlström asserts the picture plane as a plane to deposit images, but he denies it as a limiting factor in the drawing.

Frequently artists use a single positive image to crowd out the negative space, as does Alex Katz in his lithograph to Frank O'Hara (Fig. 263), which presents a point-blank stare of a youthful, empty face. The figure is cropped on all four sides by the edges of the picture plane. Katz denies the limits of the paper in this close-up, blown-up view. We are forced to come to terms with the unblinking eyes in the empty, negative shape of the face. While Katz' figures are extreme simplifications of the human form, they are, nonetheless, real portraits, whose individuality has been subsumed by the uniformity of American society with its demands to conform. Katz' paintings are at once a picture of a class and of a single individual.

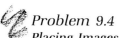

Problem 9.4
Placing Images on the Picture Plane
Make two drawings in which placement is the prime concern. In the first drawing use a nonobjective centralized image. Present the image frontally. In the student drawing in Figure 264, space is limited; there are

left: 263. Alex Katz. *Homage to Frank O'Hara: William Dumas.* 1972. Lithograph, 33¼ × 25½" (84 × 65 cm). Courtesy Brooke Alexander, Inc., N.Y.

right: 264. Centralized image. Student work. Pastel and turpentine, 30 × 22" (76 × 56 cm).

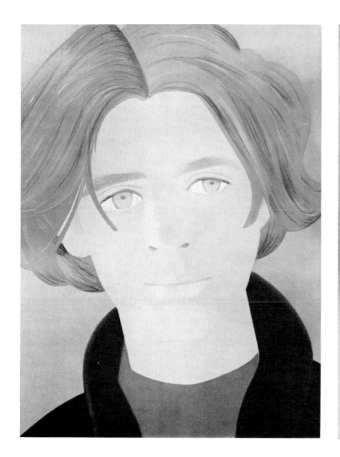

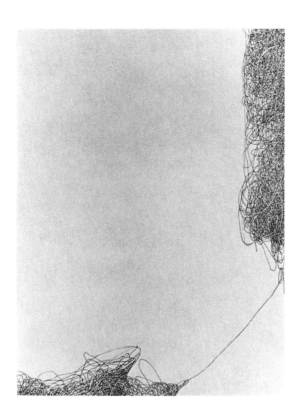

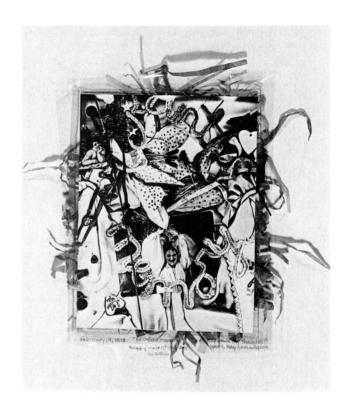

no diagonals; the composition utilizes several simple geometric motifs. The static composition is activated by small circles, crosses, and triangles, which pulsate within the grid. The media are freshly handled; the finished drawing resembles a primitive weaving. It has a direct, energetic appeal.

In the second drawing, emphasize the edges or the corners of the picture plane. Position the image so that the corners or sides are activated. You may use an abstract image or a recognizable one. Susan Hauptman's drawing (Fig. 265) can be read as a tangled web of threads or as an abstract, tangled mass of line. Placement of the image calls the attention to the bottom and side of the paper and tests our sense of gravity. Does the thread fall to the bottom, or is it being pulled forcibly by the bottom mass?

Problem 9.5
Crowding the Picture Plane

Make a composition with photocopies using an arrangement of real objects directly on the copier. Take care in choosing your objects; try for a wide range of textural variety. Make several copies, changing the composition each time. If the print seems unfinished, draw on its surface or add other elements as in Figure 266, where the student has embellished the surface with ribbons, buttons, fabric, and drawing. The result could be an odd amalgamation of seemingly realistically rendered objects in illogical relationships. If you include photographs of larger-scaled objects, the disorientation will be even more extreme.

Problem 9.6
Filling the Picture Plane

In this problem you are to use a single image that completely fills the picture plane. You may enlarge a detail of a form, or you may crowd out the negative space by filling the picture plane with the image. Confront the viewer with a composition that is cropped top, bottom, and sides by the edges of the paper.

Division of the Picture Plane

Another formal means contemporary artists have used to meet the demands of the picture plane is the grid, which divides the picture plane into units or segments. In addition to reiterating the flatness of the picture plane, its horizontal and vertical shape, the units introduce the element of sequence, which in turn brings up the idea of time. More traditional art is viewed synchronically; that is, the composition is seen all at once in its entirety. Grid compositions, on the other hand, are viewed both synchronically and linearly. We, of course, see the entire work at a first glance, but when we take a more sustained look, the composition demands to be read sequentially, segment by segment.

Pat Steir's drawn-on canvas (Fig. 267) has been gridded by intersecting lines in the upper two-thirds and by horizontal lines in the lower third. The grid alternately advances and recedes in different segments of the painting. Pronounced rectangular shapes are distributed throughout the composition, again calling attention to the horizontal/vertical axis. The irregular line that divides the two major segments can be read either as the horizon or a fluctuating graph line. The loosely stated marks and drips cancel out the otherwise rigid format. Certainly, the idea of sequence and of time is reinforced by the title *Three Green Days*. Our reading of the work is both synchronic and sequential.

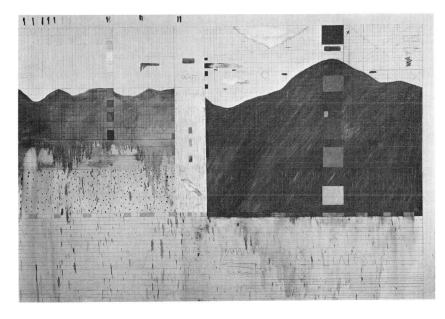

267. Pat Steir.
Three Green Days. 1972.
Oil, crayon, pencil,
and ink on canvas;
6 × 9′ (1.83 × 2.74 m).
Collection Mrs. Anthony J. A. Bryan.

More recent painters seem to have abandoned the grid format in favor of a picture plane divided into two equal units, more like a diptych (a work in two parts) than a grid. And in those two units of equal size and proportion the images are discontinuous; that is, they seem not to belong to each other. The viewer is forced to try to relate the seemingly unrelated sections. In David Salle's enormous work (Fig. 268), we are accosted by two radically different divisions. In the upper half, figures are overlaid and unrelated by technique. The central figure is gagged and bound; the one on the upper right seems to be a relative of the well-known figure in Edvard Munch's *The Scream*. This figure is being bombarded by music from a loud speaker. Notes are clashing into the head. The mute, animalistic condition of the group is paralleled by the pack of dogs in the lower right corner, and the apocalyptic nature of the work is suggested by the brutal handling of the figures on the left half of the painting. This jumbled, fragmented composition is in complete opposition to the insistently gridded lower half with its monotony of circles regularly and uniformly painted on masonite. We cannot escape the association with a loudspeaker system. (We have already been given the clue by the loudspeaker box depicted in the upper half and by the title *The Mother Tongue*.) The mute figures seem unaided by their mother tongue; they are victims of technologically generated, maddening sounds.

Rob Erdle uses an implied and irregular grid in his watercolor *Tetuan* (Fig. 269). The units vary in size and shape; each segment is slightly tilted, slightly off square. These irregular segments and their interior shapes overlap adjacent units, creating a complicated interplay. This unpredictable type of grid, while affirming the picture plane on one hand, seems also to defy its flatness. We feel that if each unit in Erdle's work were cut out and reassembled in a strictly horizontal and vertical format, the newly constructed plane would be larger than the original one.

The grid can be stated in a sequential pattern to suggest a stopped-frame, or cinematic, structure. While grids can be read in a number of ways—horizontally, diagonally, or vertically—in cinematic structure each frame logically follows the other. There is a definite sense of time lapse and movement.

These stopped-frame compositions use a regular geometric frame (like the segment of a piece of film) as in Steir's flower painting (Fig. 270). This three-part composition is conditioned by modern technology, by close-up photography. The viewer is forced to adjust to the rapid change in scale from the first, rather distantly conceived object to the disproportionately large scale of the same flower in the third section. The traditional boundaries between realism and abstraction are also called into question in this single painting. The final segment seems more closely related to the Pollock in Figure 254 than to the painting of the small vase on the left. This relation is especially apparent when you realize that each segment in the Steir painting measures 5 feet (1.53 m) square.

While most stopped-frame compositions use a regular geometric frame, a linear, sequential arrangement can be achieved by omitting the frames. May Stevens uses a linear progression in her screenprint *Big Daddy Paper Doll* (Fig. 271). The central character, who is nude and startlingly white, is flanked by different costumes that identify his various

left: 268. David Salle. *The Mother Tongue.* 1981.
Oil and acrylic on canvas and masonite,
9′4″ × 7′2″ (2.84 × 2.18 m).
Collection Doris/Robert Hillman, New York.

above: 269. Rob Erdle. *Tetuan.* 1976.
Watercolor and graphite, 3′ × 4′4″ (.91 × 1.32 m).
Private collection.

above: 270. Pat Steir.
Chrysanthemum. 1981.
Oil on canvas, 3 panels,
each 5 × 5′ (1.52 × 1.52 m).
Collection Gloria and Leonard Luria.

left: 271. May Stevens.
Big Daddy Paper Doll. 1970.
Screenprint, 14 × 35″
(36 × 89 cm).

roles and attitudes. While the white figure is centralized and dominant, it is as empty as the uniforms alongside it. We seem to have caught a fashion show in progress, and we would not be surprised to find the line of costumes continuing beyond the confines of the edge.

In cinematic grids, visual reinforcement of the picture plane comes from the contained images. Conceptual denial is suggested by the idea of continuation, by the idea that with a longer lapse of time come more stopped-framed images.

Loosely related to the divided picture plane is the composition with an inset. In older, more traditional work, the artist always felt free to draw a detail or to rearrange the composition in some area of the drawing. In contemporary work, this latitude has been claimed as a favored compositional device. An inset creates an opposition between itself and the primary subject and sets up a feeling of discontinuity between the two images. In Leonel Góngora's lithograph (Fig. 272), the artist has used several insets; in fact, all three figures plus the dark rectangle at the top of the page are set off by encircling marks. The centralized, transformed head of Samson dominates the loose composition. Góngora's beheading of Holofernes (by the encasement of the head in a white frame) parallels the actual decapitation by Judith. Góngora draws an analogy between the two biblical tales, the shearing of Samson's hair by Delilah and the beheading of Holofernes by Judith. In his palimpsestlike, layered drawing, Góngora pays tribute to a favorite Renaissance art theme, Judith's victory over Holofernes.

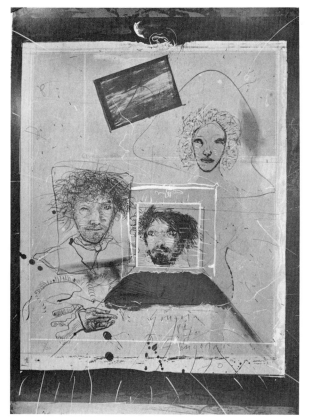

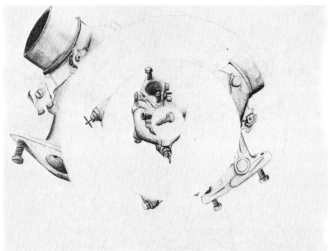

left: 272. Leonel Góngora. *Transformation of Samson and Delilah into Judith and Holofernes.* 1970. Lithograph, 29½ × 22″ (75 × 56 cm). Courtesy the artist.

below: 273. Concentric grid drawing. Student work. Conté crayon, 24 × 18″ (61 × 46 cm).

Problem 9.7
Composing with a Grid

Do three compositions using grids. Taking a machine part as subject, you may repeat the same image in each unit, change the image from unit to unit, or change the scale of the object from unit to unit.

In the first drawing, establish a grid in which each unit is the same size. In the second drawing, lightly establish the grid; then use value, texture, and line to negate the regular divisions. Try to achieve an overall effect as opposed to a sequential reading of the drawing. In the third drawing, use a grid of irregular units. You may use a concentric grid as in Figure 273, overlay sections, use grids in one area only, or simply imply a grid arrangement.

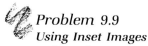

Problem 9.8
Dividing the Picture Plane

Using a picture plane that is exactly twice as wide as it is high, divide the format into two equal segments. Make a drawing with an image in one half totally unrelated to the image in the other half. This is not as easy to do as it sounds, since we attempt to relate any two images seen simultaneously. For the first image you might choose a visual cliché, an image that is well known to everyone in American culture, such as the Statue of Liberty. Try to pair with the first image another subject that is totally unrelated by form, media, technique, scale, or meaning. The result should be a very disjunctive composition, one that is unsettling to the viewer. See Figure 274 for one solution to this problem.

Problem 9.9
Using Inset Images

Make a drawing that employs an inset. The inserted image may or may not be related to the larger drawing (Fig. 275). Again, you might change subject, style, media, or scale in the inset.

left: 274. Divided picture plane—visual cliché. Student work. Chalk and pencil, 36 × 24″ (91 × 61 cm).

right: 275. Inset. Student work. Oil stick, 12 × 14″ (30 × 36 cm).

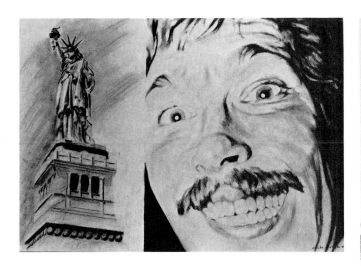

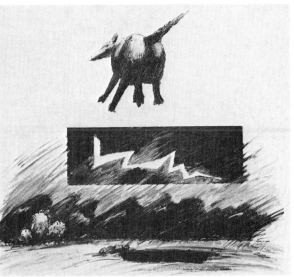

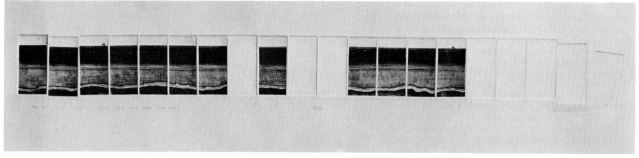

276. Image repeated in linear sequence. Student work. Etching.

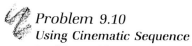

Problem 9.10
Using Cinematic Sequence

In this problem you are to repeat an image in a cinematic, linear sequence. The repeating units may progress from left to right across the page, or they may move in a vertical direction from top to bottom. Keep in mind the idea of a time lapse. This may be achieved by having the image undergo slight changes from frame to frame. In the student drawing (Fig. 276), the line of images suggests a landscape and moves across the page with a minimum of changes from one frame to the next. There is a sense of expectation as we progress from frame to frame. The embossed empty spaces are a jolting interruption in an otherwise subtly sustained progression. Another option for subject is a narrative sequence; for example, you might take an imaginary character through a catastrophic day.

SUMMARY: Personal Solutions

You have looked at and discussed a number of ways contemporary artists have dealt with the demands of the picture plane. The list is by no means comprehensive, for each time artists are confronted with the clean, unblemished surface of the picture plane, new problems arise. Out of the artist's personal and very subjective experience come the solutions to these problems. For many artists the response to the demands of the picture plane is on a highly conscious level; in others the response is more intuitive.

In your own work, whatever approach you take, the solutions or resolutions should not be turned into formulas, for there are no pat answers to any problem in art. Involvement in your own work and familiarity with the concerns and styles of other artists will help you solve your own problems in a personal and exciting way.

CHAPTER 10

<div style="border: 1px solid black;">

Thematic Development

</div>

This chapter on thematic development continues investigating contemporary issues in art and emphasizes artists' conceptual and highly personal involvement in their work by taking a look at the process of producing that work—the welding of idea, content or meaning, image, and form. A study of thematic development will show you the variety of ways artists use particular concepts so that you can better understand your own individual options.

Thematic drawings are a sustained series of drawings that have an image or idea in common. Artists have always worked in thematically related series, but a contemporary concern with process has made thematic development especially evident today. Galleries and museums not

only display works in series dealing with a single theme but also show working drawings leading to more finished pieces. Since the trend toward thematically related works is particularly current, this chapter focuses on the ways a body of related work can be developed.

There are a number of reasons to develop a series of drawings based on a single theme. The most basic reason is that art involves the mind as well as a coordination between eyes and hand. Art sometimes begins with an exercise in thinking and moves to an exercise in doing. Just as frequently, the order is reversed, but the processes of thinking, observing, and executing a drawing are always in tandem. The emphasis in a thematic series—and the emphasis throughout the problems in this chapter—is on process rather than product.

Any drawing problem has many possible solutions. Thematic drawings, since they are an open-ended body of work, provide a way to express more ideas or variations on an idea than it is possible to address in a single drawing. Nothing can better illustrate the number of possible compositional and stylistic variations on a given subject than a set of connected drawings. Since you will be using only one subject or idea throughout the series, you are free to attend more fully to matters of content and composition.

A thematic series allows you to go into your own work more deeply, with more involvement and greater concentration. Further, you work more independently, setting your own pace.

Finally, the process of working on a series develops a commitment to your ideas and thereby a professional approach. And, like a professional, you will begin more and more to notice the thematic patterns in other artists' work.

A first step toward developing thematic drawings is to look at the way other artists have handled a theme in their works. This chapter will discuss three general categories: *individual themes*, chosen by individual artists; *group themes*, developed within a movement or style, such as Cubism or Impressionism; and *shared themes*, the same images or subjects used by different artists over a period of time.

Individual Themes

An example of individual thematic development can be seen in the works of Claes Oldenburg. His proposed monument drawings depict imagined installations of familiar objects on an actual geographic site. The objects appear colossal because the viewer is forced to equate their size with the surrounding buildings and landscape. Oldenburg says that these drawings "combine two kinds of scale—the landscape and the object—in a single space (a sheet of drawing paper)." The Good Humor bar in Figure 277 serves as a piece of found architecture, a dam with a bite out of it to allow traffic to pass through.

In Oldenburg's work the emphasis is not on a polished, finished drawing but rather on an idea, a concept. His drawing style is energetic; sometimes he uses simple indications with just enough information to convey the idea, as in his collaged drawing that proposes a giant copper toilet float to be placed in the Thames River (Fig. 278). Oldenburg suggests

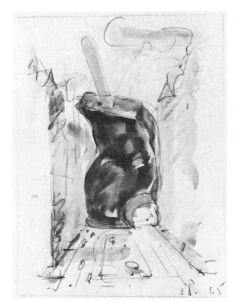

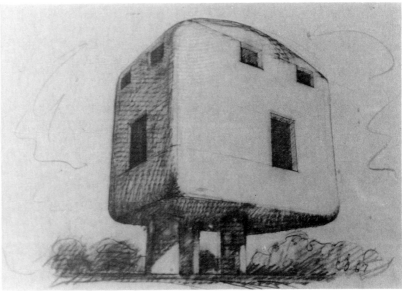

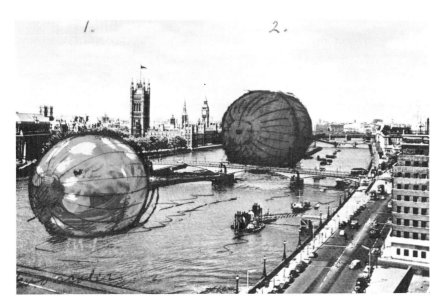

the ball would rise and fall with the tide, and in addition the large copper orbs would supply Londoners with sun, a bonus for such a foggy city.

In his *Building in the Form of an English Extension Plug* (Fig. 279), Oldenburg makes use of a more direct shape analogy. The plug is actually rather architectural looking; it is easy to see how the plug might be transformed into a modern-style building. Oldenburg explains the appropriateness of using this design for a church in that the three openings suggest a cross, and that both the plug and chapel can be identified with power, one electrical and the other religious.

The radical changes in scale make the viewer perceive the object in a different way; we become more conscious of its form. The plug is seen

right: **280.** Jim Dine.
Double Red Self-Portrait
(*The Green Lines*). 1964.
Oil and collage on canvas,
7 × 10′ (2.13 × 3.05 m).
Courtesy Pace Gallery, New York.

below left: **281.** Jim Dine.
*Charcoal Self-Portrait
in a Cement Garden.* 1964.
Charcoal and oil on canvas with
5 cement objects,
8′11¼″ × 3′9⅝″ × 2′3″
(2.75 × 1.17 × .69 m).
Allen Memorial Art Museum,
Oberlin College, Oberlin, Ohio.
(Ruth C. Roush Fund
for Contemporary Art).

below right: **282.** Jim Dine. *Fourteen
Color Woodcut Bathrobe.* 1982.
Woodcut, 6′5″ × 3′6″ (1.97 × 1.07 m).
Courtesy Pace Editions, New York.

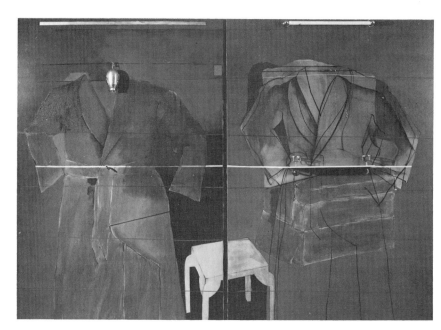

from an ant's eye view. Not only is it monumental, it is also *anthropomorphic;* that is, it takes on human characteristics.

Another example of individual thematic development is Jim Dine's bathrobe series (Figs. 280–282), which shows the artist's infusion of an everyday object with so much energy and personal meaning that it is a type of self-portrait. Dine draws a bathrobe with no one wearing it, but he becomes a part of the drawing because he projects the feeling that he is inside the robe. Dine has used the bathrobe as subject over a period of years. But he has changed the treatment of it by using different media—drawings, woodcuts, lithographs, and paintings—techniques, styles, and scales. He has also used the robe in combination with other elements, both two- and three-dimensional. The subject, or theme, has remained constant throughout these variations.

Individual themes can also deal with nonobjective images. In Figures 283 and 284, Vincent Falsetta uses scattered linear and curved patterns as repeating motifs. These vivacious elements are overlaid on a rigidly maintained, stippled grid. The works relate to each other by sharing a common motif, technique, and medium. The change from one work to the next in Falsetta's series is a subtle progression.

left: 283. Vincent Falsetta. *Untitled.* 1983.
Acrylic on canvas, 5′10″ × 5′5″ (1.78 × 1.65 m).
Private collection.

right: 284. Vincent Falsetta. *Untitled.* 1983.
Acrylic on canvas, 6′3″ × 5′10″ (1.86 × 1.75 m).
Private collection.

285. Transformation.
Student work. Vine charcoal,
24 × 18″ (61 × 46 cm).

286. Transformation.
Student work. Vine charcoal.
18 × 24″ (46 × 61 cm).

Problem 10.1
Visual Analogies

Thinking about visual analogies is a good way to begin your series. A visual analogy is a visual correspondence between two things that are otherwise dissimilar. The maxim "A picture is worth a thousand words" certainly applies here. We can readily distinguish the analogous shapes in Claes Oldenburg's extension plug drawing (see Fig. 279). With a minimum amount of change Oldenburg suggests the architectural context; the humor comes from the enormous shift in scale he forces upon the viewer.

Choose an object that interests you, that is significant to you. Analyze the object carefully; do several drawings of it in your sketchbook to grasp firmly its shape and structure. Experiment with viewpoint, drawing multiple views. After you are familiar with the visual aspects of the object, a transformational shape will probably suggest itself to you. In Figures 285 and 286, the student has converted an electric mixer into a fish; the shapes are analogous.

In addition to analyzing the form of the object, also analyze its function. Imagine it under various conditions. Imaginary leaps and associations will suggest themselves.

In Figure 287 the student makes a social comment by the forced relationship between the words and the image. The mixer is anthropomorphized conceptually—the viewer sees the mixer as a stand-in for the busy, mechanized housewife.

Your chosen object should undergo a number of transformations. You might make the transformations gradual, extending the series over a number of drawings, using different techniques, styles, and media.

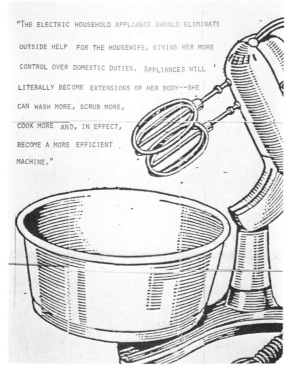

"THE ELECTRIC HOUSEHOLD APPLIANCE SHOULD ELIMINATE OUTSIDE HELP FOR THE HOUSEWIFE, GIVING HER MORE CONTROL OVER DOMESTIC DUTIES. APPLIANCES WILL LITERALLY BECOME EXTENSIONS OF HER BODY---SHE CAN WASH MORE, SCRUB MORE, COOK MORE AND, IN EFFECT, BECOME A MORE EFFICIENT MACHINE."

287. Transformation. Student work. Mixed media, 40 × 30″ (102 × 76 cm).

Problem 10.2
A Series of Opposites

Chapter 9 discussed the divided picture plane and how contemporary artists frequently create a feeling of disjunction by placing together two highly dissimilar objects. In this series you are to choose one object that will appear in each drawing. With that constant object juxtapose another object that will either amplify or cancel out the first object's meaning or function.

In Gael Crimmins' *Spout* (Fig. 288), she combines Piero della Francesca's 15th-century portrait of the Duke of Urbino with a small milk carton that is in some strange way analogous to the Duke's profile. By this surprising pairing we can read multiple meanings into the work: the debt of modern artists to Renaissance art, the dominance of man over nature, the richness of the old compared with the depleted, ordinary, contemporary carton.

In your drawings give real consideration to both the visual and conceptual effects of the opposites. Do they repel or attract?

288. Gael Crimmins.
Spout (after Piero della Francesca, *Duke of Urbino*).
Oil on paper, 22 × 22½″
(56 × 57 cm).
Private collection, Los Angeles.

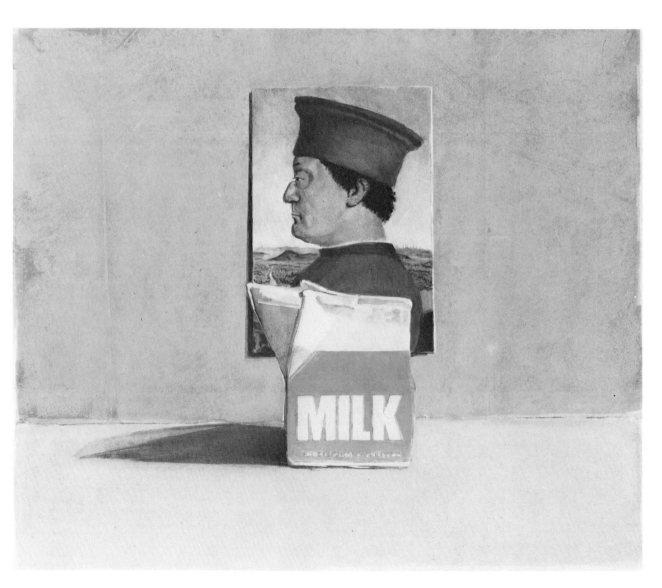

Problem 10.3
Transformation

Another way of developing a private theme is to have an object transform into another one. The two subjects need not be visually analogous to be transformed. In the student chair series in Figures 289 to 291, the torso merges with the chair, uniting and changing both figure and chair. The student has given the chair human characteristics; it has been anthropomorphized. Again, as in Problem 10.1, you should begin with analytical drawings of both objects before you begin the metamorphosis.

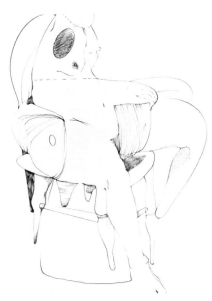

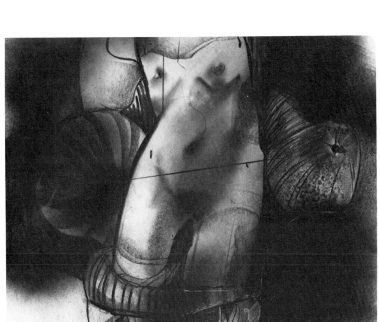

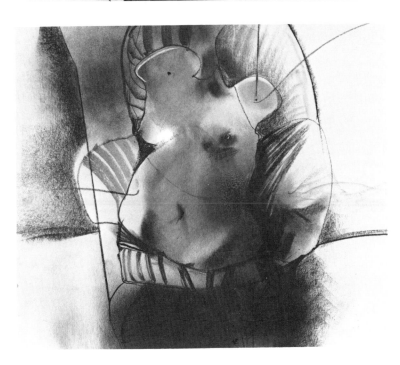

above right: **289.** Transformation. Student work. Pastel, 21 × 21″ (53 × 53 cm).

above left: **290.** Transformation. Student work. Pastel, 21 × 21″ (53 × 53 cm).

left: **291.** Transformation. Student work. Pastel, 21 × 21″ (53 × 53 cm).

Thematic Development **205**

right: **292.** Visual Narration.
Student work. Mixed media,
4½ × 3½″ (11 × 9 cm).

below left: **293.** Visual Narration.
Student work. Mixed media,
4½ × 3½″ (11 × 9 cm).

below right: **294.** Visual Narration.
Student work. Mixed media,
4½ × 3½″ (11 × 9 cm).

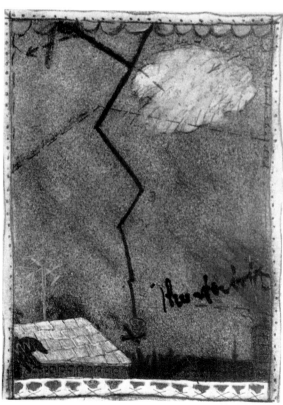

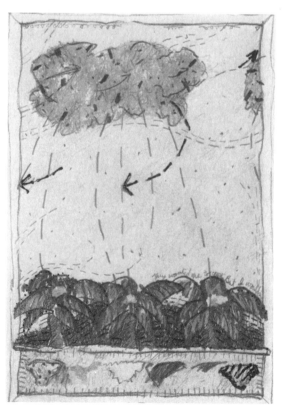

Problem 10.4
Visual Narration

A further suggestion for developing a series of drawings is to think of a visual narration. You might establish a "language" of privately developed symbols and have these symbols appear in each drawing. In Figures 292 to 294 the subject is the four elements—earth, air, fire, and water. Each drawing makes a reference to the weather; clouds, lightning, earth, and sky are the connecting motifs.

Problem 10.5
Developing a Motif

For this series you are to choose a single motif and develop it through variations of the form. Change the placement—the compositional, spatial arrangement—from drawing to drawing. Use nonobjective imagery rather than recognizable objects or figures.

In Figures 295 and 296 the motif is a centralized image that somewhat resembles a billowing piece of paper. These images seem to pulsate, at times floating forward out of the picture plane, sometimes folding back on themselves. The medium is graphite; texture and value are important elements in the spatial settings.

below: **295.** Development of a motif. Student work. Graphite, 30 × 26″ (76 × 66 cm).

right: **296.** Development of a motif. Student work. Graphite, 32 × 28″ (81 × 71 cm).

left: 297. Formal Development: Expressive. Student work.
Pastel and turpentine, 22 × 30″ (56 × 76 cm).

right: 298. Formal Development: Expressive. Student work.
Pastel and turpentine, 22 × 30″ (56 × 76 cm).

Problem 10.6
Formal Development

In this series you are to choose abstract shapes and use the same media and techniques in each of the drawings. Drawings dealing with form need not lack in expressive content. Formal development does not rule out the subjective approach. The student drawings using pastel and turpentine (Figs. 297 and 298) make a personal statement through their gestural marks. The boldness of the approach conveys an expressionistic immediacy.

Group Themes

Members of the same schools and movements of art share common philosophical, formal, stylistic, and subject interests. Their common interests result in group themes. Georges Braque and Pablo Picasso, both Cubists, illustrate the similarity of shared concerns most readily (Figs. 299, 300). Their use of ambiguous space through multiple, overlapping, simultaneous views of a single object, along with a combination of flat and textured shapes, is an identifying stylistic trademark. Collage elements—newspapers, wallpaper, and playing cards—as well as images of guitars, wine bottles, and tables appear in the works of many Cubists.

Pop artists have a preference for commonplace subjects. As the name suggests, these artists deal with popular images, taken from mass media, which are familiar to almost everyone in American culture. Not only do they choose commercial subjects such as the Coca-Cola bottle (Figs. 301, 302), but they also use techniques of advertising design such as the repeated or jumbled image. The effect of the seemingly endless rows of bottles in Andy Warhol's painting is to emphasize the conformity and sameness of a commercially oriented world. For the Pop artists both subject and technique make a comment on American life and culture.

left: **299.** Georges Braque. *Musical Forms.* 1913.
Oil, pencil, and charcoal on canvas; 36¼ × 23½″ (92 × 60 cm).
Philadelphia Museum of Art
(Louise and Walter Arensberg Collection).

above: **300.** Pablo Picasso. *Bottle, Glass and Violin.* 1912–13.
Paper collage and charcoal, 18½ × 24⅜″ (47 × 62 cm).
Moderna Museet, Stockholm.

below: **301.** Tom Wesselmann. *Still Life #50.* 1965.
Assemblage on wood; diameter 39½″ (100 cm),
depth 4″ (10 cm). Courtesy Sidney Janis Gallery, New York.

right: **302.** Andy Warhol. *Green Coca-Cola Bottles.* 1962.
Oil on canvas, 6′10″ × 4′9″ (2.08 × 1.45 m).
Whitney Museum of American Art, New York
(Purchase, with funds from the Friends of the Whitney
Museum of American Art).

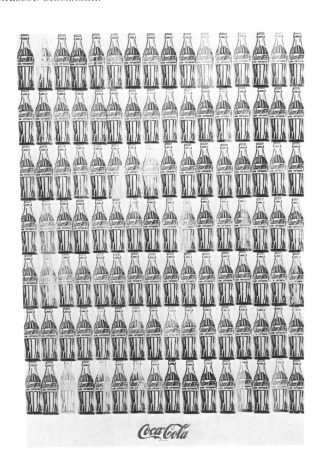

Problem 10.7
"In-the-Manner-of" Drawing

Arrange a still life of objects that are common to the contemporary scene. Make three drawings using a different style for each drawing; for example, one in the Pop style, one in the Impressionistic style, and one in the style of German Expressionism. Use media appropriate to your chosen style. Pastels are appropriate for Impressionism; acrylic paint would work well for the Pop style drawing, oil paint for German Expressionism. Look at several artists within each chosen style before you begin your stylistic homage so that you will be thoroughly acquainted with the identifying characteristics of each period. Color will be an important element in these drawings.

Shared Themes

Examples of the third category, shared themes, come from art history. Artists frequently raid the works of their predecessors for subject sources.

Larry Rivers and Mel Ramos are only two among many who have taken subjects from earlier art and given them new meaning. In *I Like Olympia in Black Face* (Fig. 303), Rivers transforms Edouard Manet's painting (Fig. 304) into a mixed-media construction. Ramos' satirical handling of the same painting transposes Manet's 19th-century figure into a 1970s centerfold (Fig. 305). Different techniques, styles, and materials have worked jolting transformations.

Shared themes include the very personal subject of the artist's own studio. A studio is the artist's contained world; it is a private and personal space. Work using this subject matter, therefore, has an autobiographical

303. Larry Rivers. *I Like Olympia in Black Face.* 1970. Mixed media construction, 5'11" × 6'3⅝" × 3'3" (1.82 × 1.94 × 1 m). Musée National d'Art Moderne. Centre Georges Pompidou, Paris.

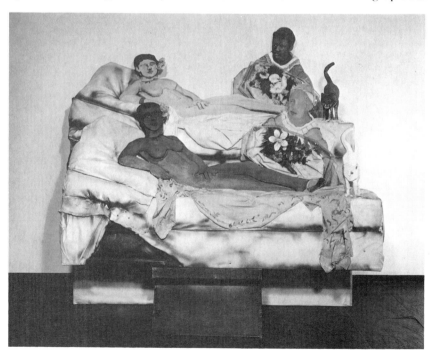

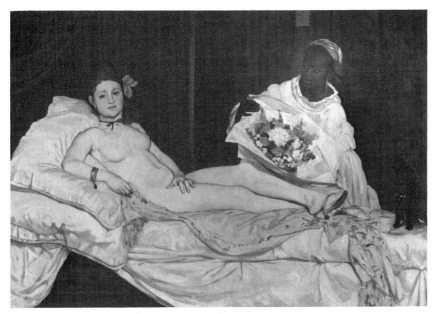

304. Edouard Manet. *Olympia.* 1863. Oil on canvas,
4′ 3¼″ × 6′ 2¾″ (1.3 × 1.9 m). Louvre, Paris.

305. Mel Ramos. *Manet's Olympia.* 1973. Oil on canvas,
4′ × 5′10″ (1.22 × 1.78 m). Courtesy Louis K. Meisel Gallery,
New York.

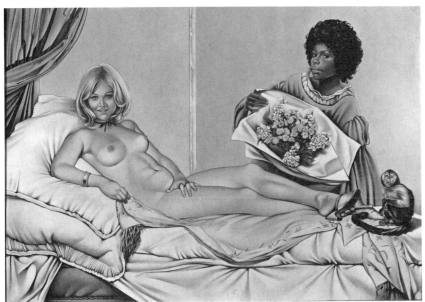

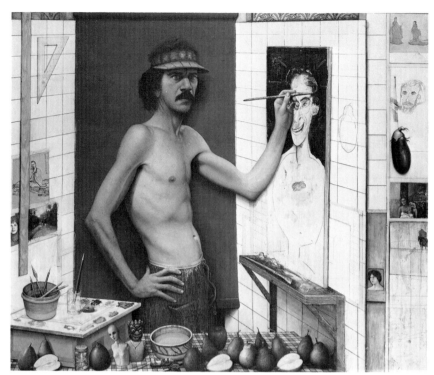

306. Gregory Gillespie. *Myself Painting a Self-Portrait.* 1980–81.
Mixed media on wood, 4′10⅛″ × 5′8¾″ (1.47 × 1.75 m).
Hirshhorn Museum and Sculpture Garden, Smithsonian Institution,
Washington, D.C.

307. William T. Wiley.
Nothing Conforms. 1978.
Watercolor on paper,
29½ × 22½″ (74.93 × 57.15 cm).
Collection Whitney Museum
of American Art, New York.
(Neysa McMein Purchase Award
[and purchase]).

overtone. This is decidedly true of Gregory Gillespie's painting (Fig. 306). Gillespie looks out at the viewer as if to a mirror. The figure in the center is painted in a realistic style, convincingly and carefully rendered. The painting within the painting is distorted, expressionistic, unlike the other objects in the studio. Traditional still-life material is lined up along the lower edge of the painting, small thumbnail sketches are attached to the walls on either side. Gillespie calls our attention to the dual basis of art, the conceptual, abstracting base and the perceptual one. He points out multiple levels of reality in this single painting.

William T. Wiley's *Nothing Conforms* (Fig. 307) shows us the kind of metamorphosis that takes place in an artist's studio. Wylie himself is absent, but we are privy to a look into a cluttered, chaotic, crumbling room, filled with symbols of time and change—candle, skeleton, worn shoe. A looped infinity symbol hangs on the wall on the right; a mirrored wall is on the left reflecting the double spiral and a triangle, symbols of eternity. This cluttered interior is the subject of the neat, highly ordered composition tacked on the wall, and in that painting within a painting is yet another painting, this one blank. Wiley has an amazing stock of images, all invested with symbolic significance and housed in humorous visual and verbal settings.

Some shared themes appeal to a wide public. Their general human concerns have a universal attraction. The traditional mother and child are the subjects (Fig. 308) of Mary Cassatt's 19th-century etching. The child completes the triangle between mother and nursemaid. A balanced, insulated, protected world is depicted. Sharply contrasting in feeling and content is Alice Neel's *Carmen and Baby* (Figure 309). Her interest

left: **308.** Mary Cassatt. *In the Omnibus.* 1891. Drypoint, soft ground, and aquatint, in color; 14⅜ × 10½″ (36 × 27 cm). National Gallery of Art, Washington, D.C. (Gift of Chester Dale, 1963).

right: **309.** Alice Neel. *Carmen and Baby.* 1972. Oil on canvas, 40 × 30″ (102 × 76 cm). Collection the artist and/or family.

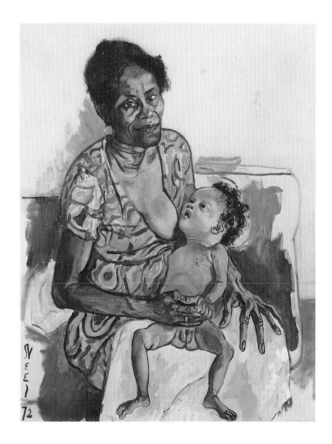

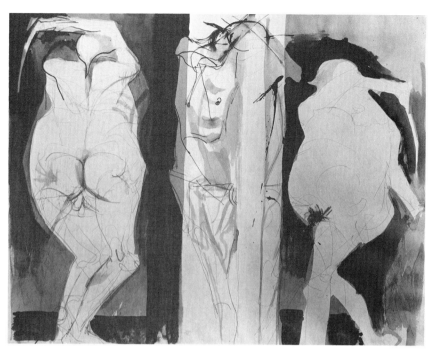

310. Rico Lebrun. *Flagellation.* 1959. Ink wash.
Private collection.

in women's experiences and motherhood furnished her with a continuing theme. The unconventional view of a mother with her ill infant is a moving portrait. Neel's view is above eye-level, so that the mother's loving face looms as the focal point of the composition. The child's strange posture with its frail bent legs is echoed in the mother's enfolding hand. Neel makes a psychologically gripping statement in this work.

Other fertile sources of thematic imagery shared by many artists are archetypal, mythological, and religious subjects. Religious subject matter has always provided emotional content for artists. Rico Lebrun's drawing of the flagellation of Christ (Fig. 310) illustrates the continuing power of such a religious subject. Lebrun uses a format that evokes a tripytch, the three-panel folding altar piece traditional in medieval and Renaissance art. The brutal subject still has power as a statement on man's inhumanity to man.

A religious subject from another culture, *Priest of Shango, the Yoruba Thunder God* (Fig. 311), by the Nigerian artist Twins Seven Seven, shows the universality of myth and religion as continuing sources of thematic imagery. The richly filled space with its highly inventive texturing conveys the idea of the power of the thunder god. Each shape interlocks into the adjoining one; a spiral motif, used as theme and variation, activates the surface. The conceptual approach is fitting for the mythic intent.

Problem 10.8
Art History Series

Choose as your subject a painting from art history. Make a series of several drawings with the painting as a point of departure. You can approach your series through any of the methods discussed in this chapter. The painting can be altered and transformed stylistically. You can make changes in the form, or you can use a contemporary compositional format taken from Chapter 9.

In Figure 312 the student has transformed a 19th-century English Pre-Raphaelite painting by Dante Gabriel Rossetti into a free-standing, three-dimensional tableau. He layered photocopies of the painting into a bas-relief. The photocopy technique is combined with some hand tinting to subtly alter the original work.

In your series you can change the meaning of a work taken from art history by transforming a religious or mythological subject into a scientific or secular context.

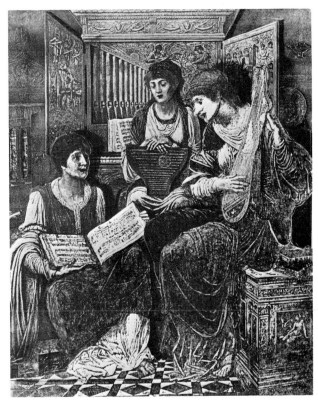

left: **311.** Twins Seven Seven. *Priest of Shango, the Yoruba Thunder God* (Oshogbo). 1966. Pen and ink with gouache, 6 × 2′ (1.83 × .61 m). Courtesy the artist.

below: **312.** Art history transformation. Student work. Hand-tinted photocopy, 11 × 8½ × 3½″ (28 × 22 × 9 cm).

left: **313.** Art history transformation. Student work. Collage and photocopy, 10 × 6½″ (25 × 17 cm).

right: **314.** Art history transformation. Student work. Collage and photocopy, 10 × 10″ (25 × 25 cm).

The transformations shown in Figures 313 and 314 are based on Leonardo da Vinci's 15th-century *The Last Supper* (Fig. 315). The subject does not change, but the use of grids and 20th-century collage techniques gives the drawings a contemporary look. In the student's earlier drawings in the series, *The Last Supper* is dominant; in later work in the series the fish develops at a more accelerated pace.

Problem 10.9
Myth as Subject

Choose as your subject a myth, for example, the Greek story of Icarus. Make a series of drawings that are loosely based on your chosen story. Do not try to illustrate the myth, simply let the idea furnish you with a departure point.

315. Leonardo da Vinci. *The Last Supper.* 1495–98.
Fresco, 14′5″ × 28′¼″ (4.39 × 8.54 m).
Santa Maria della Grazie, Milan.

SUMMARY: Development of a Theme

An artist's style is related to imagery. Sometimes an artist works with an idea in different media and in different styles, yet the theme is constant. In other artists' work the theme is the result of a stylistic consistency, and the imagery is changed from piece to piece. Whatever approach you take, let your own personal expression govern your choices.

Here is a list of some variables that will help you in structuring your thematic series:

1. subject matter or imagery
2. media or material
3. technique
4. visual elements (line, shape, color, texture, and value)
5. scale

It is necessary to find a theme that is important to you. Each drawing in your series should suggest new ideas for succeeding drawings. An artist must observe, distinguish, and relate; these three steps are essential in developing thematic work. After having completed several of these problems, you will think of ways of developing your own personal approach.

CHAPTER 11

A Look at Art Today

Since artists are both makers and critics of art, involvement with the art of others is essential for the practicing artist. The art experience, both the making and viewing of art, contributes to the growth of the artist. Familiarity with the many directions and styles in today's art will enable you to relate your work to your own experiences and to the times. An acquaintance with current trends will increase your knowledge of art and provide a reservoir of techniques and points of view from which you can choose for your own purposes.

This chapter will look at a variety of styles, new sources of subject matter, and the breakdown of strict categories in contemporary art.

316. David Salle.
Schizophrenia Prism. 1982.
Oil and acrylic on canvas,
6 × 8′ (1.83 × 2.44 m).
Collection Lewis/Susan Manilow,
Chicago.

Since this chapter is an overview of current art, it is impossible to look at any one artist or style in depth. An artist's personal expression cannot be placed within the confines of a single category. You are urged to investigate the particular individual concerns of each artist and to determine for yourself the relationship of your art to the art of our times.

Proliferation of Styles

Art has taken diverse directions in the latter half of the 20th century exhibiting the proliferation and mixing of various philosophies, styles, techniques, materials, and subjects. The result has been stylistic pluralism. Today many styles of art exist side by side; one style does not replace another in a pendulum swing, each reacting to the style preceding, as was true earlier in the century.

Present-day art includes both representational and nonrepresentational work. Some artists use an expressionistic approach; others advocate a more objective, formal approach. Some work is sophisticated; some is naive. Some artists even use two or more styles in the same work, a characteristic of David Salle's art (Fig. 316). An abbreviated look at some current styles will illustrate the point.

Minimalism

Minimal, or Reductivist, Art, a formalist style begun in the 1960s, explores painting's and sculpture's essential formal properties; that is, how form is used. It reduces the form and concentrates the viewer's focus strictly on a limited number of elements such as shape and line, as

317. Dorothea Rockeburne. *Stele.* 1980. Conté crayon, pencil, oil, gesso on linen; 7′7¼″ × 4′3¼″ (2.32 × 1.30 m). Private collection.

in Dorothea Rockeburne's *Stele* (Fig. 317). This work is an example of the precision and clarity that is found in Minimalist art. The piece has a presence that is self-contained; that is, it is stripped of references outside itself. Minimalism confronts the viewer with questions of perception.

Conceptualism

Developing about the same time as Minimalism was a revolutionary trend, Conceptualism. Earlier in the century Marcel Duchamp advocated the primacy of idea over form (Figs. 318, 319). He is credited with the idea of replacing the actual art object with documentary information about it. In Conceptual Art, idea is the essence. A logical extension of giving priority to the idea is the diminishing of the importance of the form. Some artists have found ways to convey the idea and to eliminate the art object, using descriptive words either as blueprints for proposed projects or as the remnant object. In other words, they considered it sufficient to document the idea without actually executing the project.

Earthworks and Environmental Art

Related to Conceptual Art in its secondhand presentation of the art work are Earthworks and Environmental Installations, which involve the information networks of the day-to-day environment. The artist relies heavily upon documentation, drawings, written descriptions, and photographs of the work in addition to scientific information concerning the site. Such is true of Christo's projected wrapping of the Alcalá Monument in Madrid (Fig. 320). Christo's projects, which are highly publicized in the news media, involve a partnership of art and technology.

left: **318.** Marcel Duchamp. *The Green Box.* 1934. Multiple edition of 300; mixed media; containing facsimiles of 93 documents.

right: **319.** Marcel Duchamp. Interior view of Fig. 318, Marcel Duchamp's *The Green Box,* showing enclosed documents.

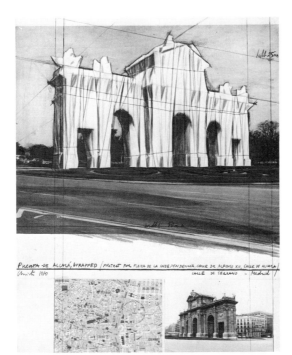

320. Christo. *Puerta de Alcalá Wrapped/Project for Madrid.* 1980. Collage (fabric, twine, photostat from a photograph by Wolfgang Volz, pastel, charcoal, pencil, photograph, and map), 28 × 22″ (71 × 56 cm). Courtesy the artist.

Photorealism and Realism

Just as photography is an important technique in the documentation of Conceptual Art and Earthworks, a style has emerged that uses the photograph as image. In the movement known as Photorealism the artist duplicates what the camera sees, both its focus and its distortion. Artists such as Tom Blackwell and Chuck Close (see Figs. 122 and 9) claim a goal of impersonality. Following the modernist dictum to produce "art about art," Photorealism falls within the formalist, or modernist, camp.

Realism (in the broader sense than Photorealism) is of long-standing tradition and has its contemporary practitioners, such as Philip Pearlstein (Fig. 321). Pearlstein is known for his oddly cropped figures, painted in a highly detached, coolly observed manner.

Pattern and Decoration

Women began the Pattern and Decoration movement as an attempt to break down the barriers between fine art and decorative art. Color, texture, and complexity are major considerations in Miriam Schapiro's *Tampa Houses* (Fig. 322). The dresses operate on multiple levels in this work; they are a formal, organizing device; they stand for themselves; they remain recognizable garments; and they furnish content and meaning in their feminist concern.

321. Philip Pearlstein.
Two Female Models in Bamboo Chairs with Mirror. 1981.
Oil on canvas,
6′3⁄16″ × 6′1⁄8″ (1.83 × 1.83 m).
The Toledo Museum of Art
(Gift of Edward Drummund Libbey).

322. Miriam Schapiro. *Tampa Houses.*
Acrylic and fabric on paper,
30 × 30″ (76 × 76 cm).
Courtesy Koplin Gallery,
Los Angeles.

Graffiti Art

Several styles revolve around rejection of establishment values in art and culture. One example of this antiart approach is the subversive movement known as Graffiti Art. Its practitioners produce undercover art painted in subways, trains, and the streets. Ironically, some of these Graffiti artists, such as Keith Haring, Jean Michel Basquait, and Kenny Scharf (Fig. 323), have been embraced by the art establishment, and their work is shown in galleries and museums.

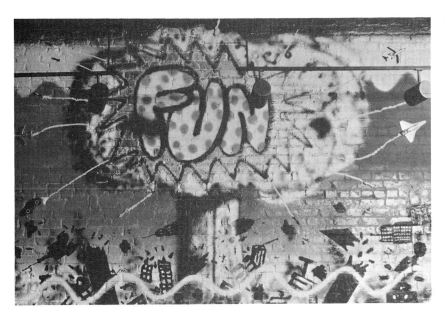

323. Kenny Scharf.
Untitled (Fun). 1982.
Spray paint on wall.
Courtesy Tony Shafrazi Gallery,
New York.

Neo-Naive and Bad Painting

Two other movements also involved in a rejection of accepted forms are the Neo-Naive and Bad Painting groups. Roy De Forest, a Neo-Naive painter, does work of a childlike directness, even if the meaning is complex and difficult to unscramble (Fig. 324). An antistyle artist of the Bad Painting group, Jonathan Borofsky, uses scrawled figures that seem to come from dream imagery. Interpretation is confusing because these images appear with serial numbers (Fig. 325). Borofsky continues his obsessive counting, he says, to provide a conceptual unity to his varied works.

New Image, New Wave, and Neo-Expressionist Painting

Rejection of the past also determines New Painting, a movement that includes New Wave and New Image Painting in New York and Neo-Expressionism internationally. Holding a profane, despairing view of the present-day social, political, and cultural predicament, New Painting is often characterized by crude figuration, strong color, expressionistic handling of paint, large scale, and offensive subject matter. This approach, which pulls out all stops, seems light years away from the cool detachment of Minimalist Art.

New Image artists depict recognizable objects, animals, or people sometimes simplistically and crudely, sometimes with more sophistication. Even though the images are identifiable, they are not presented in an associative background, thereby producing an effect that is highly disorienting for the viewer. Susan Rothenberg's ghostly horses become metaphors for the human condition (Fig. 326). The background of her work taken in isolation seems strongly energized, yet in combination with the large, single, outlined figure, the effect is numbing.

Neo-Expressionism has an immediacy of social and political import. It harks back to earlier German Expressionism in its use of subjects, symbols, style, and in its cynical despair. The German Helmut Middendorf is an exponent of this apocalyptic approach. In his painting (Fig. 327) he makes self-conscious use of such stylistic revival.

324. Roy De Forest. *Untitled.* 1976. Pastel on paper, 22½ × 30″ (57 × 76 cm). Courtesy Allan Frumkin Gallery, New York.

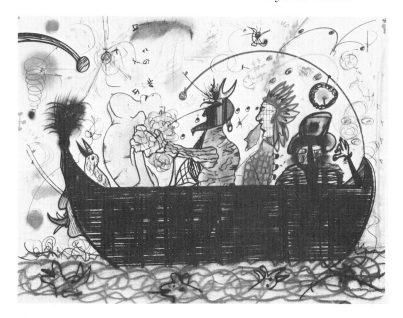

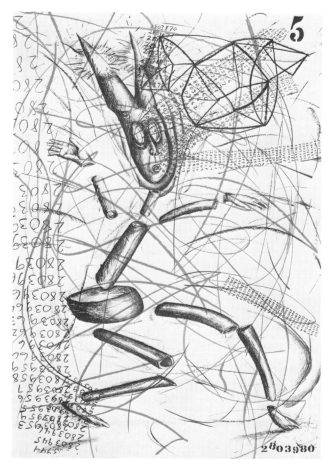

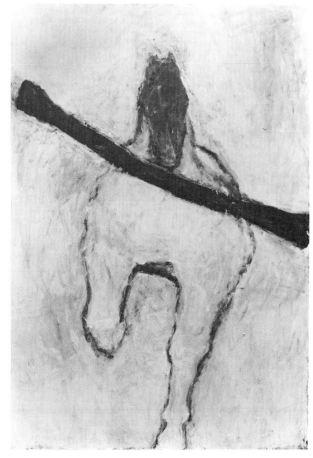

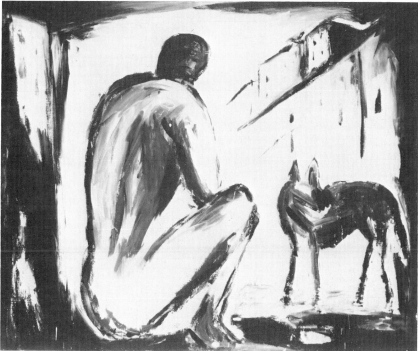

above left: 325. Jonathan Borofsky. *Stick Man.* 1983. 4-color lithograph, 4′4½″ × 3′1¾″ (1.34 × .96 m). Courtesy Gemini G.E.L., Los Angeles.

above right: 326. Susan Rothenberg. *Pontiac.* 1979. Acrylic and flashe on canvas, 7′4″ × 5′1″ (2.24 × 1.55 m). Private collection.

left: 327. Helmut Middendorf. *The Dog Painting.* 1983. Acrylic on canvas, 5′10⅞″ × 7′2⅝″ (1.8 × 2.2 m). Courtesy Galerie Gmyrek, Dusseldorf.

Contemporary Sources of Imagery

Concomitant with the expansion of styles comes an explosion of imagery. Anything goes in the choice of subject; symbols are used with a vengeance, with an abandon not seen earlier. Figurative imagery is everywhere seen. An extreme point of view is taken in much contemporary art.

328. Robert Longo. *Untitled* (White Riot series). 1982. Charcoal, 2 panels, graphite, ink on paper; each 8 × 5' (2.44 × 1.52 m), overall 8 × 10' (2.44 × 3.05 m). Collection Eli and Edythe L. Broad, Los Angeles.

329. Leon Golub. *White Squad II.* 1982. Acrylic on canvas, 10' × 15'6" (3.05 × 4.75 m). Courtesy Susan Caldwell Gallery, New York.

Political and social statements are explicit in Robert Longo's White Riot drawings (Fig. 328) and Leon Golub's hostage figures (Fig. 329). The emptiness of the backgrounds in these two artists' work seems to lock their figures into a permanent excruciating grip. The violence mirrors the nightly news reports.

Animal subject matter abounds. Mario Merz' rudely drawn beast stands as an explicit metaphor for our brute nature (Fig. 330). Again looking back to German Expressionism, he has chosen animal imagery but uses it here to symbolize the holocaust.

Accompanying the interest in Expressionism is the involvement with the primitive and the mythic. A. R. Penck (a pseudonym; the original Penck was a geologist who studied the Ice Age) worked first as a Conceptualist. His work is autobiographical, seemingly abstract, but highly personalized. His crossing over from East Germany to the West has provided him with a powerful archetypal theme of passage. His figures are stated in minimal terms, surrounded by symbolic fragments, many derived from Paleolithic cave paintings (Fig. 331). Although the images are bleak, the work produces a powerful impact.

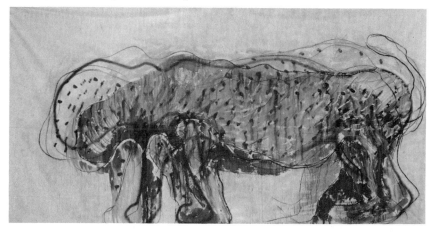

330. Mario Merz. *Animale Terribile.* 1979. Mixed media on canvas, 7'5¾" × 15'6" (2.3 × 4.75 m). Collection Christian Stein, Turin.

331. A. R. Penck. *T.III.* 1981. Dispersion on canvas, 6'7" × 9'2½" (2.01 × 2.81 m). Collection Martin Sklar, New York.

On the lighter side, irony and humor have their advocates. Some of todays artists continue the light-hearted approach of Pop Art's tongue-in-cheek style. Masami Teraoka paints cross-cultural allegories, combining the traditional with the new (Fig. 332). Teraoka looks back to 17th-century Japanese art for technique and image and invests it with a modern message.

Clichés are a favored subject. Just as the new painters have satirized old styles, they have brought out and refurbished old subjects and symbols. In previous chapters you have already seen how widely artists borrow from other artists. Andy Warhol is the Pop master of cliché. In his use of the *Mona Lisa* (Fig. 333), the ultimately depleted image, the technique is more interesting than the subject.

Appropriation of images from sources other than painting is the subject of several artists' work. John Baldessari in *A Different Kind of Order (The Thelonious Monk Story)* (Fig. 334), has used stills from old films and hung them askew on the wall. The images are of catastrophic events, of a world in disarray. The final frame tells the story:

There's a story about Thelonius Monk going around his apartment tilting all the pictures hanging on the wall. It was his idea of teaching his wife a different kind of order. When she saw the pictures askew on the wall she would straighten them. And when Monk saw them straightened on the wall, he would tilt them. Until one day his wife left them hanging on the wall tilted.

left: **332.** Masami Teraoka.
Samurai Businessman Going Home.
1981. Watercolor on paper,
13¼ × 9¾" (34 × 25 cm).
Private collection.

right: **333.** Andy Warhol. *Mona Lisa.*
1963. Silkscreen on canvas,
10'8" × 6'10" (3.25 × 2.08 m).
Courtesy Leo Castelli Gallery,
New York.

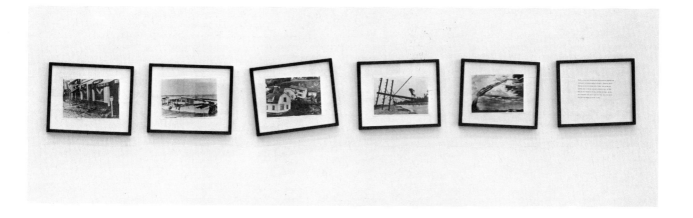

Some artists minimize content and emphasize form; others minimize formal considerations and emphasize idea or meaning. Contemporary art is not only pluralistic in style but in the number of subject possibilities as well. Images can be added to, subtracted from, transformed, destroyed, rebuilt, invented, used realistically or abstractly. Whatever choices the artist makes, imagery is exciting both for the meaning it conveys and for the way it is incorporated into the art work.

Crossover of Categories

Contributing to the trend of stylistic eclecticism is a crossover of categories in the arts; the distinctions have been blurred. This blurring has taken place in three areas. The visual arts have overlapped one another, have merged with other arts—drama, music, dance, and literature—and have been affected strongly by science and technology.

In earlier times the traditional separation of sculpture, painting, and drawing was more readily determined; today the demarcation lines are less precise. Red Grooms' three-dimensional lithograph of Gertrude Stein (Fig. 335) is both a print and a sculpture, a sort of paper doll for adults.

334. John Baldessari. *A Different Kind of Order (The Thelonious Monk Story).* 1972–73. 5 gelatin photographs and text, each 11⅝ × 14¹¹⁄₁₆″ (29 × 37 cm). The Museum of Fine Arts, Houston (Museum purchase with partial funding by The National Endowment for the Arts).

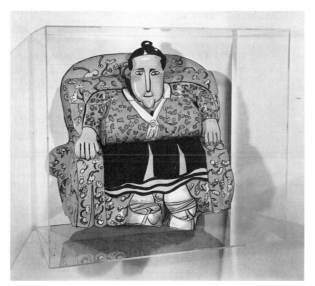

335. Red Grooms. *Gertrude.* 1975. 6-color lithograph, cut out, mounted, and boxed in acrylic; 19¼ × 22 × 10½″ (49 × 56 × 27 cm). Courtesy Brooke Alexander, Inc., New York.

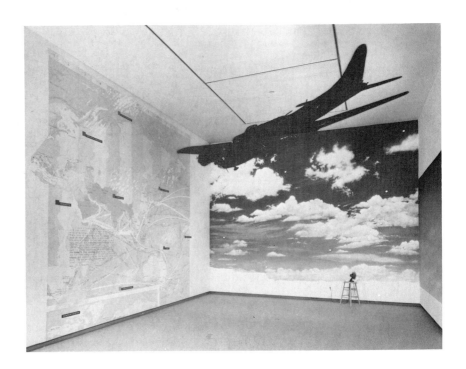

336. Vernon Fisher. *Breaking the Code.* 1981.
Mixed media installation at the Fort Worth Art Museum; 3 walls
15′6″ × 21′7″ (4.72 × 6.58 m), 15′6″ × 19′8″ (4.72 × 5.99 m), 15′6″ × 10′
(4.72 × 3.05 m). Courtesy Barbara Gladstone Gallery, New York.

337. Nic Nicosia. *Near Modern Disaster # 5.* 1983. Cibachrome,
3′4″ × 4′2″ (1.02 × 1.27 m). Courtesy the artist.

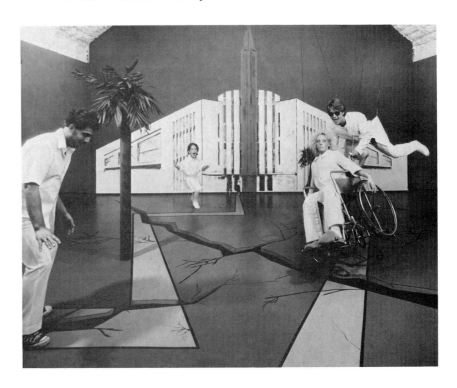

left: **338.** William Wegman. *Ray Cat.* 1978. Ink on black-and-white photograph, 13¼ × 10¾" (34 × 27 cm). Gilman Paper Company Collection.

right: **339.** Laurie Anderson. *United States, Part II.* 1980. Performance at the Orpheum Theatre, New York City, presented by the Kitchen. Courtesy Paula Court. © 1980.

Installations, such as Vernon Fisher's *Breaking the Code* (Fig. 336), frequently make use of two- and three-dimensional objects, painting, and words. Such works as Fisher's are often designed for a specific site, taking into consideration before the design of the piece the size and shape of the space to be filled.

Another variation of the installation is a direction many photographers are taking, for instance, the alteration of an environment before photographing it. Nic Nicosia tests our spatial perception with his alterations, which flatten space in unexpected and humorous ways (Fig. 337).

Other photographers simply alter and manipulate the photograph itself. William Wegman effects a witty change in his dog, Man Ray, by a quick defacing of the photograph (Fig. 338).

Art has always been connected with rituals, and ritualistic performances combine art, music, and dance. Some of today's performances are narrative; sometimes they are in an autobiographical mode; and sometimes they make political and social comment. Laurie Anderson is a performance artist who deals with a wide range of issues. Using technology as a powerful tool, Anderson combines slide projections, synthesized sound, and film. She serves in a single work as composer, writer, photographer, filmmaker, musician, and actor. She expands the role of the artist to be all-inclusive (Fig. 339).

340. Claudia Betti.
Journey into the Duat/Cycle 8.
1983. Mixed media. Image 7 × 5″
(18 × 13 cm) on paper 30 × 20″
(76 × 56 cm). Courtesy the artist.

341. Arakawa. Drawing from *The Signified Or If. . . .* 1974–75.
Colored pencil, 2′6″ × 6′8″ (.76 × 2.03 m).
Courtesy Ronald Feldman Fine Arts, New York.

342. Teel Sale. *Obituary* – Handmade Book, 1983.
Wood, bronze, paper, plastic; box: 2½ × 11″ (6 × 28 cm).
Courtesy the artist.

The relationship between the visual arts and literature is long standing. Artists have always used imagery derived from literary sources. Their interest in words manifests itself in a variety of forms. Some artists, such as Baldessari and Fisher, use words in a narrative context. Others, such as Claudia Betti, use only fragments of statements to generate ideas and images (Fig. 340). Betti begins with a phrase of philosophical import and lets the shape of the words dictate the imagery.

Some artists are involved in linguistics, the analysis of the way language works. Arakawa's drawing from *The Signified Or If* . . . (Fig. 341) is an example of the involvement with the structure of language, of signs and signifiers.

Edward Ruscha divorces the word from its semantic intent (see Fig. 104); he uses the word itself as image. The actual meaning of the word is not the meaning of the drawing.

Many artists today are involved in making one-of-a-kind books, which may or may not use language. Some are strictly visual; others, such as Teel Sale's *Obituary* (Fig. 342), combine words and images.

Machines produced by 20th-century technology have been appropriated for artists' use. Generative processes of all kinds—computer printouts, holography, photocopy, and video—are popular image makers, and some, such as copy machines, are readily available to everyone. Video continues as an important medium for artists. Used for documentation and in conjunction with performance, video introduces time and

343. Juan Downey and Claudio Bravo. *Venus and Her Mirror.* 1978. Oil on canvas with video installation 4′¾″ × 5′10″ (1.24 × 1.78 m). Courtesy Castelli/Sonnabend Tapes and Films, Inc., New York.

motion into the art work. The Chilean artists Juan Downey and Claudio Bravo collaborated on a video installation in *Venus and Her Mirror* (Fig. 343). Bravo, a Hyperrealist, executed the oil painting while Downey made the color video tape. Venus, a favorite subject in art history, has a television as a replacement for her mirror. Art as a mirror of the times has been replaced by a television—a simple message relayed in rather complex form—and Venus as a metaphor for romantic idealism has her back turned on the viewer. Strange transformations of time, place, motion, and immobility are the result of this collaborative work. It is not surprising that in a technological age the medium itself becomes the message for many artists.

The expanded use of media allows for a more complex message. The breakdown of the conventional categories of drawing, painting, sculpture, and printmaking has resulted in a rich array of crossbreeds, closing the gap between art and life, a steadfast goal of the artists in this century.

Conclusion

The whole world of sensations and experiences is open for artists to investigate. They have freedom in choosing techniques, imagery, and materials. The challenge is not only to the artist but to the viewer as well. Through art we find new associations, new ways of processing information, and new questions about our perceptions.

Space and time are necessary requirements—time to make, time to view, time to digest, time to rethink and review. We are concerned not only with the visible or sensory but also with the knowable, thinkable aspects of art. Both artist and viewer are involved in the process. Art is a creative gift to all of us.

PART FOUR

Practical Guides

GUIDE A

Materials

The relationships among form, content, subject matter, materials, and techniques are the very basis for art, so it is essential that the beginning student develop a sensitivity to materials—to their possibilities and limitations. The problems in this text call for an array of drawing materials, some traditional, some nontraditional. The supplies discussed in this chapter are all that are needed to complete the problems in the book.

Warning: Since many materials used in the manufacture of art supplies are toxic, you should carefully read the labels and follow directions. Always work in a well-ventilated room.

Paper

To list all the papers available to an artist would be impossible; the variety is endless. The importance of the surface on which you draw should not be minimized. The paper you choose, of course, affects the drawing.

Since the problems in the book require the use of a large amount of paper, and since the emphasis is on process rather than product, expensive papers are not recommended for the beginning student. Papers are limited to three or four types, all of them serviceable and inexpensive. Experimentation with papers, however, is encouraged—you may wish to treat yourself to better-quality paper occasionally.

Newsprint and *bond paper* are readily available, inexpensive, and practical. Both come in bulk form—in pads of 100 sheets. Buying paper in bulk is much more economical than purchasing single sheets. Bond paper, a smooth, middle-weight paper, is satisfactory for most media. Newsprint is good for warm-up exercises. Charcoal and other dry media can be used on newsprint; it is, however, too absorbent for wet media.

Ideally, *charcoal paper* is recommended for charcoal drawing, since the paper has a tooth, a raised texture, that collects and holds the powdery medium. Charcoal paper is more expensive than bond paper and is recommended only for a few problems, those in which extensive rubbing or tonal blending is emphasized.

A few sheets of black *construction paper* are a good investment. Using white media on black paper makes you more aware of line quality and of the reversal of values. A few pieces of toned charcoal paper would likewise furnish variety. Only the neutral tones of gray or tan are recommended.

All paper should be at least 18 by 24 inches (46 × 61 cm). If you draw on a smaller format, you can cut the paper to size.

An inexpensive way to buy paper is to purchase it in rolls. End rolls of newsprint can be bought from newspaper offices at a discount. Photographic backdrop paper is another inexpensive rolled paper. It comes in 36-foot (10.98 m) lengths and 10-foot (3.05 m) widths. The paper must be cut to size, but the savings may be worth the inconvenience. The advantage to buying rolls of paper is that you can make oversize drawings at minimal cost. Brown wrapping paper also comes in rolls and is a suitable surface, especially for gesture drawings.

Another inexpensive source of paper is scrap paper from printing companies. The quality of the paper varies as does the size and color, but it would be worthwhile to visit a local printing firm and see what is available.

Shopping for drawing papers can be a real treat. You need to examine the paper for its color, texture, thickness, and surface quality—whether it is grainy or smooth. In addition to these characteristics you need to know how stable the paper will be. Paper is, of course, affected by the materials from which it is made, by temperature, and by humidity. Paper that has a high acid or a high alkaline content is less stable than a paper made from unbleached rag or cotton; such papers are not lightfast, for example. The selected papers listed below are more expensive than the newsprint, bond, and charcoal paper that is recommended for most of the exercises in this text. Remember to select a paper that seems to you

to be right for a given project. Becoming acquainted with various papers and learning their inherent qualities is one of the joys of drawing.

Selected Papers for Drawing (high rag content)

Arches	22 × 30″; 25 × 40″	(56 × 76; 64 × 102 cm)
Copperplate Deluxe	30 × 42″	(76 × 107 cm)
Fabriano Book	19 × 26″	(49 × 66 cm)
Fabriano Cover	20 × 26″; 26 × 40″	(51 × 66; 66 × 102 cm)
German Etching	$31\frac{1}{2} \times 42\frac{1}{2}$″	(80 × 105 cm)
Index	26 × 40″	(66 × 102 cm)
Italia	20 × 28″; 28 × 40″	(51 × 71; 71 × 102 cm)
Murillo	27 × 39″	(69 × 100 cm)
Rives BFK	$22\frac{1}{2} \times 30$; $29\frac{1}{3} \times 41\frac{1}{3}$″	(57 × 76; 74 × 105 cm)
Strathmore Artists	Various sizes	

Some Suggested Oriental Papers (plant fiber content)

Hosho	16 × 22″	(41 × 56 cm)
Kochi	20 × 26″	(51 × 66 cm)
Moriki 1009	25 × 36″	(64 × 92 cm)
Mulberry	24 × 33″	(61 × 84 cm)
Okawara	3 × 6′	(.92 × 1.83 m)
Suzuki	3 × 6′	(.92 × 1.83 m)

The sketchbook pad is discussed in the Practical Guide to Keeping a Sketchbook. Size is optional. You should choose a size that feels comfortable to you, one that is easily portable, no larger than 11 by 14 inches (28 × 36 cm).

Charcoal, Crayons, and Chalks

Charcoal is produced in three forms: vine charcoal, compressed charcoal, and charcoal pencil.

Vine charcoal, as its name indicates, is made from processed vine. It is the least permanent of the three forms. It is recommended for use in quick gestures since you can remove the marks with a chamois skin and reuse the paper. The highly correctable quality of vine charcoal makes it a good choice for use early in the drawing, when you are establishing the organizational pattern. If vine charcoal is used on charcoal paper for a longer, more permanent drawing, it must be carefully sprayed several times with fixative.

Compressed charcoal comes in stick form and a block shape. With compressed charcoal you can achieve a full value range rather easily. You can draw with both the broad side and the edge, easily creating both mass and line.

Charcoal pencil is a wooden pencil with a charcoal point. It can be sharpened and will produce a much finer, more incisive line than compressed charcoal.

Charcoal is easily smudged; it can be erased, blurred, or smeared with a chamois skin or kneaded eraser. All charcoal comes in soft, medium, and hard grades. Soft charcoal is recommended for the problems in this book.

Conté crayons, too, can produce both line and tone. They come in soft, medium, and hard grades. Experiment to see which you prefer. Conté comes in both stick and pencil form. It has a clay base and is made of compressed pigments. Conté is available in white, black, sanguine, and sepia.

Water or turpentine will dissolve charcoal or conté if a wash effect is desired.

Colored chalks, or *pastels*, can be used to layer colors. These are manufactured either with or without an oil base.

Another medium in stick and pencil form is the *lithographic crayon* or *lithographic pencil*. Lithographic crayons have a grease base and are soluble in turpentine. They, too, can be smudged, smeared, and blurred and are an effective tool for establishing both line and tone. The line produced by a lithographic crayon or pencil is grainy; lithographic prints are readily identified by the grainy quality of the marks. (Lithographic crayons and pencils are specially made for drawing on lithographic stone, a type of limestone.) Lithographic crayons are produced in varying degrees of softness. Again, you should experiment to find the degree of softness or hardness you prefer.

China markers, like lithographic pencils, have a grease base and are readily smudged. Their advantage is that they are manufactured in a wide variety of colors.

Colored oil sticks are an inexpensive color medium that can be dissolved in turpentine to create wash effects.

Pencils and Graphite Sticks

Pencils and graphite sticks come in varying degrees of hardness, from 9H, the hardest, to 7B, the softest. The harder the pencil, the lighter the line; conversely, the softer the pencil, the darker the tone. 2B, 4B, and 6B pencils and a soft graphite stick are recommended. Graphite sticks produce tonal quality easily and are a time-saver for establishing broad areas of value. Pencil and graphite marks can be smudged, smeared, erased, or dissolved by a turpentine wash.

Colored pencils come in a wide range of colors, and water-soluble pencils can be combined with water for wash effects.

Erasers

Erasers are not suggested as a correctional tool, but erasure can contribute to a drawing. There are four basic types of erasers. The *kneaded eraser* is pliable and can be kneaded like clay into a point or shape; it is self-cleaning when it has been kneaded. *Gum erasers* are soft and do not damage the paper. A *pink rubber pencil eraser* is recommended for use with graphite pencils or sticks; it is more abrasive than the gum eraser. A *white plastic eraser* is less abrasive than the pink eraser and works well with graphite.

While a *chamois skin* is not technically an eraser, it is included here because it can be used to erase marks made by vine charcoal. It also can

be used on charcoal and conté to lighten values or to blend tones. As its name indicates, it is made of leather. The chamois skin can be cleaned by washing it in warm soapy water.

Inks and Pens

Any good drawing ink is suitable for the problems in this book. Perhaps the most widely known is black *India ink*. It is waterproof and is used in wash drawings to build layers of value. Both black and sepia ink are recommended.

Pen points come in a wide range of sizes and shapes. Again, experimentation is the only way to find the ones which best suit you. A crowquill pen, a very delicate pen that makes a fine line, is recommended.

Felt-tip markers come with either felt or nylon tips. They are produced with both waterproof and water-soluble ink. Water-soluble ink is recommended, since the addition of water will create tone. Invest in both broad and fine tips. Discarded markers can be dipped in ink, so you can purchase different-size tips and collect an array of sizes.

Paint and Brushes

A water-soluble *acrylic paint* is useful. You should buy tubes of white and black. You might wish to supplement these two tubes with an accent color and with some earth colors—for example, burnt umber, raw umber, or yellow ochre.

Brushes are important drawing tools. For the problems in this book you need a 1-inch (2.5 cm) and a 2-inch (5 cm) varnish brush, which you can purchase at the dime store; a number 8 nylon-bristle brush with a flat end; and a number 6 Japanese bamboo brush, an inexpensive reed-handled brush.

Other Materials

A small can or jar of *turpentine* should be kept in your supply box. Turpentine is a solvent that can be used with a number of media—charcoal, graphite, conté, and grease crayons.

Rubber cement and *white glue* are useful, especially when working on collage. Rubber cement is practical, since it does not set immediately and you can shift your collage pieces without damage to the paper. However, rubber cement discolors with age. White glue dries transparent, it is long lasting, and it does not discolor.

Sponges are convenient. They can be used to dampen paper, apply washes, and create interesting textures. They are also useful for cleaning up your work area.

Workable fixative protects against smearing and helps prevent powdery media from dusting off. Fixative comes in a spray can. It deposits uniform mist on the paper surface, and a light coating is sufficient. The term *workable* means that drawing can continue without interference from the hard surface left by some fixatives.

The purchase of a *drawing board* is strongly recommended. It should be made from Masonite and be large enough to accommodate the size of your paper. You can clip the drawing paper onto the board with large metal clips. The board will furnish a stable surface; it will keep paper unwrinkled and prevent it from falling off the easel.

Masking tape, gummed paper tape, a mat knife and blades, single-edge razor blades, scissors, a small piece of sandpaper (for keeping your pencil point sharp), and a metal container for water also should be kept in your supply box.

Nonart Implements

Throughout the text experimentation with different tools and media has been recommended. This is not experimentation just for experimentation's sake. A new tool does not necessarily result in a good drawing. Frequently a new tool will help you break old habits; it will force you to use your hands differently or to approach the drawing from a different way than you might have with more predictable and familiar drawing media. Sticks, vegetables (potatoes or carrots, for example), pieces of Styrofoam, a piece of crushed paper, pipe cleaners, and cotton-tipped sticks are implements that can be found easily and used to good effect.

Keep your supply box well stocked. Add to it newly found materials and drawing tools. Keep alert to the assets and liabilities of the materials you use. Experiment and enjoy the development of your understanding of materials.

G U I D E B

Presentation

The selection of drawings to represent your work is an important undertaking. Your portfolio should show a range of techniques and abilities. The four most important criteria to keep in mind are accuracy of observation, an understanding of the formal elements of drawing, media variety and exploration, and expressive content.

After you have chosen the pieces that best incorporate these considerations, your next concern is how to present them. The presentation must be portable and keep the works clean and whole, free from tears and bends. Since framing stands in the way of portability, that option will not be discussed.

Some possible ways of presenting your work are backing and covering with acetate, stitching in clear plastic envelopes, laminating, dry mounting, and matting. Each method of presentation has advantages.

Acetate

A widely used way of presenting work is to apply a firm backing to the drawing and then cover both drawing and backing with a layer of acetate, a clear thin plastic that holds the drawing and backing together. More importantly, the covering provides protection against scuffing, tearing, and soiling. (Matted drawings can also be covered with acetate.) Backing is a good option if a work is too large for matting or if the composition goes all the way to the edge and you cannot afford to lose any of the drawing behind a mat.

Another option is to attach the drawing with gummed linen tape to a larger piece of paper and cover it with acetate. The drawing then has a border of paper around it and can retain its edges. The drawing lies on top; it is loose, not pinned back by a mat. The size of the backing paper is an important consideration. The drawing might need a border of an inch (2.5 cm); it might need one several inches wide. Experiment with border sizes before cutting the backing paper and attaching it to the drawing.

Paper comes in more varieties and neutral colors than does mat board. The choice of paper is important. The drawing and the paper it is done on should be compatible with the texture, weight, value, and color of the backing paper. Backing paper should not dominate the drawing.

A disadvantage to acetate as a protective cover is its shiny surface. This interferes with the texture of the drawing and with subtleties within the drawing.

Plastic Envelopes

If flexibility or the idea of looseness is important to the drawing, there is another simple means of presentation: stitching the drawing in an envelope of clear plastic. For a drawing of irregular shape—for example, one that does not have square corners—a plastic envelope might be an appropriate choice. A plastic casing would allow a drawing done on fabric to retain its looseness and support the idea of flexibility.

A disadvantage to clear plastic is its watery appearance and highly reflective surface, which distorts the drawing. The greatest advantage to this method of presentation is that large drawings can be rolled, shipped, and stored easily.

Lamination

Lamination is midway in stiffness between drawing paper and a loosely stitched plastic envelope. You are familiar with laminated drivers' licenses and credit cards.

Laminating must be done commercially. It is inexpensive, but cost should not be the most important consideration. The means of presentation must be suited to the concept in the drawing. Laminating is a highly limiting way of presenting work—once sealed, the drawing cannot be reworked in any way.

Dry Mounting

If the likelihood of soiling and scuffing is minimal, you might want to *dry mount* the drawing. You do this in exactly the same way as you dry mount a photograph, sealing the drawing to a rigid backing and leaving the surface uncovered. Dry-mount tissue is placed between drawing and backing. Heat is then applied by means of an electric dry-mount press, or if done at home, by a cool iron. Dry-mount tissue comes in a variety of sizes; rolled tissue can be found for large drawings. This tissue must be the same size as the drawing. Wrinkling can occur, and since a drawing sealed to backing is not easily removed, extreme care should be taken in the process. Carefully read and follow the instructions on the dry-mount tissue package before you start.

Since dry mounting is done with heat, it is important that the media used in the drawing do not run or melt when they come in contact with heat. Greasy media such as china markers, lithographic sticks, or wax crayons should not be put under the dry press for mounting.

Matting

Matting is the most popular and traditional choice for presentation. The mat separates the drawing from the wall on which it is hung and provides an interval of rest before the eye reaches the drawing. Secondly, a mat gives the drawing room to "breathe." Like a rest in music, it offers a stop between the drawing and the environment; it allows for uncluttered viewing of the drawing.

For this reason mats should not call attention to themselves or they will detract from the drawing. A colored mat screams for attention and diminishes a drawing's impact. White or off-white mats are recommended at this stage, especially since most of the problems in this book do not use color. An additional argument for white mats is that art is usually displayed on white or neutrally colored walls, and the mat furnishes a gradual transition between the wall and the drawing.

Materials for Matting

The materials needed for matting are as follows:

- a mat knife with a sharp blade
- all-rag mounting board
- gummed linen tape
- a 36-inch-long (92 cm) long metal straightedge
- a pencil
- a gum or vinyl eraser
- a heavy piece of cardboard for cutting surface

Change or sharpen the blade in your knife often. A ragged edge is often the result of a dull blade. A continuous stroke will produce the cleanest edge. Mat blades should not be used for cutting more than one mat before being discarded. The expense of a blade is minimal in com-

parison with the cost of mat board, so be generous in your use of new, sharp blades.

Do not use illustration board or other kinds of board for your mat. Cheaper varieties of backing materials, being made from woodpulp, contain acid; they will harm a drawing by staining the fibers of the paper and making them brittle. Use white or off-white, all-rag mat board, sometimes called museum board, unless special circumstances dictate otherwise. A heavyweight, hot-pressed watercolor paper can be used as a substitute for rag board.

Masking tape, clear tape, gummed tape, and rubber cement will likewise discolor the paper and should be avoided. They will lose their adhesive quality within a year or so. Use gummed linen tape, because it is acid free.

Instructions for Matting

Use the following procedure for matting. Work on a clean surface. Wash your hands before you begin.

1. Carefully measure the drawing to be matted. The edges of the mat's opening will overlap the drawing by ⅜ inch (1 cm) on all sides.
2. For an 18- by 24-inch (46 × 61 cm) drawing, the mat should have a 4-inch (10 cm) width on top and sides and a 5-inch (13 cm) width at the bottom. Note that the bottom border is slightly wider—up to 20 percent—than the top and sides.
3. On the front surface of the mat board mark lightly with a pencil the opening to be cut. You can erase later.
4. Place a straightedge on the mat just inside the penciled line toward the opening and cut. Hold down both ends of the straightedge. You may have to use your knee. Better still, enlist a friend's help. If the blade slips, the error will be on the part that is to be discarded and can, therefore, be corrected. Cut the entire line in one continuous movement. Do not start and stop. Make several strokes; do not try to cut through completely on your first stroke (Fig. 344).
5. Cut a rigid backing ⅛ inch (.3 cm) smaller on all sides than the mat.
6. Lay the mat face down and align the backing so that the two tops are adjoining. Cut four or five short pieces of linen tape, and at the top, hinge the backing to the mat (Figs. 345, 346).
7. Minor ragged edges of the mat can be corrected with fine sandpaper rubbed lightly along the edge of the cut surface.
8. Erase the pencil line and other smudges on the mat with a gum or vinyl eraser.
9. Hinge the drawing to the backing *at the top only*. This allows the paper to stretch and contract with changes in humidity (Fig. 347).
10. You may cover the matted drawing with acetate, which will protect both the drawing and mat. Place the backed, matted drawing face down on a sheet of acetate 2 inches (5 cm) wider on all sides than the mat. Cut 2-inch (5 cm) squares from each corner of the acetate (Fig. 348). Fold the acetate over, pulling lightly and evenly on all sides. Attach the acetate to the backing with tape.

top

window to be cut out

bottom

straight edge– cut along window side

344. Cutting mat board.

mat– face down

tape

top of mat

tape

backing

345. Hinging the mat.

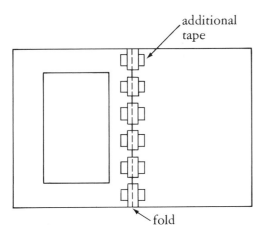

additional tape

fold

346. Hinging the mat.

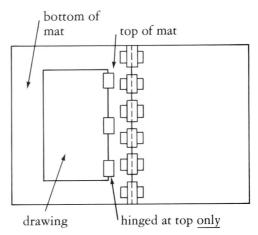

bottom of mat

top of mat

drawing

hinged at top <u>only</u>

347. Hinging drawing at the top.

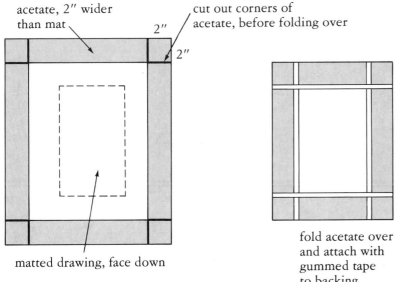

acetate, 2″ wider than mat

2″

cut out corners of acetate, before folding over

2″

matted drawing, face down

348. Cutting acetate.

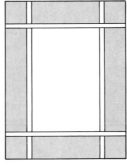

fold acetate over and attach with gummed tape to backing

SUMMARY: Selecting a Method of Presentation

In making your decision about what kind of presentation is suitable, you should first try to visualize the piece in a variety of ways. If you are attentive, the work itself will probably suggest an appropriate presentation. Matting is generally the safest. Stitching in plastic and lamination should be reserved for only those pieces that absolutely demand that type of presentation. Whatever your choice, remember that compatibility between drawing and method of presentation is essential.

If the manner of presentation is not clear to you, experiment with the piece. Place it in a discarded mat, or use some L-frames to crop the composition exactly right. Assess the drawing without a mat. Lay it on a larger piece of paper. Does the drawing go to the edge? Can you afford to lose half an inch (1 cm) on the borders? Is the idea of looseness or flexibility important to the drawing? Would a reflective covering detract from or enhance the drawing? What kind of surface and media are used in the drawing? What kind of backing would best complement the piece? What size mat or paper backing is the most appropriate? Does a cool white, a warm white, an off-white, a neutral, or a gray look best with the drawing? Does the size of the drawing present a problem?

The care and storage of individual drawings is another professional concern. Minimal good care is simple. You should spray-fix your drawings as soon as they are finished. Remove any smudges and store the drawings in a flat, rigid container slightly larger than the largest drawing. This ensures that the drawings will not become dog-eared, soiled, bent, or smudged. You should place a clean piece of paper between drawings so that the charcoal from one does not transfer onto the white of another.

Your attitude toward your work influences others' attitudes. A bad drawing can be improved by good presentation, while a good drawing can be destroyed by poor presentation. Each drawing does not have to be regarded as a precious monument, but proper care and handling of your work is a good habit.

GUIDE C

Keeping a Sketchbook

Paul Klee has said that the way we perceive form is the way we perceive the world, and nowhere is this more strikingly visible than in a well-kept sketchbook. The sketchbook takes art out of the studio and brings it into daily life. By means of the sketchbook, actual experience is reintroduced into the making of art. This is a vital cycle, infusing your work with direct experience and at the same time continuing the acute observation that you have been using in the studio.

You are no doubt already aware of the indispensable role of the sketchbook in helping you solve formal problems encountered in the classroom. Keeping a sketchbook is an important extension of classroom activity.

The first consideration in choosing a sketchbook is that it be portable, a comfortable size to carry. Any materials are appropriate for a sketchbook, but crayons, water-soluble felt-tip markers, and pencils are some convenient media.

A sketchbook is an ideal place to juggle form, ideas, and materials. You can experiment freely with any or all of these aspects of art and have the record of your investigations for quick reference.

Any of the problems in the chapters on art elements is an appropriate stepping-off place for sketchbook development. You should try for continuity; force yourself to develop one idea through ten or fifteen pages. In Figures 349 to 353 the student chose an article of clothing as the subject of a number of sketchbook drawings. He began with a contour drawing of the shirt and then imagined the shirt as if it were hung, crumpled, starched, and hidden. Each drawing suggested new forms, new media.

You should use your sketchbook daily. Though this may seem artificial and awkward in the beginning, you will soon develop a reliance on the sketchbook that will prove profitable.

The sketchbook is a practical place for self-instruction. It is a good testing ground for ideas and formal design concerns as well as for media experimentation. Sketchbook drawings are not meant to be final statements. They are directional signals that point to a new problem or suggest a new solution to an old problem.

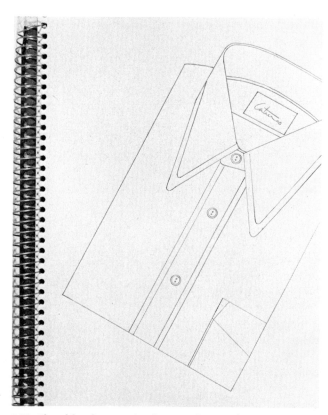

349. Sketchbook page. Student work. Pencil.

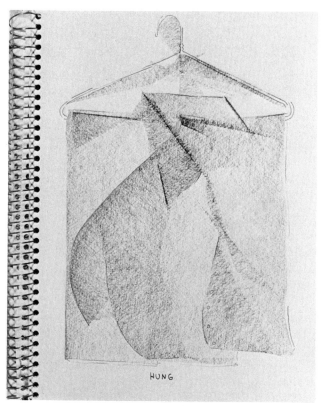

350. Sketchbook page. Student work. Pencil and charcoal.

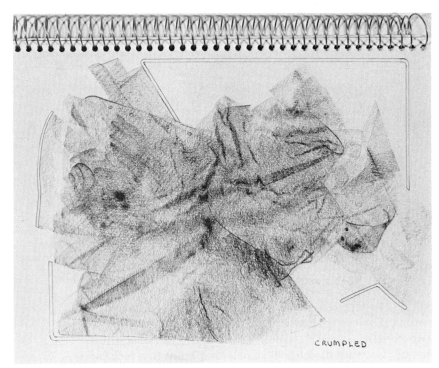

351. Sketchbook page. Student work. Pencil and charcoal.

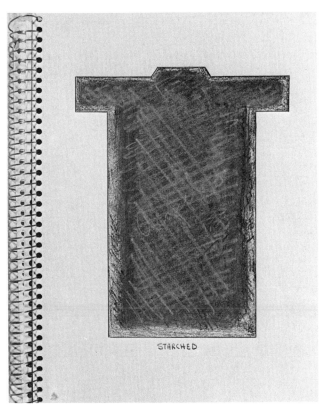

352. Sketchbook page. Student work. Mixed media.

353. Sketchbook page. Student work. Ebony pencil.

354. Sketchbook page. Student work. Mixed media.

For example, in Figures 354 to 357 the student began with fruit as a subject. The oval and round shapes are maintained through the series of drawings while scale, texture, placement, and media are juggled. In the first drawing (Fig. 354) the objects are placed in the center of the page. In the second drawing (Fig. 355) one of the objects has "fallen" out of the picture plane. In the third drawing (Fig. 356) the circular object is close to

355. Sketchbook page. Student work. Mixed media.

356. Sketchbook page. Student work. Mixed media.

the edge. In the last drawing (Fig. 357) there is a transformation—the shapes become negative. The final drawing resembles a landscape with emphasis on the negative space.

It would be impossible for an artist to carry out every idea. The sketchbook offers a place to record both visual and verbal ideas for selection and extended development later. Claes Oldenburg's concern with

357. Sketchbook page. Student work. Mixed media.

verbal and visual analogies is apparent in his sketchbook *Notes in Hand.* In his drawing *Ketchup + Coke Too?* (Fig. 358) from this notebook Oldenburg equated ketchup, french fries, and Coke with the Pisa group—cathedral, tower, and baptistry. The equation is a verbal one noted along the sides of the drawing. Oldenburg makes suggestions for materials to be used if he ever decides to make this grouping into a sculpture. He uses a time-saving device of drawing over an advertisement.

Sketchbook drawings are, in the long run, time-savers. Quickly conceived ideas are often the most valid ones. Having a place to jot down notations is important. Robert Smithson's *Spiral Jetty* (Fig. 359) is an example of a rapidly stated idea. His verbal notes are minimal; the drawing style is hasty. This is one of the preliminary sketches for a complex earthwork Smithson constructed on the Great Salt Lake in Utah. A more finished drawing made after his ideas had become more firmly established can be seen in Figure 19 encountered earlier.

The sketchbook could function as both a verbal and visual journal. It is a place to record critical and personal comments on what you have read, seen, and experienced. For example, a student made a photocopy of Rembrandt's *The Staalmeesters* (Fig. 360) and added a critical statement from an article concerning the work. A quote from the article, "sometimes awkward, sometimes mere white patches," provides ideas for a series of sketchbook drawings. The student eventually turned the verbal statement itself into a drawing (Fig. 361). The verbal reference to the white patches became a literal basis for her third sketch, a collage using white shapes (Fig. 362).

left: 358. Claes Oldenburg. *Ketchup + Coke Too?* from *Notes in Hand* by Claes Oldenburg. 1965. Ball-point pen, 11 × 8½" (28 × 21.6 cm). Courtesy the artist.

right: 359. Robert Smithson. *The Spiral Jetty w/Sun.* 1970. Pencil, 11⅞ × 9" (30 × 23 cm). Courtesy John Weber Gallery, New York.

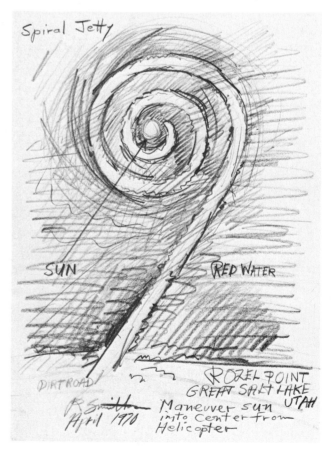

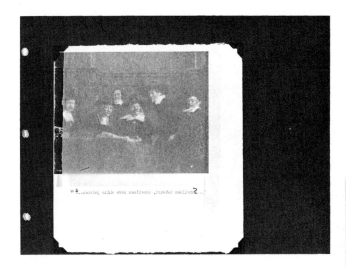

above: 360. Sketchbook page. Student work.
Photocopy and collage.

right: 361. Sketchbook page. Student work.
Mixed media.

below: 362. Sketchbook page. Student work.
Mixed media.

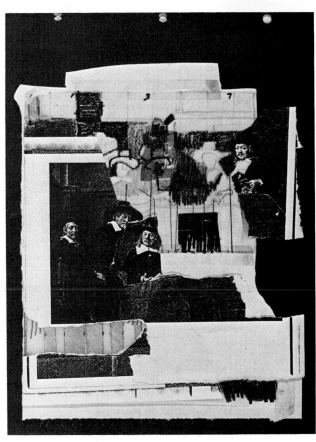

The sketchbook serves as a repository, a memory bank for information and feelings that might escape if you do not jot them down. Keeping a written journal is a particularly important aspect of a sketchbook. Frequently a fleeting thought—either yours or someone else's—can trigger new responses when it is seen from a later vantage point.

While your approach in keeping a sketchbook is serious, playful improvisation should not be minimized. The main thing to remember about your sketchbook is that you are keeping it for yourself, not an instructor, even though you have been given assignments in it. You are the only one who benefits from a well-kept sketchbook. Looking back through a sketchbook can give you direction when you are stuck and provide a constant source of ideas for new work. When you use an idea from your sketchbook, you have the advantage of choosing an idea that has continuity to it—you have already done some thinking about that idea. A new viewpoint adds another dimension. Both *process* and *progress* are the rewards of dedication to keeping a sketchbook.

SUMMARY: The Advantages of a Sketchbook

A sketchbook serves different functions. It is a personal tool that you can use in many ways. For example, in a sketchbook you can

- acquaint yourself with new forms
- record drawings of an object through sustained observation
- introduce new imagery
- juggle the elements in a given composition
- record media experimentation

In addition to developing visual ideas, you can use your sketchbook to record verbal ideas and information. In it you can

- write quotations that appeal to you
- keep an artist's diary
- keep a personal journal that records your daily interests, activities, and insights
- keep a source book or address book for materials
- attach clippings from other sources
- critically review other art work that you have seen
- make comments on what you have read and seen

Over the years your sketchbooks will form a valuable repository. Through these records you can trace your growth as an artist. You may see that you have a preference for certain ideas and relationships. The sketchbook will jolt your memory, reminding you of visual and verbal information you might otherwise have forgotten.

Remember the ground rules. Choose a sketchbook for its portability. Use it daily; set yourself a minimum number of fifteen pages a week. For each theme, develop no fewer than ten variations. Above all, remember that the sketchbook is a personal source, a chance to experiment. It is yours, and yours alone.

Breaking Artistic Blocks

Generally, there are two times when artists are susceptible to artistic blocks: in an individual piece when they feel something is wrong and do not know what to do about it, and when they cannot begin to work at all. These are problems that all artists, even the most experienced, must face. They are common problems that you should move quickly to correct.

Correcting the Problem Drawing

What can you do with a drawing you cannot seem to complete? The initial step in the corrective process is to separate yourself, physically and mentally, from the drawing in order to look at it objectively. You, the artist/maker, become the critic/viewer. This transformation is essential in assessing your work. The original act of drawing was probably on the intuitive level; now you begin the process of critical analysis. You are going to learn to bring into consciousness what has been intuitively stated.

Turn away from your work for a few minutes. Occupy your mind with some simple task such as straightening equipment or sharpening pencils. Then pin the drawing on the wall, upside down or sideways. Have a mirror handy to view the drawing. The mirror's reversal of the image and the new perspective of placement will give you a new orientation so you can see the drawing with fresh eyes. This fresh viewpoint

allows you to be more aware of the drawing's formal qualities regardless of the subject you have chosen.

When you can see how line, value, shape, volume, texture, and color are used, you are not so tied to the subject matter. Frequently the problem area will jump out at you. The drawing itself tells you what it needs. Be sensitive to the communication that now exists between you and your work. Before, *you* were in command of the drawing; now *it* is directing you to look at it in a new way. At this stage you are not required to pass judgment on the drawing. You simply need to ask yourself some nonjudgmental questions about the piece. The time for critical judgments comes later. What you need to discover now is strictly some *information* about the drawing.

Ask yourself these questions:

1. What is the subject being drawn?
2. Which media are used and on what surface?
3. How is the composition related to the page? Is it a small drawing on a large page? A large drawing on a small page? Is there a lot of negative space? Does the image fill the page? What kind of space is being used in the drawing?
4. What kind of shapes predominate? Amoeboid? Geometric? Do the shapes exist all in the positive space, all in the negative space, or in both? Are they large or small? Are they the same size? Are there repeated shapes? How have shapes been made? By line? By value? By a combination of these two? Where is the greatest weight in the drawing? Are there volumes in the drawing? Do the shapes define planes or the sides of a form? Are the shapes flat or volumetric?
5. Can you divide value into three groups: lightest light, darkest dark, and mid-gray? How are these values distributed throughout the drawing? Is value used in the positive space only? In the negative space only? In both? Do the values cross over objects or shapes, or are they contained within the object or shape? Is value used to indicate a single light source or multiple light sources? Does value define planes? Does it define space? Does it define mass or weight? Is it used ambiguously?
6. What is the organizational line? Is it a curve, a diagonal, a horizontal, or a vertical? What type of line is used—contour, scribble, calligraphic? Where is line concentrated? Does it create mass? Does it create value? Does it define edges? Does it restate the shape of a value? Again, note the distribution of different types of line in the drawing; ignore the other elements.
7. Is invented, simulated, or actual texture used in the drawing? Are there repeated textures, or only one kind? Is the texture created by the tool the same throughout the drawing? Have you used more than one medium? If so, does each medium remain separate from the other media? Are they integrated?

This list of questions looks long and intimidating at first glance, but you can learn quickly to make these assessments—make them almost automatically, in fact. Of course, many of these questions may not apply to each specific piece, and you may think of other questions that will help you in making this first compilation of information about your drawing.

Critical Assessment

After letting the drawing speak to you and after having asked some nonjudgmental questions about it, you are ready to make a *critical assessment*. It is time to ask questions that pass judgments on the piece.

To communicate your ideas and feelings in a clearer way, you should know what statements you want to make. Does the drawing do what you meant it to do? Does it say something different—but perhaps *equally important*—from what you meant it to say? Is there a confusion or a contradiction between your intent and what the drawing actually says? There may be a conflict here because the drawing has been done on an intuitive level, while the meaning you are trying to verbalize is on a conscious level. Might the drawing have a better message than your original intended message?

Can you change or improve the form to help the meaning become clearer? Remember, form is the carrier of meaning. Separate the two functions of making and viewing. What is the message to you as viewer?

An important reminder: Go with your *feelings*. If you have any doubts about the drawing, wait until a solution strikes you. However, do not use this delay to avoid doing what you must to improve the drawing. Try something—even if the solution becomes a failure and the drawing is "ruined," you have sharpened your skills and provided yourself with new experiences. The fear of ruining what might be a good drawing can become a real block to later work. Be assertive; experiment; do not be afraid to fail.

Problems in an individual piece tend to fall within these five categories:

- inconsistency of style, idea, or feeling
- failure to determine basic structure
- tendency to ignore negative space
- inability to develop value range and transitions
- failure to observe accurately

Inconsistency refers to the use of various styles, ideas, or feelings within a single work. A number of techniques and several types of line may be employed within a single drawing, but the techniques and elements must be compatible with one another and with the overall idea of the drawing. Frequently an artist will unintentionally use unrelated styles in the same drawing; this results in an inconsistency that can be disturbing to the viewer. For example, a figure drawing may begin in a loose and gestural manner and seem to be going well. Suddenly, however, when details are stated, the artist feels insecure, panics, tightens up, and begins to conceptualize areas such as the face and hands. The style of the drawing changes—the free-flowing lines give way to a tighter, more constricted approach. As conceptualization takes the place of observation, the smooth, almost intuitive interrelationship of the elements is lost. The moment of panic is a signal for you to stop, look, analyze, and relax before continuing.

A frequent problem encountered in drawing is the *failure to determine basic structure*, to distinguish between major and minor themes. For example, dark geometric shapes may dominate a drawing, while light

amoeboid shapes are subordinate. Although it is not necessary for every drawing to have a major and minor theme, in which some parts dominate and others are subordinate, it is important for the artist to consider such distinctions in the light of the subject and intent of a particular drawing. Details should overshadow the basic structure of a drawing only if the artist intends it. The organization of a drawing is not necessarily predetermined; however, at some point in its development, you should give consideration to the drawing's basic structure.

Human beings are object-oriented and have a *tendency to ignore negative space.* We focus our attention on objects. A problem arises for the artist when the space around the object is ignored and becomes merely leftover space. It takes conscious effort to consider positive and negative space simultaneously. Sometimes it is necessary to train ourselves by first looking at and drawing the negative space. When we draw the negative space first, or when positive and negative space are dealt with simultaneously, there is an adjustment in both. In other words, the positive and negative shapes are altered to create interrelationships. There are times when only one object is drawn on an empty page. In these instances, the placement of the drawing on the page should be determined by the relationship of the negative space to the object.

One way to organize a drawing is by the distribution of values. Problems arise when students are *unable to develop value range and transitions.* For many students, developing a value range and gradual value transitions is difficult. The problem sometimes is a lack of ability to see value as differentiated from hue. At other times, it is failure to consider what range of value distribution is most appropriate for the idea of the drawing. Too wide a range can result in a confusing complexity or a fractured, spotty drawing. Too narrow a range can result in an uninteresting sameness.

The final problem, *failure to observe accurately,* involves lack of concentration on the subject and commitment to the drawing. If you are not interested in your subject, or if you are not committed to the drawing you are making, this will be apparent in the work.

Once you have pinpointed the problem area, think of three or more solutions. If you are still afraid of ruining the drawing, do three drawings exactly like the problem drawing and employ a different solution for each. This should lead to an entirely new series of drawings, triggering dozens of ideas.

The failure to deal with this first category of problems—being unable to correct an individual drawing—can lead to an even greater problem—not being able to get started at all.

Getting Started

There is a second type of artistic blockage, in some ways more serious than the first: the condition in which you cannot seem to get started at all. There are a number of possible solutions to this problem. You should spread out all the drawings you did over the period of a month and analyze them. It is likely that you are repeating yourself by using the same medium, employing the same scale, or using the same size paper. In other words, your work has become predictable.

When you break a habit and introduce change into the work, you will find that you are more interested in executing the drawing. The resulting piece reflects your new interest. A valid cure for being stuck is to adopt a playful attitude.

An artist, being sensitive to materials, responds to new materials, new media. This is a good time to come up with some inventive, new, nonart drawing tools. Frequently you are under too much pressure, usually self-imposed, to produce "art," and you need to rid yourself of this stifling condition. Set yourself the task of producing one hundred drawings over a 48-hour period. Use any size paper, any medium, any approach—and before you get started, promise yourself to throw them all away. This will ease the pressure of producing a finished product and will furnish many new directions for even more drawings. It may also assist you to get over the feeling that every drawing is precious.

All techniques and judgments you have been learning are pushed back in your mind while your conscious self thinks of solutions to the directions. Your intuitive self, having been conditioned by some good solid drawing problems, has the resource of past drawing experience to fall back on. Art is constantly a play between what you already know and the introduction of something new, between old and new experience, the conscious and the intuitive, the objective and the subjective.

Art does not exist in a vacuum, and while it is true that art comes from art, more to the point is that art comes from everything. If you immerse yourself totally in doing, thinking, and seeing art, the wellsprings soon dry up and you run out of new ideas. Exhausting physical exercise is an excellent remedy, as is reading a good novel, scientific journals, or a weekly news magazine. A visit to a natural history museum, a science library, a construction site, a zoo, a cemetery, a concert, a political rally—these will all provide grist for the art mill sooner or later. Relax; "invite your soul." Contact with the physical world will result in fresh experiences from which to extract ideas, not just to improve your art but to sharpen your knowledge of yourself and your relation to the world.

Keep a journal—a visual and verbal one—in which you place notes and sketches of ideas, of quotes, of what occupies your mind. After a week reread the journal and see how you spend your time. How does the way you spend your time relate to your artistic block?

Lack of authentic experience is damning. Doing anything, just existing in our complex society, is risky. Art is especially risky. What do we as artists risk? We risk confronting things unknown to us; we risk failure. Making art is painful because the artist must constantly challenge old ideas and experiences. Out of this conflict comes the power that feeds the work.

An artistic block is not necessarily negative. It generally means that you are having growing pains. You are questioning yourself and are dissatisfied with your previous work. The blockage may be a sign of good things to come. It is probably an indication that you are ready to begin on a new level of commitment or concentration, or you may be ready to begin a new tack entirely. When you realize this, your fear—the fear of failure, which is what caused the artistic block in the first place—is reduced, converted, and put to use in constructive new work.

GLOSSARY

Italicized terms within the definitions are themselves defined in the Glossary.

abstraction An alteration of *forms*, derived from observation or experience, in such a way as to present essential rather than particular qualities.

achromatic Relating to light and dark, the absence of *color*, as opposed to *chromatic* (relating to color).

actual texture The *tactile* quality of a surface, including the mark made by a tool, the surface on which it is made, and any foreign material added to the surface. See also *invented texture, simulated texture.*

aerial perspective The means by which atmospheric illusion is created.

aggressive line An emphatically stated *line.*

ambiguous space Space that is neither clearly flat nor clearly volumetric, containing a combination of both two- and three-dimensional elements.

amoeboid shape See *organic shape.*

analogous colors Colors adjacent to one another on the color wheel.

analytical line A probing *line* that penetrates space, locating objects in relation to one another and to the space they occupy.

anthropomorphism Ascribing human form or attributes to nonhuman forms.

arbitrary value *Value* that does not necessarily conform to the actual appearance of an object; the use of value based on intuitive responses or the need to comply with compositional demands.

assemblage A work of art composed of fragments of objects or *three-dimensional* materials originally intended for other purposes; the art of making such a work.

background See *negative space.*

base line The imaginary *line* on which an object or group of objects sits.

biomorphic shape See *organic shape.*

blind contour A contour exercise in which the artist never looks at the paper.

blurred line Smudged, erased, or destroyed *line.*

calligraphic line Free-flowing *line* that resembles handwriting, making use of gradual and graceful transitions.

cast shadow One of the six categories of *light.*

chiaroscuro Modeling, the gradual blending of light to dark to create a *three-dimensional* illusion.

chromatic Relating to *color*, as opposed to *achromatic* (relating to light and dark).

collage Any flat material, such as newspapers, cloth, or wallpaper, pasted on the *picture plane*.

color Visual assessment of the quality of light that is determined by its spectral composition.

color wheel A circular arrangement of twelve hues.

complementary colors Contrasting colors that lie opposite each other on the color wheel.

composition The organization or arrangement of the *elements of art* in a given work.

conceptual drawing A drawing that in its essential *form* is conceived in the artist's mind, rather than derived from immediate visual stimuli.

cone of vision angle of sight

constricted line A *crabbed*, angular, tense *line*, frequently aggressively stated.

content The subject matter of a work of art, including its emotional, intellectual, *symbolic*, thematic, and narrative connotations, which together give the work its total meaning.

contour line *Line* that delineates both the outside edge of an object and the edges of *planes*, as opposed to *outline*, which delineates only the outside edge of an object.

core of shadow One of the six categories of *light*.

crabbed line See *constricted line*.

cross-contour line *Line* that describes an object's horizontal or cross-contours rather than its vertical contours. Cross-contour line emphasizes the volumetric aspects of an object.

directional line See *organizational line*.

elements of art The principal graphic and *plastic* devices by which an artist composes a physical work of art. The elements are *color*, *line*, *shape*, *texture*, *value*, and *volume*.

empty space See *negative space*.

expressive Dealing with feelings and emotions, as opposed to *objective* and *subjective*.

eye level An imaginary horizontal *line* parallel to the viewer's eyes.

field See *negative space*.

figure/field See *positive shape*.

figure/ground See *positive shape*.

foreground/background See *positive shape*.

foreshortening A technique for producing the illusion of an object's extension into space by contracting its form.

form In its broadest sense, the total structure of a work of art—that is, the relation of the *elements of art* and the distinctive character of the work. In a narrower sense, the *shape*, configuration, or substance of an object.

frottage A *textural* transfer technique; the process of making rubbings with graphite or crayon on paper laid over a textured surface.

fumage A *textural* technique that uses smoke as a medium.

geometric shape *Shape* created by mathematical laws and measurements, such as a circle or a square.

gestural approach A quick, all-encompassing statement of *forms*. In gesture the hand duplicates the movement of the eyes, quickly defining the subject's general characteristics—movement, weight, *shape*, tension, *scale*, and *proportion*. See *mass gesture*, *line gesture*, *mass and line gesture*, and *sustained gesture*.

grattage A textural technique that incises or scratches marks into a surface prepared with a coating, for example, gesso.

ground See *negative space*.

group theme Development of related works by members of the same schools and movements of art who share common philosophical, formal, stylistic, and subject interests.

highlight One of the six categories of *light*.

hue The characteristic of a *color* that causes it to be classified as red, green, blue, or another color.

icon A portrait or image that is an object of veneration (usually religious veneration).

illusionistic space In the graphic arts, a representation of *three-dimensional space*.

implied line A *line* that stops and starts again; the viewer's eye completes the movement the line suggests.

implied shape A suggested or incomplete *shape* that is "filled in" by the viewer.

incised line A *line* cut into a surface with a sharp implement.

indicative line See *organizational line*.

informational drawing A category of objective drawing, including diagrammatic, architectural, and mechanical drawing. Informational drawing clarifies concepts and ideas that may not be actually visible, such as a chemist's drawings of molecular structure.

intensity The saturation, strength, or purity of a color.

interspace See *negative space*.

invented texture An invented, nonrepresentational patterning that may derive from *actual texture* but does not imitate it. Invented texture may be highly stylized.

light In the graphic arts, the relationship of light and dark patterns on a *form*, determined by the actual appearance of an object and by the type and direction of light falling on it. There are six categories of light as it falls over a form: *highlight*, *light tone*, *shadow*, *core of shadow*, *reflected light*, and *cast shadow*.

light tone One of the six categories of *light*.

line A mark made by an implement as it is drawn across a surface. See also *aggressive*, *analytical*, *blurred*, *calligraphic*, *constricted*, *contour*, *crabbed*, *implied*, *lyrical*, *mechanical*, *organizational*, and *whimsical* line.

line gesture A type of gesture drawing that describes interior forms, utilizing *line* rather than *mass*. See *gestural approach*.

local color The known color of an object regardless of the amount or quality of light on it.

lyrical line A *subjective* line that is gracefully ornate and decorative.

mass In the graphic arts, the illusion of weight or density.

mass and line gesture A type of gesture drawing that combines broad marks with thick and thin lines. See *gestural approach*.

mass gesture A type of gesture drawing in which the drawing medium is used to make broad marks to create *mass* rather than line. See *gestural approach*.

mechanical line An *objective* line that maintains its width unvaryingly along its full length.

modeling The change from light to dark across a surface; a technique for creating spatial illusion.

monochromatic A color scheme using only one color with its various hues and intensities.

montage A technique that uses pictures to create a composition.

multiple perspective Different *eye levels* and perspectives used in the same drawing.

negative space The space surrounding a *positive shape*; sometimes referred to as *ground, empty space, interspace, field,* or *void*.

nonobjective In the visual arts, work that intends no reference to concrete objects or persons, unlike *abstraction*, in which observed forms are sometimes altered to seem nonobjective.

objective Free from personal feelings; the emphasis is on the descriptive and factual rather than the *expressive* or *subjective*.

one-point perspective A system for depicting *three-dimensional* depth on a *two-dimensional* surface, dependent upon the illusion that all parallel lines that recede into space converge at a single point on the horizon, called the *vanishing point*.

optical color Perceived color modified by the quality of light on it.

organic shape Free-form, irregular *shape*. Also called *biomorphic* or *amoeboid shape*.

organizational line The *line* that provides the structure and basic organization for a drawing. Also called *indicative* or *directional line*.

outline Line that delineates only the outside edge of an object, unlike *contour line*, which also delineates the edges of *planes*.

papier collé The French term for pasted paper; a technique consisting of pasting and gluing paper materials to the *picture plane*.

perspective A technique for giving an illusion of space to a flat surface.

photomontage A technique that uses photographs to create a composition.

pictorial space In the graphic arts, the illusion of space. It may be relatively flat or *two-dimensional*, illusionistically *three-dimensional*, or *ambiguous space*.

picture plane The *two-dimensional* surface on which the artist works.

planar analysis An approach in which *shape* functions as *plane*, as a component of *volume*.

plane A *two-dimensional*, continuous surface with only one direction. See also *picture plane*.

plastic In the graphic arts, the illusion of *three-dimensionality* in a *shape* or *mass*.

positive shape The *shape* of an object that serves as the subject for a drawing. The relationship between positive shape and *negative space* is sometimes called *figure/field, figure/ground, foreground/background,* or *solid/void* relationship.

primary colors Red, blue, and yellow.

private theme Development by an individual artist of a personal, sustained, related series of works.

proportion Comparative relationship between parts of a whole and between the parts and the whole.

reflected light One of the six categories of *light*.

saturation See *intensity*.

scale Size and weight relationships between *forms*.

schematic drawing A drawing derived from a mental construct as opposed to visual information.

scribbled-line gesture A type of gesture drawing using a tight network of tangled *line*. See *gestural approach*.

secondary colors Colors achieved by mixing primary colors; green, orange, and violet.

shadow One of the six categories of *light*.

shallow space A relatively flat space, having height and width but limited depth.

shape A *two-dimensional*, closed, or implicitly closed configuration. The two categories of shape are *organic* and *geometric shape*.

shared theme Thematic work in which the same images or subjects are used by different artists over a long period of time.

simulated texture The imitation of the *tactile* quality of a surface; can range from a suggested imitation to a highly illusionistic duplication of the subject's texture. See also *actual texture* and *invented texture*.

simultaneity Multiple, overlapping views of an object.

solid/void See *positive shape*.

stacked perspective The use of stacked parallel base lines in the same composition.

structural line Line that helps locate objects in relation to other objects and to the space they occupy. Structural lines follow the direction of the *planes* they locate.

stylistic eclecticism The use side by side of varying philosophies, styles, techniques, materials, and subjects.

subjective Emphasizing the artist's emotions or personal viewpoint rather than informational content; compare *objective*.

sustained gesture A type of gesture drawing that begins with a quick notation of the subject and extends into a longer analysis and correction. See *gestural approach*.

symbol A *form* or image that stands for something more than its obvious, immediate meaning.

tactile Having to do with the sense of touch. In the graphic arts, the representation of *texture*.

tertiary colors Colors that result when a primary and a secondary color are mixed.

texture The *tactile* quality of a surface or its representation. The three basic types of texture are *actual, simulated*, and *invented texture*.

theme The development of a sustained series of works that are related by subject, that have an idea or image in common. See *private theme*, *group theme*, and *shared theme*.

three-dimensional Having height, width, and depth.

three-dimensional space In the graphic arts, the illusion of *volume* or volumetric space—that is, of space that has height, width, and depth.

three-point perspective A system for depicting *three-dimensional* depth on a *two-dimensional* surface. In addition to lines receding to two points on the horizon, lines parallel and vertical to the ground appear to converge to a third, vertical *vanishing point*.

trompe-l'oeil The French term for trick-the-eye illusionistic techniques. See also *simulated texture*.

two-dimensional Having height and width.

two-dimensional space Space that has height and width with little or no illusion of depth, or *three-dimensional* space.

two-point perspective A system for depicting *three-dimensional* depth on a *two-dimensional* surface, dependent upon the illusion that all parallel lines converge at two points on the horizon.

value The gradation of tone from light to dark, from white through gray to black.

value scale The gradual range from white through gray to black.

vanishing point In *one-point perspective*, the single spot on the horizon where all parallel lines converge.

void See *negative space*.

volume The quality of a *form* that has height, width, and depth; the representation of this quality. See also *mass*.

whimsical line A playful, *subjective* line with an intuitive, childlike quality.

SUGGESTED READINGS

Because the text is based on a contemporary approach to drawing, the Suggested Readings concentrate on modern art and modern artists.

Students may also find helpful such periodicals as *Art News, Art Forum, Artweek, Arts,* and *Art in America.*

Surveys and Criticism

Alloway, Lawrence. *American Pop Art.* New York: Macmillan, 1974.

Amaya, Mario. *Pop Art and After.* New York: Viking, 1965.

American Drawings 1963–1973. New York: Whitney Museum of American Art, 1973.

Arnason, H. H. *History of Modern Art.* New York: Abrams, 1968.

Ashton, Dore. *A Reading of Modern Art.* Cleveland: Press of Western Reserve University, 1969.

Battcock, Gregory. *Idea Art: A Critical Anthology.* New York: Dutton, 1973.

Battcock, Gregory. *The New Art: A Critical Anthology.* New York: Dutton, 1973.

Battcock, Gregory. *Super Realism.* New York: Dutton, 1975.

Beier, Ulli. *Contemporary Art in Africa.* New York: Praeger, 1968.

Cooper, Douglas. *The Cubist Epoch.* New York: Praeger, 1971.

Drawings: Recent Acquisitions. New York: Museum of Modern Art, 1967.

European Drawings. New York: Solomon R. Guggenheim Museum, 1966.

Foster, Hal. *The Anti-Aesthetic.* Port Townsend, Wash.: Bay Press, 1983.

Geldzahler, Henry. *New York Painting and Sculpture: 1940–1970.* New York: Dutton, 1969.

Gottlieb, Carla. *Beyond Modern Art.* New York: Dutton, 1976.

Johnson, Ellen H. *American Artists on Art from 1940 to 1980.* New York: Harper & Row, 1982.

Kuh, Katherine. *Break-up: The Core of Modern Art.* Greenwich, Conn.: New York Graphic Society, 1968.

Lipman, Jean, and Richard Marshall. *Art About Art.* New York: Dutton/Whitney Museum of American Art, 1968.

Lippard, Lucy. *From the Center.* New York: Dutton, 1976.

Lippard, Lucy. *Six Years: The Dematerialization of the Art Object from 1966 to 1972.* New York: Praeger, 1973.

Lucie-Smith, Edward. *Art Now.* New York: Morrow, 1977.

Meyer, Ursula. *Conceptual Art.* New York: Dutton, 1972.

100 European Drawings. Introduction by Jacob Bean. New York: Metropolitan Museum of Art, 1964.

Pincus-Witten, Robert. *Postminimal-*

ism. New York: Out of London Press, 1977.

Plagens, Peter. *Sunshine Muse.* New York: Praeger, 1974.

Rose, Barbara. *American Art Since 1900: A Critical History.* New York: Praeger, 1967.

Rosenberg, Harold. *The Anxious Object.* New York: Horizon Press, 1964.

Rosenberg, Harold. *The De-definition of Art.* New York: Collier Books, 1973.

Russel, John, and Suzi Gablik. *Pop Art Redefined.* New York: Praeger, 1969.

Sandler, Irving. *The New York School.* New York: Harper & Row, 1978.

Sondheim, Alan. *Individuals: Post Movement Art in America.* New York: E.P. Dutton, 1977.

Sontag, Susan. *Against Interpretation and Other Essays.* New York: Dell, 1978.

Steinberg, Leo. *Other Criteria: Confrontations with Twentieth-Century Art.* New York: Oxford University Press, 1979.

Women Chose Women. New York Cultural Center. New York: Worldwide Books, 1973.

Color

Albers, Josef. *Interaction of Color,* rev. ed. New Haven, Conn: Yale University Press, 1972.

Birren, Faber. *Principles of Color.* New York: Van Nostrand Reinhold, 1969.

Fabri, Frank. *Color: A Complete Guide for Artists.* New York: Watson-Guptill, 1967.

Itten, Johannes. *The Art of Color.* New York: Van Nostrand Reinhold, 1974.

Perspective

D'Amelio, Joseph. *Perspective Drawing Handbook.* New York: Leon Amiel, 1964.

Walters, Nigel V., and John Bromham. *Principles of Perspective.* New York: Watson-Guptill, 1974.

Works on Individual Artists

Josef Albers
Albers, Josef. *Interaction of Color,* rev. ed. New Haven, Conn.: Yale University Press, 1972.

John Baldessari
Tucker, Marcia, and Robert Pincus-Witten. *John Baldessari.* New York: The New Museum, 1981.

Leonard Baskin
Baskin: Sculpture, Drawings and Prints. New York: Braziller, 1970.

Romare Bearden
Romare Bearden: The Prevalence of Ritual. New York: Museum of Modern Art, 1971.

Joseph Beuys
Joseph Beuys: The Secret Block for a Secret Person in Ireland. New York: Museum of Modern Art, 1974.

Paul Cézanne
Chappeuis, Adrien. *The Drawings of Paul Cézanne.* Greenwich, Conn.: New York Graphic Society, 1973.

Vija Celmins
Vija Celmins. Introduction by Susan Larsen. Newport Beach, 1980.

Clemente Chia
Bastian, H., and W. M. Faust. *Clemente Chia Cucchi.* Bielefeld, 1983.

Christo
Bourdon, David. *Christo.* New York: Abrams, 1972.

Christo: Valley Curtain, Rifle, Colorado. New York: Abrams, 1977.

Joseph Cornell
Waldman, Diane. *Joseph Cornell.* New York: Braziller, 1977.

José Luis Cuevas
Carlos Fuentes. *El Mundo de José Luis Cuevas.* New York: Tudor, 1969.

Willem de Kooning
Cummings, Paul, et al. *Willem de Kooning: Drawing–Paintings–Sculpture, New York–Berlin–Paris.* New York: Whitney Museum of American Art in association with Prestel-Verlag, Munich, and W. W. Norton, 1983.

De Kooning: Drawings/Sculptures. New York: Dutton, 1974.

Jim Dine
Gordon, John. *Jim Dine.* New York: Praeger/Whitney Museum of American Art, 1970.

Shapiro, David. *Jim Dine: Painting What One Is.* New York: Abrams, 1981.

Jean Dubuffet
Drawings, Jean Dubuffet. New York: Museum of Modern Art, 1968.

Marcel Duchamp
Marcel Duchamp. New York: Museum of Modern Art and Philadelphia Museum of Art, 1973.

Alberto Giacometti
Lust, Herbert C. *Giacometti: The Complete Graphics and 15 Drawings.* New York: Tudor, 1970.

Giacometti, Alberto. *Giacometti, A Sketchbook of Interpretive Drawings.* New York: Abrams, 1967.

Arshile Gorky
Seitz, William C. *Arshile Gorky: Paintings, Drawings, Studies.* New York: Arno Press, 1972.

Juan Gris
Rosenthal, Mark. *Juan Gris.* Berkeley, 1983.

Red Grooms
Tully, Judd. *Red Grooms and Ruckus Manhattan.* New York: Braziller, 1977.

George Grosz
Love Above All, and Other Drawings: 120 Works by George Grosz. New York: Dover, 1971.

David Hockney
Stangos, Nikos, ed. *David Hockney.* New York: Abrams, 1977.

Robert Indiana
Robert Indiana. Philadelphia: Institute of Contemporary Art of the University of Pennsylvania, 1968.

Jasper Johns
Jasper Johns. Whitney Museum of American Art. New York: Abrams, 1974.

Kozloff, Max. *Jasper Johns.* New York: Abrams, 1972.

Wassily Kandinsky
Grohmann, Will. *Kandinsky.* Paris: Cahiers d'Art, 1930.

Kandinsky, Wassily. *Concerning the Spiritual in Art and Painting in Particular.* Trans. Michael Sadleir. New York: Wittenborn, 1964.

Paul Klee
Grohmann, Will. *The Drawings of Paul Klee.* New York: C. Valentin, 1944.

Käthe Kollwitz
Zigrosser, Carl. *Prints and Drawings of Käthe Kollwitz.* New York: Dover, 1951.

Rico Lebrun
Rico Lebrun: Drawings. Berkeley: University of California Press, 1968.

Fernand Léger
Green, Christopher. *Léger and the Avant Garde.* New Haven: Yale University Press, 1976.

Roy Lichtenstein
Waldman, Diane. *Roy Lichtenstein.* New York: Abrams, 1971.

Richard Lindner
Ashton, Dore. *Richard Lindner.* New York: Abrams.

David Macaulay
Macaulay, David. *Great Moments in Architecture.* Houghton Mifflin, Boston, 1978.

Henri Matisse
Cassou, Jean. *Paintings and Drawings of Matisse.* Paris: Braun and Cie. New York: Tudor, 1939.
Matisse as a Draughtsman. Greenwich, Conn.: New York Graphic Society/ Baltimore Museum of Art, 1971.

Mario Merz
Granath, Olle. *Mario Merz.* Stockholm, 1983.

Helmut Middendorf
Wildermuth, A., and W. M. Faust. *Helmut Middendorf.* Groninger, 1983.

Henry Moore
Wilkinson, Alan G. *The Drawings of Henry Moore.* London: Tate Gallery Publications, 1977.

Giorgio Morandi
Vitale, Lamberto. *Giorgio Morandi.* 2 vols. Florence, Italy: Ufizzi, 1983.

Claes Oldenberg
Baro, Gene. *Claes Oldenberg: Prints and Drawings.* London: Chelsea House, 1969.
Haskell, Barbara. *Claes Oldenberg: Object into Monument.* Pasadena, Calif.: Pasadena Art Museum, 1971.
Oldenberg, Claes. *Notes in Hand.* New York: Dutton, 1971.

Pablo Picasso
Picasso: His Recent Drawings 1966–68. New York: Abrams, 1969.

Jackson Pollock
Friedman, B. H. *Jackson Pollock: Energy Made Visible.* New York: McGraw-Hill, 1972.

Robert Rauschenberg
Forge, Andrew. *Rauschenberg.* New York: Abrams, 1969.
Robert Rauschenberg. National Collection of Fine Arts. Washington, D.C.: Smithsonian Institution, 1976.

Larry Rivers
Hunter, Sam. *Larry Rivers.* New York: Abrams, 1969.
Rivers, Larry. *Drawings and Digressions.* New York: Clarkson Potter, 1979.

Lucas Samaras
Samaras, Lucas. *Samaras Pastels.* Denver: Denver Art Museum, 1981.

Georges Seurat
Franz, E., and B. Growe., eds. *Georges Seurat.* Bielefeld, 1983.
Russell, John. *Seurat.* New York: Praeger, 1965.

Ben Shahn
Morse, John D. *Ben Shahn.* New York: Praeger, 1967.

Richard Smith
Smith, Richard. *Richard Smith Recent Work 1972–77: Paintings, Drawings, Graphics.* Cambridge: Massachusetts Institute of Technology Press, 1978.

Robert Smithson
Robert Smithson: Drawings. New York: The New York Cultural Center, 1974.

Saul Steinberg
Rosenberg, Harold. *Saul Steinberg.* New York: Knopf, 1978.

Pat Stier
Arbitrary Order: Paintings by Pat Stier. Houston: Contemporary Arts Museum, 1983.

Wayne Thiebaud
Wayne Thiebaud Survey 1947–1976. Phoenix, Ariz.: Phoenix Art Museum, 1976.

Jean Tinguely
Hulten, K. G. Pontus. *Jean Tinguely: Meta.* Greenwich, Conn.: New York Graphic Society, 1975.

Andy Warhol
Coplans, John. *Andy Warhol.* Greenwich, Conn.: New York Graphic Society, 1970.

William Wegman
Wegman, William. *Man's Best Friend.* New York: Abrams, 1982.

Neil Welliver
Welliver, Neil. *Neil Welliver, Watercolors and Prints, 1973–78.* New York: Brook Alexander.

Tom Wesselmann
Tom Wesselmann: The Early Years/Collages 1959–62. Long Beach: California State University Art Galleries, 1974.

PHOTOGRAPHIC SOURCES

Chapter 1 **3:** Photo by Geoffrey Clements, Staten Island, New York. **4:** Reprinted with permission of McGraw-Hill Book Company from *Morris' Human Anatomy*, Schaeffer, 10th edition, Philadelphia: The Blackiston Co., 1942. **7:** Reprinted with permission of Macmillan Publishing Company from *Creative and Mental Growth*, Viktor W. Lowenfeld and Lambert Brittain, 6th edition. Copyright © 1975. **9:** Photo by Bevan Davies, New York. **13:** Photo by Geoffrey Clements, Staten Island, New York/Paula Cooper Gallery, New York. **14:** The Solomon R. Guggenheim Museum, New York. **15:** Nohra Haime Gallery, New York. **16:** © S.P.A.D.E.M., Paris/V.A.G.A., New York, 1986. **17:** Constance Lebrun Crown, Santa Barbara, California. **19:** Photo by Nathan Rabin, New York. **20:** Brooke Alexander, Inc., New York. **25:** Leo Castelli Gallery, New York; © Roy Lichtenstein, V.A.G.A., New York, 1986. **26:** Photo by Robert E. Mates and Paul Katz, New York/Nancy Hoffman Gallery, New York. **27:** © A.D.A.G.P., Paris/V.A.G.A., New York, 1986. **28:** Photo by J.M. Snyder. **29–31:** Photos by Malcolm Lubliner, Los Angeles; © Roy Lichtenstein, V.A.G.A., New York, 1986. **32:** © BEELDRECHT, The Netherlands/V.A.G.A., New York, 1986. **33:** Richard Smith.

Chapter 2 **34:** © BILD-KUNST, West Germany/V.A.G.A., New York, 1986. **35:** Claes Oldenburg. **38:** Constance Lebrun Crown, Santa Barbara, California. **39:** The Solomon R. Guggenheim Museum, New York. **41–50:** Photos by Danielle Fagan, Austin, Texas. **52:** Leo Castelli Gallery, New York. **53:** Photo by Pramuan Burusphat. **54:** Walker Art Center, Minneapolis. **55:** Photo by Eric Pollitzer, Hempstead, New York/Paula Cooper Gallery, New York. **56:** © S.I.A.E., Italy/V.A.G.A., New York, 1986. **57:** © A.D.A.G.P., Paris/V.A.G.A., New York, 1986. **58:** Photo by Pramuan Burusphat. **59:** Mac Adams. **60:** Photo by Rudolph Burckhardt, New York. **61–62:** Photos by Danielle Fagan, Austin, Texas. **63:** © A.D.A.G.P., Paris/V.A.G.A., New York, 1986. **64–65:** Photos by Danielle Fagan, Austin, Texas. **66:** Photo by Pramuan Burusphat. **67–68:** Photos by Danielle Fagan, Austin, Texas.

Chapter 3 **69:** Photo by Ivan Dalla-Tana/Tony Shafrazi Gallery, New York. **70:** Sue Hettmansperger. **71.** Margo Leavin Gallery, Los Angeles. **75:** Metro Pictures, New York. **81.** Photo by Frank J. Thomas, Los Angeles. **83:** University Art Museum, University of California, Santa Barbara. **85:** Reprinted with permission of Mrs. Nelli Weighardt. **89–93:** Photos by Danielle Fagan, Austin, Texas. **95:** Sotheby's, London; © Larry Rivers, V.A.G.A., New York, 1986. **97–98:** Photos by Danielle Fagan, Austin, Texas. **103:** Photo by Robin Smith Photography Ltd., Christchurch, New

277

Zealand. **105–106:** © S.I.A.E., Italy/ V.A.G.A., New York, 1986. **108–111:** Photos by Pramuan Burusphat. **112–113:** Photos by Danielle Fagan, Austin, Texas. **114–116:** Photos by Pramuan Burusphat.

Chapter 4 118: Photo by David Boorsma. **121:** Photo by M. Lee Fatheree/Beth Van Hoesen. **124:** Photo by Kenneth Karp, New York. **125:** Photo by Eric Pollitzer, Hempstead, New York. **127:** © Robert Rauschenberg, V.A.G.A., New York, 1986. **130:** Constance Lebrun Crown, Santa Barbara, California. **131:** Photo by Danielle Fagan, Austin, Texas. **132:** Photo by Pramuan Burusphat. **134–136:** Photos by Pramuan Burusphat. **137:** Allan Frumkin Gallery, New York. **138:** Photo by Pramuan Burusphat. **139:** Photo by Danielle Fagan, Austin, Texas. **141:** Allan Frumkin Gallery, New York. **143–145:** Photos by Pramuan Burusphat. **146–147:** Photos by Danielle Fagan, Austin, Texas. **149:** Photo by Danielle Fagan. **152:** Robert Miller Gallery, New York. **153:** Photo by Geoffrey Clements, Staten Island, New York. **154–159:** Photos by Pramuan Burusphat.

Chapter 5 160: Photo by Prudence Cumming Assoc. Ltd., London. **163–164:** © S.P.A.D.E.M., Paris/V.A.G.A., New York, 1986. **165:** © Estate of Ben Shahn, V.A.G.A., New York, 1986. **166:** © BILD-KUNST, West Germany/V.A.G.A., New York, 1986. **169–170:** © A.D.A.G.P. Paris/V.A.G.A., New York, 1986. **171:** Sperone Westwater Gallery, New York. **172:** ARCO Center for Visual Art, Los Angeles. **173:** Photo © Leonard von Matt, Buochs, Switzerland. **174:** © Photo Archives Editions ARTHAUD, Paris/Librairie Ernest Flammarion, Paris. **175:** Walker Art Center, Minneapolis. **176:** © S.P.A.D.E.M., Paris/ V.A.G.A., New York, 1986. **177:** Photo by Danielle Fagan, Austin, Texas. **178–180:** Photos by Pramuan Burusphat. **181:** Photo by Danielle Fagan, Austin, Texas. **182:** Photo by Pramuan Burusphat. **183–184:** Photos by Ann Harkness, Denton, Texas. **186:** © A.D.A.G.P., Paris/V.A.G.A., New York, 1986. **187:** © BILD-KUNST, West Germany/V.A.G.A., New York, 1986. **188:** © S.P.A.D.E.M., Paris/ V.A.G.A., New York, 1986. **189–190:** Photos by Pramuan Burusphat. **196:** © Larry Rivers, V.A.G.A., New York, 1986. **197:** Photo by Danielle Fagan, Austin, Texas. **198:** © A.D.A.G.P., Paris/V.A.G.A., New York, 1986. **199:** © COSMOPRESS, Geneva/A.D.A.G.P., Paris/V.A.G.A., New York, 1986. **200:** Photo by Danielle Fagan, Austin, Texas.

Chapter 6 202: Photo by W. Staehle. **203:** Photo by Danielle Fagan, Austin, Texas. **204:** © A.D.A.G.P., Paris/V.A.G.A., New York, 1986. **205:** Photo by William H. Bengtson/Phyllis Kind Gallery, Chicago. **206.** The Solomon R. Guggenheim Museum, New York. **207:** Photo by Barney Burstein, Boston. **208:** Photo by Don Netzer, Denton, Texas. **209:** Photo by Pramuan Burusphat. **210:** Photo by Laura Silagi/Los Angeles Center for Photographic Studies. **211:** Photo by Eric Pollitzer, Hempstead, New York/Sidney Janis Gallery, New York; © Tom Wesselmann, V.A.G.A., New York, 1986. **214:** Leo Castelli Gallery, New York. **215:** © Robert Rauschenberg, V.A.G.A., New York, 1986. **216:** Photo by Danielle Fagan, Austin, Texas. **217:** Staempfli Gallery, New York. **218:** © Alan Magee, 1981. **219:** © A.D.A.G.P., Paris/ V.A.G.A., New York, 1986. **222:** Photo by Pramuan Burusphat. **223:** © James Rosenquist, V.A.G.A., New York, 1986. **224:** Photo by Danielle Fagan, Austin, Texas. **226:** © Audrey Flack, V.A.G.A., New York, 1986.

Chapter 7 Plate 1: Photo by David Wharton/Dallas Museum of Art. **Plate 2:** Harry N. Abrams., Inc., New York. **Plate 3:** John Berggruen Gallery, San Francisco. **Plate 5:** Photo by Otto E. Nelson, New York. **Plate 6:** Photo by Michael Tropea, Chicago. **Plate 7:** Photo by Schopplein Studio SFCA/Morgan Gallery, Kansas City, Missouri. **Plate 8:** Denver Art Museum.

Chapter 8 227–232: Photos by Danielle Fagan, Austin, Texas. **233–234:** Photos by Ann Harkness, Denton, Texas; reprinted with permission of Houghton Mifflin Company from *Great Moments in Architecture*, David Macaulay. Copyright © 1978 by David Macaulay. **235:** © David Hockney, 1969. **236–237:** Brooke Alexander, Inc., New York. **240–241:** © S.I.A.E., Italy/V.A.G.A., New York, 1986. **242:** Photo by Ann Freedman, New York/André Emmerich Gallery, New York; © David Hockney, 1977. **244:** © Öyvind Fahlström, V.A.G.A., New York, 1986. **245:** Photo by Ann Harkness, Denton, Texas; reprinted with permission of Houghton Mifflin Company from *Great Moments in Architecture*, David Macaulay. Copyright © 1978 by David Macaulay. **246:** © A.D.A.G.P., Paris/V.A.G.A., New York, 1986.

Chapter 9 247: Leo Castelli Gallery, New York. **248:** Photo by Geoffrey Clements, Staten Island, New York/Paula Cooper Gallery, New York. **249:** Brooke Alexander, Inc.,

New York. **251–252:** Photos by Pramuan Burusphat. **256:** © A.D.A.G.P., Paris/ V.A.G.A., New York, 1986. **257:** Photo by Pramuan Burusphat. **260:** Photo by Pramuan Burusphat. **262:** The Solomon R. Guggenheim Museum, New York; © Öyvind Fahlström, V.A.G.A., New York, 1986. **264:** Photo by Pramuan Burusphat. **266:** Photo by Pramuan Burusphat. **267:** Photo by Bevan Davies, New York. **268:** Photo by Alan Zindman/Mary Boone Gallery, New York. **270:** Photo by D. James Dee, New York. **271:** Photo by Bevan Davies, New York. **273:** Photo by Pramuan Burusphat. **274–275:** Photos by Danielle Fagan, Austin, Texas. **276:** Photo by Pramuan Burusphat.

Chapter 10 277: Photo by Allan Finkelman/Sidney Janis Gallery, New York. **278:** Photo by Otto E. Nelson, New York, Sidney Janis Gallery, New York. **279:** Photo by R.D. Fleck, Toronto, Canada. **280:** Photo by Oliver Baker Associates, Inc., New York/ Sidney Janis Gallery, New York. **283–284:** Photos by John Jackson. **285–286:** Photos by Pramuan Burusphat. **287:** Photo by Ann Harkness, Denton, Texas. **288:** Photo by Susan Einstein/Hunsaker/Schlesinger Associates, Los Angeles. **289–298:** Photos by Pramuan Burusphat. **299:** © A.D.A.G.P., Paris/V.A.G.A., New York, 1986. **300:** © S.P.A.D.E.M., Paris/V.A.G.A., New York, 1986. **301:** Photo by Eric Pollitzer, Hempstead, New York; © Tom Wesselmann, V.A.G.A., New York, 1986. **302:** © Andy Warhol, V.A.G.A., New York, 1986. **303:** © Larry Rivers, V.A.G.A., New York, 1986. **304:** Girandon Art Resource, New York. **306:** Reproduced with permission of Forum Gallery, New York. **308:** © A.D.A.G.P., Paris/V.A.G.A., New York, 1986. **309:** Robert Miller Gallery, New York. **310:** Constance Lebrun Crown, Santa Barbara, California. **312:** Photo by Danielle Fagan, Austin, Texas. **313–314:** Photos by Pramuan Burusphat. **315:** Alinari Art Resource, New York.

Chapter 11 316: Photo by Glenn Steigelman, Inc., New York/Mary Boone Gallery, New York. **317:** Photo by Rick Gardner, Houston, Texas/Texas Gallery, Houston. **318–319:** Photos by Geoffrey Clements, Staten Island, New York; © A.D.A.G.P., Paris/ V.A.G.A., New York, 1986. **321:** © Toledo Museum of Art, 1982. **322:** Photo by Jake Shteynvarts. **323:** Photo by Tseng Kwong Chi. **325:** Photo by Douglas M. Parker Studio, Los Angeles. **326:** Willard Gallery, New York. **327:** Photo by Olaf Berghorn. **328:** Photo by Kevin Noble/Metro Pictures, New

York. **329:** Photo by D. James Dee, New York. **331:** Sonnabend Gallery, New York. **332:** Space, Los Angeles. **333:** © Andy Warhol, V.A.G.A., New York, 1986. **336:** Photo by David Wharton/Fort Worth Art Museum. **338:** Holly Solomon Gallery, New York. **339:** Reproduced with permission of Holly Solomon Gallery, New York. **340:** Photo by Danielle Fagan, Austin, Texas. **342:** Photo by Ann Harkness, Denton, Texas.

Practice Guides 349–357: Photos by Pramuan Burusphat. **359:** Photo by Nathan Rabin, New York. **360–362:** Photos by Pramuan Burusphat.